Silver and Gold

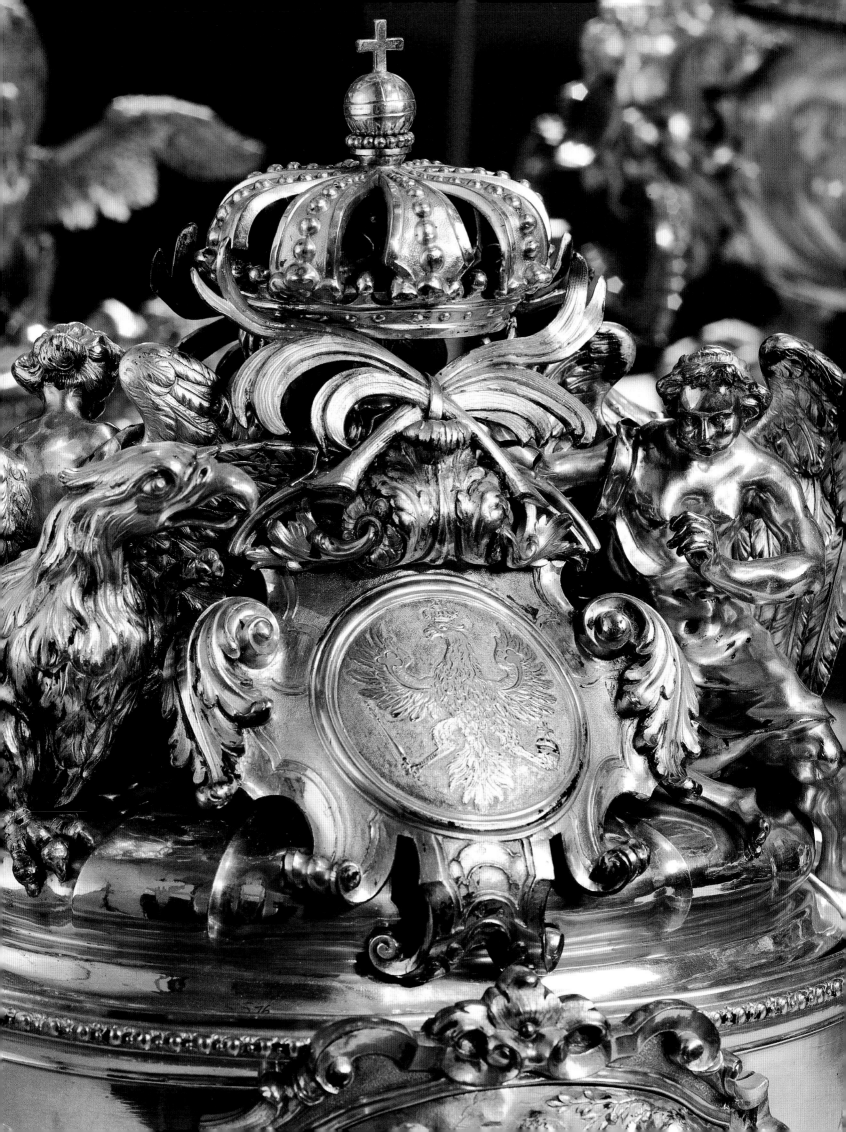

SILVER AND GOLD

Courtly Splendour from Augsburg

Lorenz Seelig

With photographs by

Wolf-Christian von der Mülbe

Prestel

MUNICH · NEW YORK

Photographic Acknowledgements on p. 128

Front cover: Arm of an armchair, *c.* 1670 - 4 (plate 21)

Back cover: Ewer and basin from the gold dressing-table set made for the
Tsarina Anna Ivanovna, *c.* 1736 - 40 (plate 47)

Frontispiece: Pie dish from the Berlin buffet, *c.* 1731 - 3 (plate 38)

Translated from the German by Elizabeth Clegg
Copy-edited by Simon Haviland

Prestel-Verlag
Mandlstrasse 26, D-80802 Munich, Germany
Tel. (89) 38 17 09-0; Fax (89) 38 17 09-35
and 16 West 22nd Street, New York, NY 10010, USA

Prestel books are available worldwide. Please contact your nearest
bookseller or write to either of the above addresses for information
concerning your local distributor.

Lithography by eurocrom 4, Villorba TV, Italy (colour illustrations),
Karl Dörfel GmbH, Munich (black-and-white illustrations)
Typeset by Reinhard Amann, Aichstetten
Printed and bound by Passavia Druckerei GmbH Passau

Printed in Germany

ISBN 3-7913-1456-4 (English edition)
ISBN 3-7913-1447-5 (German edition)

Contents

Foreword

The objects produced by the goldsmiths and silver-smiths of Augsburg from the sixteenth to the early nine-teenth century were made for the courts, for the Church (both Protestant and Roman Catholic), for the upper strata of the bourgeoisie, for the cities and for the guilds; and they are now treasured items in the collections of the world's museums. These products are evidence of the artistic genius and skill that once flourished among the craftsmen of the old Imperial city, being passed down from generation to generation as virtually no-where else in Europe. The high degree of mastery with which the precious metals – silver and gold – were further refined was thus the basis for a quite extraordi-nary development of precisely this branch of Augsburg craftsmanship. Its products were frequently regarded as appropriate vehicles for carefully programmed icon-ography and were employed as elements of public dis-play, bestowing brilliance on the power exercised by their owners.

Only a few of the objects produced by the goldsmiths of Augsburg (and this is above all the case with those commissioned by the courts) are still to be found in their original contexts. By this we mean the contexts for which they were made and within which (through the lustre of their surfaces, the sumptuousness of their con-struction and decoration and, not least, the sheer weight and thus the material costliness of the precious metal it-self) they served as status symbols. Yet only knowledge of the intended function of any given work enables us to rediscover its real importance and to determine the real significance invested in it. In this respect, the museums that serve as modern treasure houses for the products of the goldsmiths come up against almost insuperable bar-riers: for, in a museum display, the original ceremonial context of these isolated relics of the *ancien régime* is lost, and their aura all but extinguished. Something of this aura does undeniably endure, however, in the case of an item such as the silver throne made in 1650 for Queen Christina of Sweden by Abraham I Drentwett: this still stands in the throne room of the Royal Palace in Stock-holm, a symbol of the state and of its monarch on account of the sheer venerability of its appearance.

Recent research, which has taken a strong interest in the social function of works of art, has focused on forms of ceremony and display, areas long neglected by special-ists in this field. It has proved of particular value in

opening up new insights into the products of the gold-smiths of Augsburg. In Munich in 1994, drawing on re-search of this kind, the Bayerisches Nationalmuseum mounted the comprehensive exhibition *Silber und Gold: Augsburger Goldschmiedekunst für die Höfe Europas.* This brought together loans from the great museum collec-tions that derive from precious objects assembled at the courts – those, for example, of Vienna, St Petersburg, Moscow, Copenhagen, Berlin, Dresden and Munich. By means of such a focus on the context of the court, it was possible to single out an important part, and probably the most telling aspect, of the overall production of the masters of Augsburg.

The exhibition demonstrated that only a survey or-ganized in terms of various functional categories – items for the table and for the buffet, for the dressing-table and for the treasury or for the decoration of state – can show how essential to the objects now dispersed between many different museums is their original character as part of an ensemble. The attempt (recorded in the illus-trations to the present volume) to gather together as many of the surviving parts of such ensembles as pos-sible in self-contained groups – for instance, the buffet of the Berlin Schloss, the silver furniture made for the House of Guelph, or the dinner service made for Fried-rich Wilhelm von Westphalen, Prince-Bishop of Hil-desheim – and to reconstruct these groups as they ori-ginally appeared, resulted in the spectacle of a mass of silver and gold that was almost dazzling. By this means too we hoped to convey (and for the first time on such a scale) a fundamental aspect of the work of the Augsburg goldsmiths: for, in the context of the court, the experi-ence of profusion and the display of magnificence were indispensable factors.

The record of this attempt at the reconstruction of former contexts is testament to the mastery of the pho-tographer Wolf-Christian von der Mülbe. With his feel-ing for the sumptuousness of detail and for the over-powering general impression of the great ensembles, he has been able to achieve images that capture both the ceremonial character and the formal sophistication of the items supplied to the courts, while also preserving a sense of the twentieth-century viewer's astonishment at the achievements of Augsburg craftsmanship.

The introduction to this volume has been written by Lorenz Seeling who, as curator of metalwork at the

Bayerisches Nationalmuseum, was largely responsible for organizing the exhibition held there in 1994 and who, together with other scholars, published his own painstaking research, as well as many new findings, in the accompanying catalogue. Here he takes stock of this widely praised scholarly undertaking, the new book serving as both fruit and confirmation of his contribution to this field.

Prestel-Verlag has devoted itself to this publication in a spirit of great receptiveness to the varied aspects of its subject. It is thanks to them that a brilliant chapter in the history of the Augsburg goldsmiths can be presented to a wider public in so elegant a volume. The skill of the photographer, the expertise of the author and the commitment of the publisher have here combined to convey the beauty, the sumptuousness and the significance of those works in silver and gold that – thanks to the skill of the craftsmen and the economic power of the Imperial city – were once treasured at all the courts of Europe and have thereby been assured of wide and lasting fame.

REINHOLD BAUMSTARK

General Director, Bayerisches Nationalmuseum

Augsburg as the European Capital of the Goldsmith's Art

From the sixteenth to the eighteenth century, the goldsmiths of Augsburg – and this term is used to denote workers in silver as well as in gold – dominated their field, both within Germany and throughout central Europe. Particularly between the time of the Thirty Years War (1618-48) and the demise of the Holy Roman Empire (1806), Augsburg was the unchallenged capital of work in precious metals. Several factors may serve to explain this dominance. The first concerns questions of religion. Augsburg, a city anxious to preserve its own independence, was willing to grant freedom to its citizens in matters of religion. Following the Peace of Augsburg in 1555, which to a large extent made possible the harmonious coexistence of Protestants and Catholics, goldsmiths of both confessions were permitted to practise their craft there. This

egalitarian arrangement also encouraged talented workers to move to Augsburg from other cities. A great many goldsmiths – from Kiel and from Lübeck, from Danzig and from Breslau, from Frankfurt am Main and from Ulm – came to work in Augsburg, not only serving there as apprentices and workshop assistants, but also qualifying as 'masters'. These newcomers also brought formal and technical innovations with them to Augsburg.

The church also wielded considerable commercial power at this period, in particular as a major source of patronage. The situation in Augsburg thus offered goldsmiths, as also other artists and craftsmen, much wider opportunities, in that they were able to accept commissions from both the Protestant and the Catholic church, though there was, of course, far greater demand from the

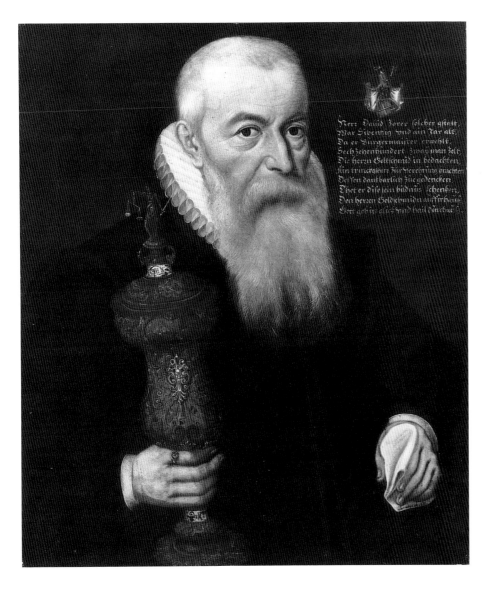

1 *The goldsmith and mayor of Augsburg, David Zorer. Painting, probably Augsburg, about 1602; private collection. The covered standing-cup held in the subject's right hand was made in about 1602 by Jakob Schenauer and is now in the collection of the Bayerisches Nationalmuseum.*

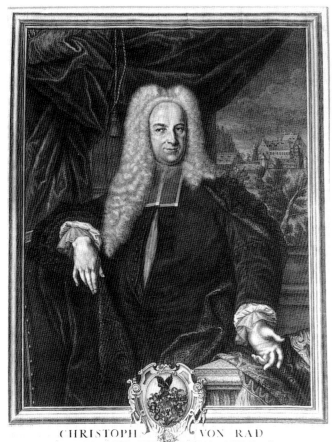

CHRISTOPH VON RAD
IHRO RÖMISCH KAYSERL UND KÖNIGL CATHOL MAYEST
GEHEIMER CAMMER UND HOF IUBELIER
WIE AUCH DES INNERN RATHS IN
DES H. R. REICHS STADT AUGSPURG
GEBOHREN DEN XVI IULII AÑO MDCLXXXVI GESTORBEN D XIV IULII AÑO MDCXLV

latter. In other centres of the goldsmith's art, on the contrary, the dominance of one confession (and source of patronage) at the expense of the other had led to a serious decline in commissions; this was as true of Catholic Cologne as it was of Protestant Nuremberg.

The Augsburg goldsmiths (fig. 1) tended, all the same, to work much less for the local market than they did for export, and they were thus also able to profit from the traditionally strong position of the trading houses. Leading entrepreneurs with large capital resources – such as the Fuggers – were intensively engaged in the trade in silver ore and, before that, also in silver mining. As a result, sufficient amounts of precious metal were always available in Augsburg – in contrast to the situation in other cities, where goldsmiths often suffered from the lack of raw material. This too ensured that Augsburg continued to attract commissions. Moreover, the trading companies of Augsburg, with their businesses closely integrated with that of the banks, their extensive contacts, their branches in other cities, and in some cases their partial involvement in art dealing, were able to ensure that gold and silver products from Augsburg workshops reached the foreign market.

In such circumstances, it is not surprising that there gradually evolved a system for promoting these products that ensured a leading role for the specialized silver dealers (figs. 2, 3). Often themselves starting out as goldsmiths, these functioned as middlemen between craftsmen and their customers. Most of their energy and expertise was devoted to securing orders: they sent representatives to attend the large fairs (in particular those in Frankfurt am

2 *The Augsburg silver dealer and merchant Christop von Rad. Engraving, Augsburg, c. 1730. The subject was an assessor appointed by the city authorities and also an Imperial court jeweller; he supplied items for the court in Vienna in particular.*

3 *Trade card of the Augsburg silver dealer Wilhelm Michael Rauner. Engraving, Augsburg mid-18th century.*
In the era of Rococo the Augsburg silver dealers played a leading role in the supply of extensive ensembles, for example large dinner services.

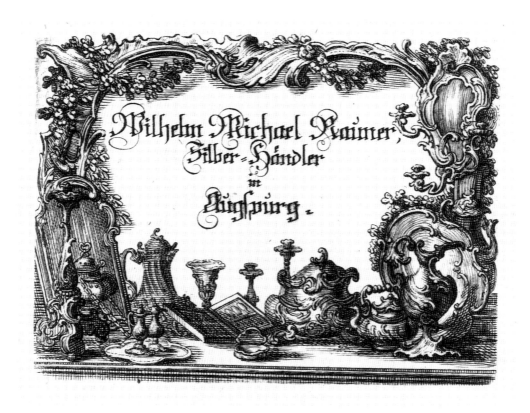

Main and Leipzig), they kept up correspondence with abbeys and courts and they particularly sought out ecclesiastical and aristocratic clients, even maintaining some sort of presence at political assemblies and dynastic festivities in the cities and at courts, in order to offer their services on such occasions. In approaching potential customers, they would refer to the designs they carried with them (fig. 24) and draw on their wide knowledge of the field to consult the appropriate specialists, for example where the production of a large or complex ensemble was concerned. Such a readiness to divide commissions between several workshops was characteristic of the goldsmith's art in Augsburg. It was also advantageous: as a result of such arrangements it was possible to complete even larger commissions remarkably swiftly. As far as one can tell, the goldsmiths and silversmiths themselves almost never took part in such negotiations, which were entirely the business of the silver dealers. These also took responsibility for settling the financial aspects of the transaction, often at considerable risk to themselves. In all probability, it was also due to the silver dealers, who were alert to every fashionable trend, that it was in Augsburg above all that precious raw material of exotic origin as well as new man-made materials produced in Europe – for instance attractive shells from distant oceans or the Meissen porcelain known as 'white gold' – were incorporated into the objects produced by the goldsmiths' workshops.

In addition, Augsburg's prominent position as a political stage was of particular importance, especially in the sixteenth century. During the Imperial Diets (parliaments) held in Augsburg, the city was host to numerous princes and their retainers, and these eminent persons would often acquire the products of the local goldsmiths. Over time it was possible to establish closer relations between craftsmen and those commissioning their work, these last often using the objects they acquired as gifts, which in turn encouraged even more widespread admiration for the city's luxury products. The well-developed tradition of presenting gifts (fig. 9) was thus one of the most fundamental reasons for the great flowering of the goldsmith's art in the large cities and especially in Augsburg, for only the leading centres were in a position to carry out large commissions within a short time.

One particular advantage of Augsburg in relation to other cities lay in the unusually close co-operation between various highly specialized craftsmen, who readily collaborated on complex compositions, for example stonecutters and gem-cutters, clock-makers and those who built organs and automata, cabinet-makers and case-makers, embroiderers and braid-makers. Particularly decisive from the artistic point of view, was the pre-eminence of Augsburg sculptors, who prepared the models for many of the figurative elements incorporated into work produced by the goldsmiths. The sculptors Georg Petel, Egid Verhelst and Johann Michael Feichtmayr all contributed in this way to the work of the Augsburg goldsmiths. Leading Augsburg painters, meanwhile, were able to supply paintings for the cabinets for which the city was widely known. Of considerable significance was Augsburg's position as

a leading centre of printmaking and publishing. Prominent draughtsmen active in the city would supply goldsmiths with designs for their work (see p. 19, figs. 6, 26) that were in keeping with the ornamental forms in fashion at any given time. Then there were engravers who, if necessary, were also able to engrave on silver (plate 17). Even those employed to engrave notes for the great music publishers of Augsburg might be engaged: the notes being played by the harpsichordist of the Hildesheim centrepiece (plate 59) were probably engraved by a professional hand. Out of the very intensive artistic ambience of the Imperial city of Augsburg, the goldsmith's craft thus emerged as a specific branch of art: its practitioners, with their extremely high standards regarding quality, invariably saw their occupation as equal in rank to painting, sculpture and architecture.

The strength of the Augsburg goldsmith's art was not least due to its tightly organized practice as a craft. This was governed above all through regulations issued in 1529 and often extended and updated during the following decades and centuries. Apprentices, who had to be the 'legitimate children of honest fathers' and at least twelve years of age, were employed for four (this later became six) years in a master's workshop, where they were treated as members of his household. This training period was followed by employment as a workshop assistant (*Geselle*), initially for four years, and by the eighteenth century for eight years. It was also necessary for them to work for several years as a journeyman (also called *Geselle*). (These periods of time were shorter in the case of those goldsmiths who had been born in Augsburg or had completed their training there.) It was only then that the goldsmith might submit his 'masterpiece' (on the basis of which he would receive the title of 'master'). Until about the end of the seventeenth century, the objects to be made were a gold ring, a seal cut in silver and a silver drinking vessel. In the eighteenth century a distinction was introduced between those working in gold and those working in silver, the latter having only to make a silver drinking vessel and to cut a seal. With the passage of time these rules became less strict. As long as the goldsmith's 'masterpieces' were executed and accepted within a certain period of time, he was allowed to purchase the so-called *Gerechtigkeit* (lit. legitimacy) permitting him to run his own workshop, if such a right did not come to him by other means, for example through patrimony or through marriage.

The number of those employed in any single workshop (figs. 4, 5) was always strictly limited: in the early days six, and later only five, individuals (including the master himself) were allowed to be actively engaged in each. Further hands might only be taken on in exceptional circumstances, and only then with permission, for example when a coppersmith was required for the execution of larger embossed silver vessels. Strict controls were also imposed on the use of tools facilitating the serial production of works in silver and gold. Here the principal intention was to establish a balanced relationship between the various workshops and to allow no single master to dominate the others. Such an attempt – one

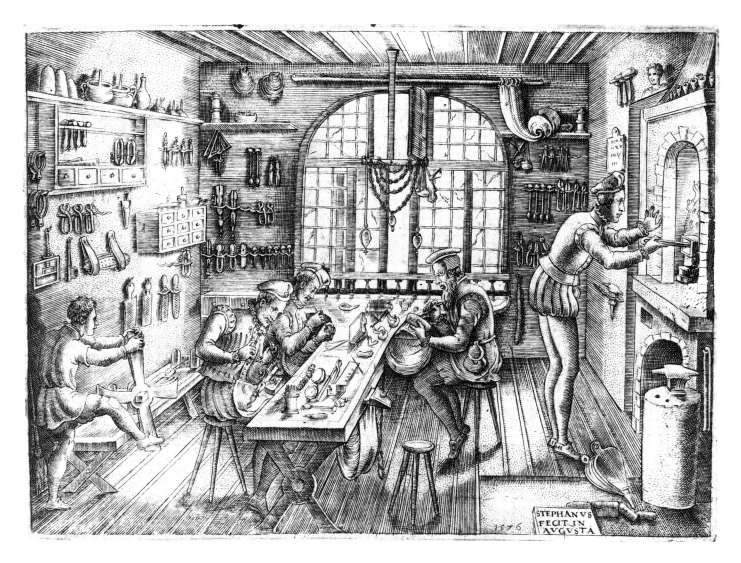

4 *A goldsmith's workshop.*
Engraving, Étienne Delaune, Augsburg, 1576.
These very elegantly dressed craftsmen are engaged in
particular in making jewellery and other gold objects.
On the left, wire is being pulled on a drawing bench.

that was admittedly often enough called into question and under-
mined by ambitious individuals – contrasts sharply, for example,
with the situation prevailing in London and Paris: in both cities it
was possible for individual workshops of comparable standing to
attain quite different positions depending on their respective pro-
ductivity. In Augsburg, on the other hand, large commissions had
to be assigned to several workshops, often to those with the rele-
vant specializations. As a result, the number of goldsmiths work-
ing in Augsburg continued to rise. The peak was reached in the
eighteenth century: of Augsburg's 31,000 inhabitants in about
1735/40, some 260-275 were active as master goldsmiths, and to

these must be added the journeymen and apprentices engaged in
their respective workshops. Art historians studying the art of the
Augsburg goldsmiths have been able to identify an overall total of
2240 masters active in the city between the sixteenth and the nine-
teenth centuries.

Overall supervision of the goldsmiths' workshops was the task
of two wardens appointed by the city council and recruited from
the circle of masters. During the recruitment process there was al-
ways a keen concern for parity between Protestants and Catholics.
The same was true of the selection of the assayers who were
responsible for the standard of the worked silver, this being

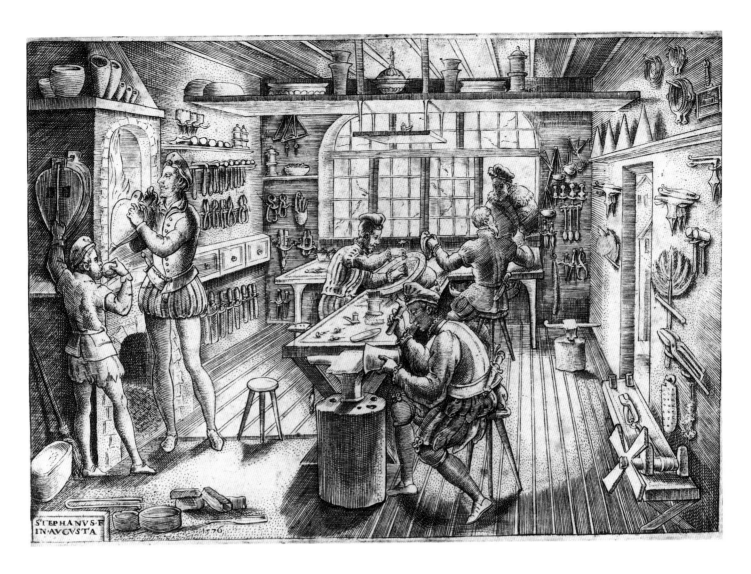

5 *A silversmith's workshop.*
Engraving, Étienne Delaune, Augsburg, 1576.
The workshop shown here is also a place where goods are sold;
in the foreground a beaker is being beaten on an anvil while,
in the background, a customer looks in at the window.

rigorously observed in Augsburg. By this means, the buyer could always feel reassured that purchased objects made in Augsburg workshops complied with the prescribed silver content. The reputation of Augsburg in this respect was, indeed, such that the Augsburg standard was regarded as the quintessence of reliability. The main concern here was not so much artistic as financial: as silver might at any moment be melted down and, if necessary, used for coins, a reduction in the silver content signified an appreciable decline in value. Assessing the silver content thus assumed considerable importance.

To begin with, the master would stamp his master's mark on the piece he had prepared – or, in the case of complex items, on the separately worked individual parts – in order to make possible at every moment an identification of the maker. Such marks, consisting of the maker's initials, the merchant's mark or a device, were thus simply an unmistakable means of identification, but by no means a signature used out of artistic pride. The assayer would then test the silver content by taking a sample. Making a zigzag line with an engraving tool – the so-called *Tremulierstich* – he would remove a splinter of silver, which would then be analysed using various methods. With regard to the standard, 14-lot silver was initially prescribed (in modern terms this would be defined as

875/1000 alloy), consisting of fourteen parts of silver to two parts of copper and other constituents. From the early seventeenth century, 13-lot silver – that is to say 812/1000 silver – was used.

If the standard of the tested work was in accordance with the prescriptions and the piece was judged to be sound, the assayer added the town mark in confirmation of this. If the standard, in accordance with a specific request accompanying the commission, was above the prescribed 13-lot silver content, then this too had to be recorded by means of an inscription or a stamp in place of the assayer's mark, as in the set of vessels made by Johann Ludwig II Biller for the princely house of Thurn und Taxis, for example (see p. 44). In Augsburg the so-called *Pyr* was used as the town mark. The fruit, shaped like a bunch of grapes or a pineapple, was incorporated within the city's coat of arms and was seen to represent a pine cone; according to the Augsburg humanists, it alluded to the city's Roman foundations. The frequently changing form of the assayer's mark in Augsburg – about 360 different stamps are known, further differentiated from 1734 by the addition of a letter in alphabetical order – allows an unusually precise dating of objects in precious metal made there. No other German city evinces a comparably precise and extensive chronology of town marks as that established by the fundamental research carried out by Helmut Seling.

Sometimes, of course, one comes across pieces that bear neither an assayer's mark nor a master's mark. This is especially the case with items commissioned by princes who themselves provided the silver to be worked, along with the commission. This silver was often obtained by melting down older objects made in styles that had fallen out of fashion.

As a result of the conditions we have noted in political, religious and cultural life, the goldsmiths of Augsburg were able to carry out even large commissions in the shortest possible time. They received some of the most important of these from the courts of Europe, which were notable for their ostentatious use of silver and gold. This tradition is explained by the contemporary understanding of the necessity for princely pomp: magnificence was obligatory for the sovereign, both as a form of reassurance for his subjects and as a means of defying his rivals. It was, moreover, only the sovereign (already in control of the use of silver and gold in connection with the minting of coins) who had access to sufficient amounts of raw precious metal. At the courts, as we have already observed, there was always to be found a large supply of gold and silver objects. These might be used as a form of payment or handed over to silver dealers or goldsmiths to be reworked into new pieces.

Accordingly, whenever large or elaborate objects in precious metal were made, this was usually at the expense of the irreparable loss of older items. Artfully worked silver might thus be understood to embody a substantial part of a state's wealth. The most striking example is provided by the huge commission offered to the Augsburg goldsmiths in 1731 by King Friedrich Wilhelm I (see pp. 30, 31, 33 - 34). The furniture and dinner service intended for the Berlin Schloss had a total silver content weighing 8400 pounds. This was in effect a substantial reserve fund, to which the king and his descendants might resort in times of war. By far the greatest loss of valuable works in silver belonging to the German courts occurred in the period 1792 - 1815, during the wars set off by the French Revolution and the rise of Napoleon. Even in the case of the works commissioned by Friedrich Wilhelm I, only a few objects have survived (frontispiece, plate 38); all the rest were melted down so that the silver could be used for coins. Such a course of events is symptomatic of the fate that always hung over the products of the goldsmith's art. Nowadays only isolated examples, albeit of the highest historical and artistic significance, testify to the former sumptuousness of the silver holdings of the European courts.

Drinking Vessels and Display Platters for Courtly Tables and Buffets

During the Renaissance and the era of the Baroque, exceptional significance was invested in ceremonial drinking. Frequently a guest would be greeted with a wine-filled drinking vessel of elaborate form, the so-called *Willkomm*, the welcome cup. Treaties too might be sealed with a drink, and a beaker or cup of wine might be offered as an integral part of the annual counting of property tax payments in the city council chamber. Such practices reveal how central a position formal drinking occupied in the life of the legal community. Accordingly, commissions for drinking vessels, which might be extremely varied in form, were counted among the most important that a goldsmith might receive. Drinking vessels with figurative structure and decoration were, in fact, a speciality of the goldsmiths and silversmiths of Augsburg. Local sculptors often supplied the appropriate models, as is revealed by the frequent similarities between the products of the city's sculpture and goldsmith workshops. The items executed in precious metal were enhanced by their carefully worked bases and the brilliant gilding of their subtly finished surfaces.

Welcome cups most commonly took the form of huntable game: such objects were especially to be found among the appointments of princely hunting lodges. To drink from such a vessel, it was merely necessary to remove the head of the silver figure. The interior was usually gilded to prevent undesirable reactions between the wine and the copper contained in the silver alloy. Among the surviving examples of animal figures serving as the catch of the high-ranking hunter, the most frequently encountered are wild boars and stags (deer-hunting still being the prerogative of the nobility). Elias Zorer's rearing boar (plate 2), with a diamond ring in its snout, as also Albrecht von Horn's imposing stag (plates 1, 2), with its decorative collar (which also covers the joint where the removable head meets the body), appear to represent tamed creatures; and silver-mounted stag collars are in fact cited in the inventories of princely collections. Both animals are of an extreme liveliness and there is an emphatic plasticity in their modelling. Albrecht von Horn's stag has an air of solemn dignity quite beyond that associated with the decorative stag figures produced by other Augsburg goldsmiths (see plate 8).

Vessels in the form of silver horses are also frequently to be found, sometimes serving as the prizes for the winners of tournaments or archery contests. The noble steed found among the figures produced by Elias Zorer, moreover (plate 2), might well have been intended to allude to the horse as the mount of princes; the taming of the wild horse by the sovereign was understood in earlier centuries as a symbol of the exercise of sovereignty (see fig. 6).

The figures of the he-goat and the ox made by the eminent sculptor-goldsmiths Melchior I Gelb and Elias Zorer (plate 2) are not directly connected with the princely sphere. The he-goat prancing on its back legs, and shown here with strongly sensual features, was traditionally seen as belonging to the entourage of Bacchus and would thus readily be understood to allude to the high-spirited enjoyment of wine. It is probable, meanwhile, that the rearing ox originally functioned as the welcome cup of a butchers' guild, as is indicated by the concealed, engraved images of a cleaver and the head of an ox on the inside of the collar. This figure, certainly much appreciated as a masterly rendering of its subject, soon entered the collection of the Landgraf of Hessen-Kassel.

A more complex type of figured drinking vessel was the so-called *Trinkspiel* (drinking game), or automaton, which was activated by a mechanism concealed within the base. (Invariably, one finds that the delicate mechanical parts of such vessels have long ceased to function.) Complex, adjustable steering mechanisms made it possible to determine the direction of movement in advance: the automaton would, for example, travel in a circle or trace a square across the surface of the table. Whichever of the drinkers was sitting where the automaton came to a stop would then have to drain the vessel dry. To do so he would raise the silver figure, which was usually set into the base with smooth rods, and remove its head.

Two of the best known Augsburg automata from the courtly sphere show Diana, the Goddess of Hunting, and the chivalric Saint George (plates 5, 4). There are notable formal similarities between the two, not only with regard to the graceful mounted figures, in each case posed to appear to best advantage when seen from the side, but also in the recurrence of the same elongated octagonal base bearing the accompanying subsidiary figures. Almost thirty models of the Diana group are known, each slightly different from the rest; it is here shown in a version by Joachim Fries of Darmstadt, which has been preserved complete with all its accessories. A report of 1612 indicates that such objects were chiefly intended as prizes for those taking part in tournaments. Certainly, the subjects themselves reflect the courtly enthusiasm for hunting motifs.

The figure of Saint George, here shown as the Dragon Killer, was made by the goldsmith Jakob I Miller, who is also known as the maker of many automata with Diana motifs. At both Protestant and Catholic courts Saint George was the most keenly recognized symbol of Christian chivalry. As we know from the comments in contemporary descriptions of court festivities, a figure of Saint George serving as a table decoration might be perceived as an allusion to the struggle against the Infidel. It is possible that any

challenge presented or accepted at court would be strengthened by drinking out of such a figured vessel, just as so-called *Heiligen-minne* (saintly love) was pledged by drinking out of special vessels in honour of a divine patron.

Technically more elaborate than the *Trinkspiel* was the *Tisch-automat* (table automaton), whose figures could move independently while concealed miniature organ mechanisms played various tunes. The Viennese table automaton made by Sylvester II Eberlin (plate 3), which comes from the Prague *Kunstkammer* of the Emperor Rudolph II, is a work clearly intended for display, and notable for its emphatic plasticity and its gilt surface set off with colour. The wagon rolling across the table – and seeming to parody the progress of a triumphal entry – itself sets the figures seated on it into motion. Bacchus raises his right arm with a bunch of grapes in his hand; the parrot, beating its wings, looks up at the fruit; and the stout musician embarks on a tune on his bagpipes.

The table automaton of a centaur carrying the figure of Diana on its back made by Melchior Mair (plate 3) is a very refined variant of the automated table decoration. The hybrid creature, half man and half horse, would use its steel bow to shoot one of the miniature steel arrows hidden in its quiver. Whichever of those sitting around the table was hit by the arrow had to drain a drinking vessel. This item, acquired in Prague in 1610 by the Elector Christian II for his Dresden *Kunstkammer*, is still close to the Diana and Saint George pieces (plates 5, 4) in so far as it combines many separate compositional elements. It differs, of course, in its sturdy base, which in this case is made of ebony.

Further figures to be found among the automata are Hercules and Saint Christopher (plate 7). These form a pair, both in terms of composition and by virtue of the supernatural powers invested in them. Hercules, a hero of pagan mythology, bears on his shoulders a terrestrial globe on which there perches an eagle – that of Jupiter, but perhaps also that of the Emperor. Christopher, meanwhile, a 'hero' of the Christian church, holds aloft a celestial globe on which there sits the Christ Child, shown raising his hand to bestow a blessing. In each case the upper half of the sphere can be removed so that the lower half can be used as a shallow drinking vessel. The extremely delicate engraving on the surface of both spheres (which were subsequently interchanged) corresponds to a representation of Heaven and Earth that was extremely modern for its time. The goldsmith Elias Lenker here provides an original transposition of the motif of Atlas, as striking for its sculptural power as for the refined precision of its details.

In a later reworking of the same motif by Heinrich Mannlich, typical of the High Baroque, we find the vigorous image of a man straining beneath the weight of an indeterminate burden with the general appearance of a sphere tied up in a cord net (plate 7, centre). Depending on whether one favours a pacifist or a bellicose interpretation, this object might be interpreted as a bale of merchandise or as an incendiary bomb. Such ambiguity is an inevitable concomitant to the adoption of a figure from the realms of genre in place of one with well-established associations. In

keeping with its relatively late date – it comes from a period when automata of the type we have considered were no longer made – this piece has no mechanism in its base, which is in fact flat. The figure is, rather, to be classified as a table piece intended to contain sweetmeats and spices.

The same function is to be associated with the four salvers made by Hans Jakob I Baur in about 1653 (plate 6), which come from a set of eighteen identical pieces. Only in the Armoury of the Kremlin in Moscow (where the silver collections have rarely been in danger of being melted down) have such extensive series been preserved as were once to be found as a matter of course at all the great princely courts. This type of salver is a Baroque transformation of the Italian Renaissance *tazza*, exemplified in the simple drinking bowl on the buffet shown in plate 8. The shallow scalloped bowls rest on strongly sculptural figures of Mars and Minerva, who in turn each stand on a domed foot. A salver of this sort, clearly unsuitable for drinking, would have been reserved exclusively for proffering sweetmeats.

The so-called buffet served as a complement to the principal table; and it was on a buffet that the silver treasures of the court would be displayed on festive occasions. The step-like construction allowed a compositionally balanced arrangement of usually large silver objects: these would rise in a staggered pattern, without any overlapping, against a fabric covering. Such a display would be seen as testifying to both the material wealth and the political power of the court.

To begin with, in so far as they had a practical function, buffets were chiefly intended for the presentation of those silver objects used to serve guests seated at the table. They would therefore be most likely to display drinking vessels, various forms of jugs for pouring drinks, and large cisterns, these last being used for cleaning glasses as well as for cooling drinks. Later buffets were, however, intended principally for display, retaining only a few aspects of their former practical function.

The three-tiered structure of the buffet displaying objects from the Late Renaissance (plate 8) imitates on a much reduced scale the buffet set up for the banquet held to mark the coronation of the Emperor Matthias in 1612 in the Römer in Frankfurt am Main. The engraving by Johann Theodor de Bry (fig. 7) shows, behind the Electors' table, a construction draped in cloth with cups

6 *Design for an equestrian statuette of King Gustavus II Adolphus of Sweden.*
Drawing, Hans Friedrich Schorer, Augsburg, c. 1645.
Nationalmuseum, Stockholm.
The Augsburg goldsmith David I Schwestermüller, whose comments are marked on this sheet, executed a corresponding silver figure of the king.

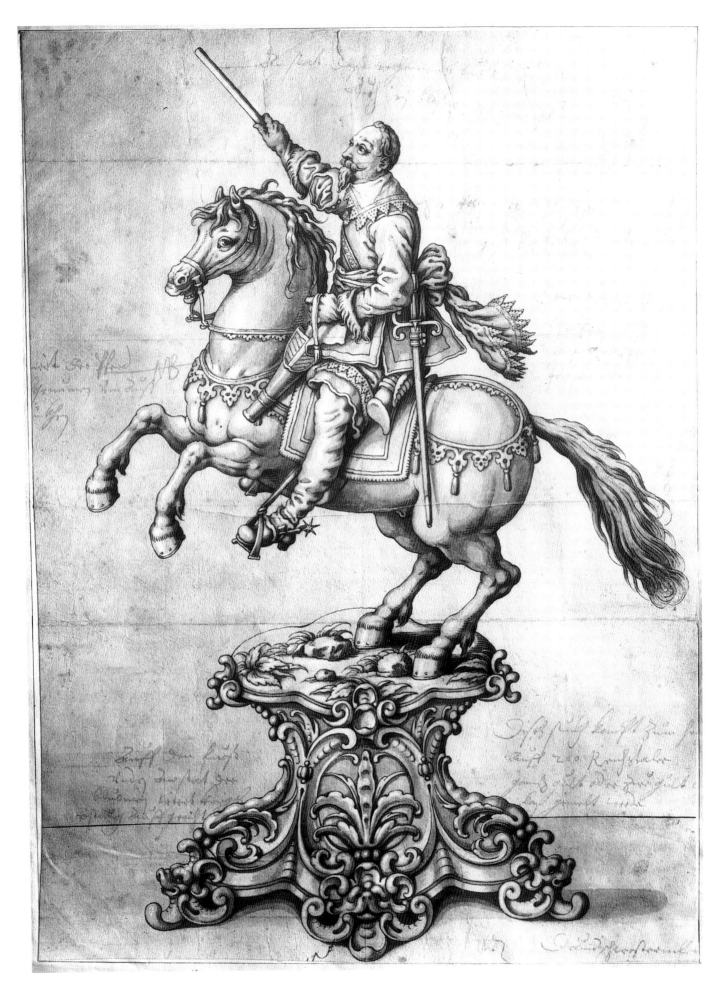

displayed on each of its three levels. In the sixteenth and the early seventeenth centuries such buffets were often laid with double standing-cups, made up out of two halves identical in shape. The double standing-cup, distinguished by its tall, slender form, was an effective object for display on the buffet but could also be dismantled to provide two matching drinking vessels. In earlier centuries it was the custom to offer double standing-cups of this sort – often filled with gold coins – as a form of precious gift, for example on the occasion of triumphal entries or as a mark of homage to a monarch or other authority.

During the 1540s there appeared in Augsburg a horizontally accentuated type of double standing-cup which had evolved out of a form prevailing in the late Gothic period. Here the principal emphasis was on the strongly sculptural elements of decoration and on the animating of the surface by means of engraved or etched designs, and sometimes also with the addition of enamel. On the two halves of the Dresden standing-cup made by Hans Schebel (plate 8, middle row, left and right; plate 9, top) we find such a *basse-taille* enamel decoration. The covered cup with a beaker-shaped bowl, broadening slightly as it rises, only came into its own in the last third of the sixteenth century. Its smooth exterior offered much scope for decorative elements, whether plant tendrils or curlicues. On such items one can invariably find examples of skilfully embossed low relief work (plate 8, top).

Further types of covered standing-cup supply convincing proof of the variety to be found in the work of Augsburg goldsmiths. The drinking vessel made by Heinrich Winterstein, for example (plate 8, lower left; plate 9, left), takes the form of a gourd, its thick stalk about to be attacked by a peasant with an axe. Particularly in the early sixteenth century, such cups were rather more likely to be given a more naturalistic fruit or vegetable form. Later, as in this example, an element of abstraction made itself felt, especially in the much more strictly controlled use of line. The powerful curlicues on both the gourd and the base, designed in the *Schweifwerk* style, are characteristic in this respect.

The decorative windmill beaker made by Georg Christoph I Erhart, and deriving from Netherlandish models, is among the more playful of the surviving drinking games (plate 8, middle row, centre). This item is in fact a tumbler in the literal sense: if the bowl is filled with wine it has to be fully drained because the vessel has no steady supporting base. It can thus only be set down as if it had fallen, that is to say upside-down, so that it rests on the rim of its bowl. The windmill beaker demanded of those who used it a manner of drinking as swift as it was skilful. The drinker had first to blow into the small wheel mechanism in order to start up the windmill's sails; before these came to a stop the beaker had to be drained. The hand that moved around the dial was probably used to keep the score, in terms of the number of drinks consumed, or yet to be consumed.

The tazza – also known in German as a *Kredenz* – is a type especially characteristic of the Late Renaissance, its broad bowl resting on a sculpturally worked stem. Such items, often made in large sets, could serve as drinking vessels, though iconographic sources suggest that a certain dexterity would then be required because the wine-filled vessel was traditionally not grasped by the stem but by the base. On the whole, however, tazzas were often used to offer guests sweetmeats or fruit. (The term *Kredenz* in itself shows that this sort of vessel was associated with the taking of food: it is derived from the Latin verb *credere* [to believe, to trust], implying that the recipient could put his trust in the contents.) The tazza made by Christoph Lencker is distinguished by the powerfully sculptural character of its stem, which is framed by three putto busts (plate 8, lower centre).

Unlike the buffet of the late sixteenth or early seventeenth century (plate 8), that of the Early and High Baroque (plate 10) displays a number of remarkably large platters. In Germany after the mid-seventeenth century, such buffets were increasingly – albeit not exclusively – laid with display items of the sort seen in the copper engraving of about 1658 recording the banquet held to mark the coronation of the Emperor Leopold I in the Römer in Frankfurt am Main (fig. 8). The stepped construction is here topped off with large display platters. These relatively lightly worked objects had no practical function: in effect, they were images worked in silver. Such imposing items proved to be extraordinarily well-received presents at the Moscow court, where they came to be the preferred items for display on the principal buffet of the ceremonial hall of the Palace of Facets in the Kremlin. Certainly aware of the tastes prevailing in Moscow, the ambassadors of the powerful states of western Europe often brought colossal platters to Russia as diplomatic gifts. An etching of 1677 by Romeyn de Hooghe shows a Dutch delegation being received by the Tsar (fig. 9); on this occasion a large chandelier was formally presented.

Among the most important examples of this type is the platter made by Hans Jakob I Baur (plate 10, upper centre; plate 11) and presented to the Tsar in Moscow on behalf of the Swedish Queen Christina in 1647. It is a work striking both for its dimensions and for the extraordinary refinement in the working of its details. Right across the slightly convex centre, which dispenses with any explicit accommodation for a ewer, an episode from the Old Testament is enacted: the patriarch Jacob, returning to Canaan, is reconciled with his brother Esau, whom he had once deprived of his birthright as the first-born. As a means of bringing out details in the very crowded scene arranged in several layers of relief, subtle use is made of chiselling and partial gilding. Individual sculptural elements are separately worked and then attached to the base, for example the figure of the greyhound that stands below the horse. We find here the same model as in the case of the Diana and centaur groups in plates 5 and 3 (evidently the goldsmith fell back on older Augsburg workshop stock patterns).

The use of such appliqué elements, themselves produced by casting, reached its peak in the platter made by Andreas I Wickert, which shows the Rape of Proserpina by Pluto, God of the Underworld (plate 10, lower left). Both the figures in the main scene and the four gilded nereids dominating the lively design of the border

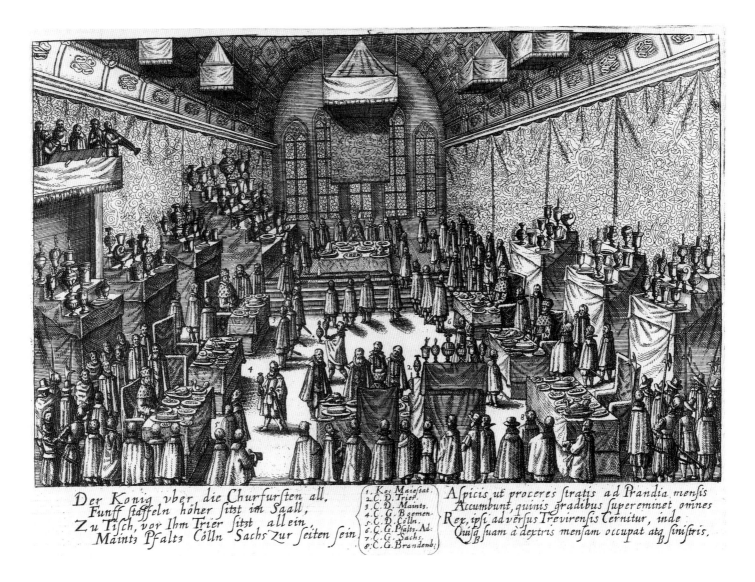

Der König vber die Churfursten all.
Funff staffeln höher sitzt im Saal,
Zu Tisch, vor Ihm Trier sitzt all ein
Maintz Pfaltz Cölln Sachs zur seiten sein

1. Kö; Maiestat.
2. C. D. Trier.
3. C. D. Maintz.
4. C. G. Boemen.
5. C. D. Cölln.
6. C. G. Pfaltz. Ad.
7. C. G. Sachs.
8. C. G. Brandenb;

Aspicis ut proceres stratis ad Prandia mensis
Accumbunt, quinis gradibus supereminet omnes
Rex, ipsi adversus Trevirensis Cernitur, inde
Quisq suam à dextris mensam occupat atq sinistris.

7 *Banquet in the Römer in Frankfurt am Main to mark the coronation of*
Emperor Matthias in 1612.
Engraving, Johann Theodor de Bry, Frankfurt am Main, c. 1612.
After the ceremony of the Imperial election and coronation, the coronation banquet took
place, its arrangement varying only slightly on each occasion.

are separately made and attached to the base by screws. In comparison with the work of Hans Jakob I Baur, the so-called auricular ornament employed by Wickert is much more shell-like and more emphatically interspersed with fantastical elements that recall grotesque grimaces and the bodies of snakes. The same is true of the platter made by David Bessmann with its scene of Abigail before David (plate 10, lower right). The compositions incorporated by both Bessmann and Baur are derived from designs supplied by the Augsburg painter and draughtsman Hanns Ulrich Franck.

The platter made by Isaak Warnberger represents a later stage of stylistic development. The decoration on its broad border combines birds and fruits with attached rosettes (plate 10, lower centre). This item came to the Moscow Kremlin in 1682, as a gift from King Charles XI of Sweden; the scene at its centre depicts various forms of courtly tournament. This scene also makes clear the purpose of such large-scale items of goldsmith's work: in front of the balcony on which distinguished personages sit to watch the contest, there hang the objects that will be offered as prizes: a platter, a ewer and basin set, and a decorative vase.

Among examples of this last category (only a few of which have survived) we may count the two opulent objects made by Abraham II Drentwett (plate 10, upper left and right). These two

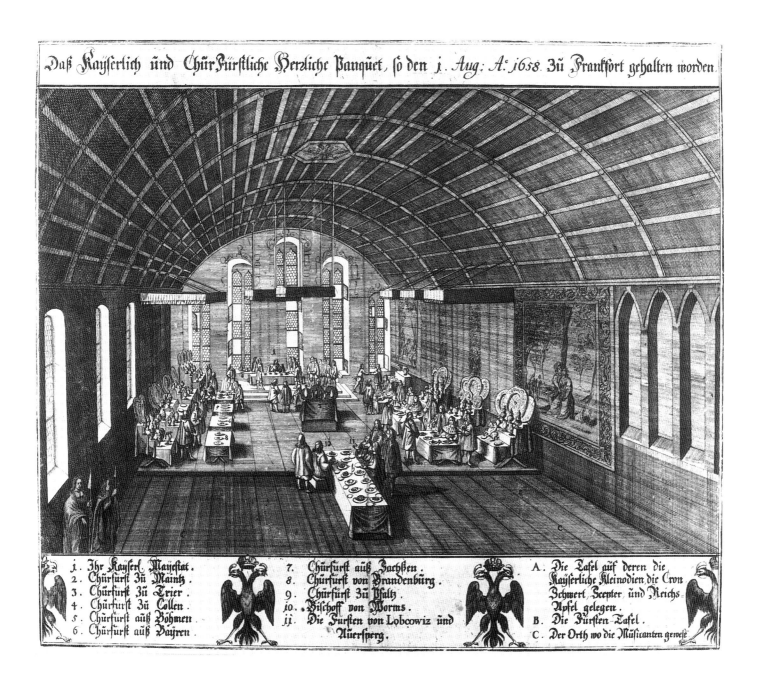

Daß Kayserlich ünd Chür Fürstliche Herzliche Panquet, so den 1. Aug: A:̊ 1658. Zü Frankfort gehalten worden.

1. Ihr Kayserl. Majestat.
2. Chürfürst Zü Maintz.
3. Chürfürst Zü Trier.
4. Chürfürst Zü Collen.
5. Chürfürst auß Böhmen.
6. Chürfürst auß Bayren.

7. Chürfürst auß Sachßen.
8. Chürfürst von Brandenbürg.
9. Chürfürst Zü Pfaltz.
10. Bischoff von Worms.
11. Die Fursten von Lobcowiz ünd Auersperg.

A. Die Tafel auf deren die Kayserliche Kleinodien die Cron Schwert Scepter ünd Reichs Apfel gelegen.
B. Die Fürsten Tafel.
C. Der Orth wo die Müsicanten geweße.

8 Banquet in the Römer in Frankfurt am Main to mark the coronation of
Emperor Leopold I in 1658.
Engraving, Johann Martin (?) Lerch, Vienna (?), c. 1658.
On the buffet at the right there is a silver equestrian statuette very similar to that of King
Gustavus II Adolphus of Sweden (see fig. 6).

entered the Kremlin Armoury as diplomatic gifts. A year after the victorious relief of the Siege of Vienna in 1683, the Emperor Leopold I had these vases – together with a pair of andirons (plates 22, 25) and further pieces of Augsburg goldsmiths' work – brought to Moscow in order to win the commitment of Ivan and Peter Alekseyevich (joint heirs to the Russian throne, though at this time still minors) to an armed coalition against the Turks (see p. 27). Each of the vases, with its very effective acanthus-leaf decoration, thus offers distinct, but equally appropriate, side and frontal views: respectively, the Imperial eagle perched on Turkish turbans, and the bust of a warrior dressed *all'antica* (doubtless an allusion to the Empire) emerging from the main body of the vessel. With these pieces, however, the principal consideration was evidently the overall decorative appearance (which would have been effective from a distance) and not the details (which would have required a much closer view).

9 *A Dutch delegation presents gifts to Tsar Alexei in 1676.*
Etching, Romeyn de Hooghe, Amsterdam, 1677.
Many of the Dutch silver objects presented to Moscow in 1676
are now in the State Armoury of the Kremlin.

Silver Altars and Silver Furniture

Among the larger objects in precious metal to be found at the courts of Europe were items of furniture. For their manufacture, large amounts of precious metal were required, such as only princes had at their disposal. For other classes, moreover, the possession of silver was strictly regulated by sumptuary laws. The earliest sorts of luxury furniture to be produced in Augsburg combined gleaming precious metal with exotic hardwood: silver inlays and mounts would be set off against the deep black ebony. The stylistic development of Augsburg ebony-silver furniture, which began in the 1570s, led to the emergence of a number of dominant forms around 1600. This was particularly so in two categories, one sacred and one profane: respectively, altars and cabinets.

The use of gold ornamentation was already known in some small domestic altars from Augsburg intended exclusively for private devotion. From the third quarter of the sixteenth century Augsburg goldsmiths also started to provide larger silver altars, in particular for installation in princely oratories. The most important altar to be made in Augsburg was that completed in the first decade of the seventeenth century for the *Reiche Kapelle* in the Munich Residenz (fig. 10), which incorporated components of an older silver retable made in Augsburg in 1565-70. In the private chapel exclusively reserved for the Duke and his consort, and thus of an intimate character, the ebony-silver altar is architectonically connected with the dominant display wall.

Also of considerable significance, although quite distinct in conception, is the Protestant altar installed in 1620 in the castle at Husum and now in the Nationalmuseet in Copenhagen (plates 12 - 15). This had been donated to the Duchess Augusta von Holstein-Gottorf (who lived at Husum after becoming a widow) by a merchant from Antwerp as a gesture of gratitude for her assistance in securing his assets. The merchant had been resident in Hamburg but had maintained close trading connections with Augsburg.

The Husum altar, originally free-standing against the rear wall of the chapel, adopts the form of a winged retable of the medieval period. The outside of each of the wings is covered with large engraved silver plates, showing scenes from the Passion of Christ after engravings by Hendrick Goltzius. The inner surfaces, revealed as the wings (hinged to the rotating columns) are opened, have embossed silver reliefs, also with scenes from the Passion (plate 15). In the arched central section we find on a kind of stage a markedly three-dimensional account of the Crucifixion (plates 13, 15). While the relief with the Last Supper, found in the predella, marks the beginning of Christ's Passion, the crowning group of the Resurrection, with Christ triumphing over Death and the Devil, points to the coming Salvation through the Lord. In contrast to other Augsburg goldsmith retables of the early seventeenth century, the Husum altar is distinguished by its clear basic shape and by the extensive renunciation of detailed decorative elements. Thus, the ebony sections, accented by means of narrow silver bands, establish a suitable background and frame for the work in silver, which is sparingly but effectively gilded. In both its embossed and its cast sections, this work reveals Albrecht von Horn as pre-eminent among sculpturally gifted goldsmiths.

Dating from virtually the same years is an example of furniture in ebony and silver for the secular sphere – the octagonal working and hunting table once in the possession of the Saxon Elector Johann Georg I (plates 16, 17). The top, an elongated octagon, can be removed and is inlaid with panels of engraved silver. As on the outer sides of the wings of the Husum altar, we here encounter the remarkable artistic skill of the Augsburg engravers who also worked in silver. Examples of heroic virtues are presented in the engraved scenes from the legendary history of the cities of Troy and Rome (plate 17), thematically connected through the figure of Aeneas. The table case (plate 16), opening at both front and back, its ebony veneer bearing solid silver mounts, contains about 250 objects in its numerous drawers and trays. As well as hunting and dressing-table requisites, there are various artist's and craftsman's utensils. The open drawer at the top contains silver apothecary's tools and bathing requisites; also notable here are silver plates and bowls. The painted paper appliqué work on the inner sides of the doors shows utensils associated with hunting and falconry. The present images probably replaced the originals in the nineteenth century.

This work, of extremely complex design, was probably conceived and assembled by Philipp Hainhofer, the Augsburg agent and art dealer. Although it is the only surviving example of its type, one would be justified in regarding it as a form of counterpart to the Augsburg cabinets also commissioned by Hainhofer. Examples of the latter include both the cabinet in Uppsala owned by King Gustavus II Adolphus of Sweden, and the Pomeranian

10 *The altar of the* Reiche Kapelle *in its present state.*
Hans Schebel, Augsburg, c. 1565-70, and Jakob Anthoni, Augsburg, 1605-6; Residenz, Munich.
After the extensive destruction of the Reiche Kapelle *that occurred during the Second World War, any attempt to reconstruct the lateral reliquary shrines was out of the question.*

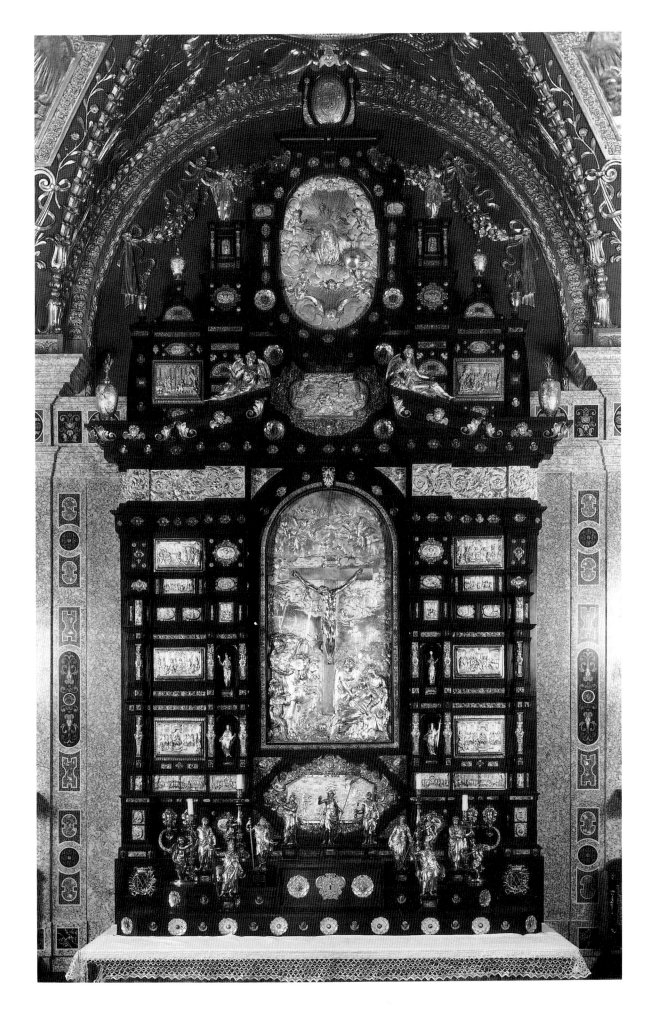

cabinet (fig. 11), the case of which was burnt in Berlin in 1945 (although the largely salvaged contents are now in the Berlin Kunstgewerbemuseum). An item of this sort might be described as a miniature *Kunstkammer*, in which objects from the three realms of nature, art and science would be collected. The working and hunting table of the Elector Johann Georg I, however, was more practical in function. Although its design was above all intended to evoke pleasure in the interplay of its neatly interlocking components, this very quality was also a measure of its practicality: it could be used as a portable piece of furniture, if necessary even away from the owner's residence.

The transition from ebony-silver to pure silver furniture that occurred in Augsburg towards the mid-seventeenth century is embodied in the fountain in Schloss Rosenborg in Copenhagen (plates 18, 19), one of the most sparkling achievements of Augsburg craftsmanship. This truly regal object was acquired by King Frederik III of Denmark in 1649, shortly after his coronation. From the container concealed in the top, perfumed water once flowed through the dolphin spigots attached to the three columns into the three projecting shallow bowls. The original commission for this piece was probably informed by the notion of the fountain as a symbol of princely generosity - the *liberalitas principis*. The upper section also contained a censer for precious perfumes, the burning of such exotic substances acting directly on the senses of both smell and sight to provoke associations of well-being and, accordingly, of prosperity. The drawers fitted into this structure contained the most varied objects, for the exclusive use of the king, such as writing and shaving utensils. Here there are parallels with the Dresden working and hunting table made about twenty-five years earlier (plates 16, 17).

In accordance with the dominant theme of water, the silver group of five figures shows the goddess Diana with her companions, surprised while bathing by Actaeon. On top of the decorative *tempietto* the figure of the unfortunate hunter appears once again, his head already transformed into that of a stag (the punishment immediately demanded by Diana). This composition, extremely skilful both in its incorporation within the overall design and in its narrative and expressive use of gesture, is a superb example of small-scale sculpture cast in silver, its figures surely derived from models provided by an Augsburg sculptor. While the upper part of the fountain is an ensemble entirely executed in silver, both precious in appearance and ornamental in character, the solid middle section, complete with drawers, still belongs within the tradition of ebony-encased Augsburg furniture. The stand, however, extraordinarily heavy in comparison with the fountain itself, and with three powerful baluster-form supports, was not made in Augsburg, probably coming from Hamburg.

The mid-seventeenth century marked a significant turning-point for Augsburg craftsmanship in the manufacture of silver furniture, as is also demonstrated by the silver throne of Queen Christina of Sweden (fig. 12) made in 1650 by Abraham I Drentwett – an imposing chair in keeping with the character of the Swedish

regalia. This is the earliest surviving piece of Augsburg furniture to *appear* to be worked entirely in silver. In fact it has a solid core of wood, this serving both as an assurance of stability and as the base on to which the silver elements are fixed.

Dating to about twenty-five years later, around 1670-4, are the two armchairs commissioned by the Great Elector Friedrich Wilhelm von Brandenburg for himself and his second wife, Dorothea von Holstein-Sonderburg-Glücksburg (plates 20, 21). These chairs, made by David I Schwestermüller, are especially notable for the use of embossed silver plates and powerful, sharply profiled acanthus-leaf decoration. Their gilt frames are reminiscent of the braid trimming on a piece of fabric. Also striking are the cast sections, remarkable for their size, the plasticity of their treatment, and their extensive gilding, above all the half-figures of winged youths emerging from the large acanthus leaves where the arms meet the back.

Direct models for this piece are to be found in the Dutch ivory chairs of 1639 that were first owned by Prince Johann Moritz von Nassau-Siegen, and were acquired by the Great Elector in 1652 and brought to Berlin on his orders. We may therefore assume that it was from Berlin that the model for the two silver chairs was sent to Augsburg. We are primarily concerned here with a type that was to be found in the Netherlands during the first half of the seventeenth century; this connection is also demonstrated by the motif of the lion masks. Ultimately, however, the form is derived from the traditional type of the ceremonial chair, the *faldistorium*, that was already in use in the Middle Ages, both in secular and in ecclesiastical contexts. The pair of armchairs do not therefore represent a product specific to work in precious metal; nor can they, strictly speaking, be viewed as a type of seating reserved exclusively for a sovereign. Silver thrones of the Baroque era were much more elaborate in their design: the back was invariably high and frequently topped by a crown.

Until the third quarter of the seventeenth century, then, the silver furniture produced in Augsburg remained exceptional in the German context, being still regarded there as an extreme luxury. In France, however, the situation was fundamentally different. In this comparatively wealthy kingdom that had hardly known anything of the horrors of the Thirty Years War, the ostentatious extravagance of silver furniture had been on the increase from the early seventeenth century, proving an especially appropriate medium for the self-representation so crucial to the absolute monarchy of Louis XIV. None the less, much of the silver that had come to play a significant role in room decoration in seventeenth-century France had to be removed in accordance with the edicts promulgated by the king in 1689, whereby silver had to be melted down in order to finance his expensive military campaigns. All the more significant, therefore, are those examples of Augsburg work in silver that have survived: these allow us to obtain a vivid idea of the splendour of the silver objects formerly to be found at the courts of Europe.

Of the various types of silver furniture, it was probably the fire-

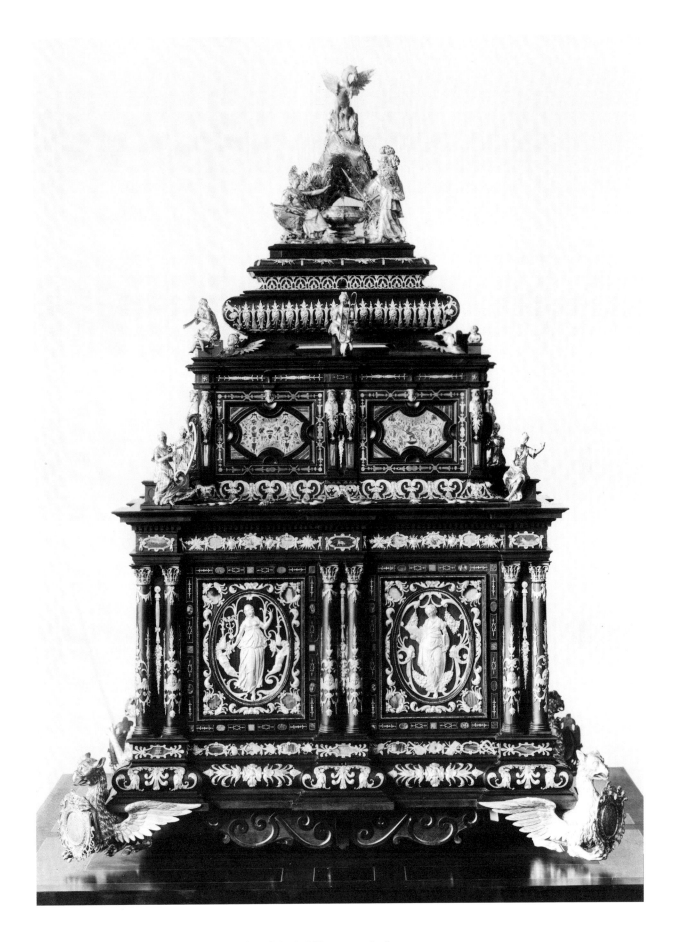

11 *The Pomeranian Cabinet. Augsburg, c. 1610–16, formerly in the Schlossmuseum, Berlin.*
The remarkable figurative decoration, with its crowning group of the gods on Parnassus,
was executed by the leading Augsburg goldsmith Matthäus Walbaum.

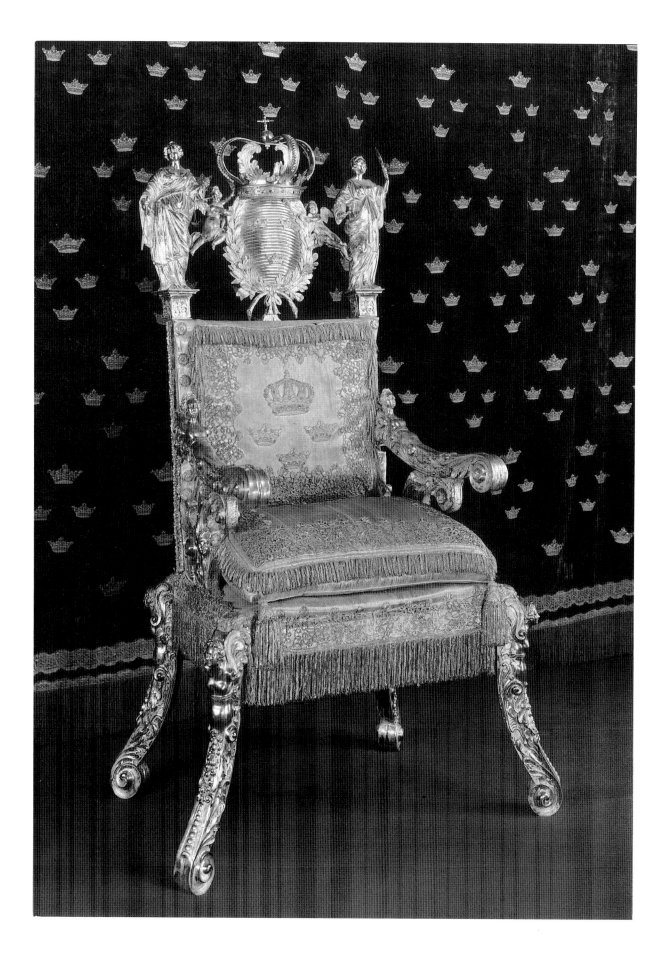

12 *The throne of Queen Christina of Sweden. Abraham I Drentwett, Augsburg, 1650; Royal Palace, Stockholm.*
This silver armchair was always used at the coronation ceremonies of Swedish monarchs in the Cathedral at Uppsala.

place sets that were in widest use. The fixtures for a fireplace were usually made of durable metal, brass or bronze being the most preferred. Augsburg craftsmen, however, following the French example, also made andirons and other objects for the fireplace in silver. From the practical point of view, this introduced numerous disadvantages, for silver is not only sensitive to heat but it might also easily be blackened by soot from the fire. Clearly, however, the most important concern here was for effectiveness in terms of display.

Andirons, used in pairs, served the practical purpose of providing iron racks on which logs for the fire were piled; these, however, were concealed behind a front section which would often be treated figuratively, thus bestowing an additional decorative function. Among the few surviving examples of silver andirons produced in Augsburg is the pair made in about 1680 by Johannes Kilian and Lukas Lang, now in the Armoury of the Kremlin in Moscow (plates 22, 25). The two figures, worked extensively in the embossing technique, were probably intended as personifications of America and Asia. There may have been a further pair of figures representing Europe and Africa – for in large halls, and particularly in dining-rooms, there were often two fireplaces. There is, however, an exclusively European character about the Roman military trophies placed on unusually high supports and the accompanying putti, probably trumpeting the Fame of War. As these imposing pieces of work were part of the ambassadorial gift that the Emperor Leopold I had brought to Moscow in 1684 after the victory over the Turks (see p. 21), one is tempted to assume that their design was intended to express the Emperor's claim to universal domination. Though derived from the bronze andirons of the Renaissance, these later, taller examples are characteristic of the second half of the seventeenth century, that is to say the era of the Late Baroque, when there was a preference for large fireplace openings. This can be verified by reference to the engravings of Jean Lepautre or Abraham II Drentwett.

The fire-screen made in Augsburg by the brothers Johann Ludwig I and Lorenz II Biller (plates 22-24) is also in the Armoury of the Kremlin; but it is not to be regarded as part of the same gift to Moscow, as it was made a good decade later. It also differs in both form and function from the majority of such items. The metal sheet of the fire-screen in the Kremlin, rising from a tall voluted base, has a vertically elongated oval shape, the latter preserving the form traditionally reserved for such items (which in most cases would have consisted of a vertically positioned piece of basketwork or other light material). Fire-screens, quite commonly items of everyday use in their simpler forms, were primarily intended to lessen the heat emanating from a fire. The silver fire-screen now in Moscow had, however, an exclusively aesthetic function and, accordingly, a distinctive form: it was intended to conceal the dark fireplace opening during the summer months – that is to say when no fire was lit – and simultaneously to complement the decoration of the room. It is thus exceptionally large and cannot be adjusted to various heights. Its central relief (plate 24)

shows a scene with Jupiter and Semele, evidently an allusion to the element of fire and thus to the original function of the fire-screen. Responding to Juno's prompting, Jupiter's beloved, Semele, asks the Father of the Gods to appear to her in all his divine splendour. When he does so, Semele is consumed in his dazzling radiance. In comparison with the treatment of the scene in the relief, the decorative ornamentation of this fire-screen, with its acanthus leaves and blossoms, is striking for both its high quality and its boldness. This is also true of the emphatically sculptural head in the border above the relief, which we may perhaps identify as that of the sun-god, Apollo (plate 23).

Fireplace sets certainly offered exceptional possibilities for the incorporation of figural and pictorial elements; but they were none the less only a sideline for the Augsburg goldsmiths engaged in making furniture. At the centre of their extensive production one finds, rather, those types of furniture that had a determining influence on the overall character of the decoration of a room. This was above all the case with the sets of mirror, table and two candle stands (or *guéridons*), called triads, usually placed in front of a stretch of wall between two windows and constituting a fundamental component of room decoration in the era of the Baroque.

Of such sets produced in Augsburg (and, according to the sources, large complexes of this sort were first made towards the end of the seventeenth century), the most important surviving examples are those found among the silver furniture produced for the House of Guelph (plates 26-31). This double set is outstanding on account of its size, its completeness and its quality. This was commissioned from Augsburg goldsmiths in 1725-6 by Prince Maximilian Wilhelm von Braunschweig-Lüneburg, then resident in Vienna. After the prince's death in 1726, the entire complex was acquired by Duke August Wilhelm von Braunschweig-Wolfenbüttel, who lived in Braunschweig (Brunswick); around 1729-30 he had an armchair and four other chairs made in Augsburg, to add to the other items. In 1731 King George II of England (who was also Elector of Hanover) bought this collection of silver furniture from the estate of August Wilhelm in order to provide more imposing decorations for his Hanover palace. To mark this change of ownership, the monogram AW (August Wilhelm) on the backs of the chairs was replaced by the monogram G II R (Georgius II Rex). These, and the other items, were subsequently installed both at Windsor and in Vienna and are now in the collection of Prince Ernst August of Hanover.

In contrast to the case of the Augsburg silver furniture supplied, for example, to the court at Dresden, the items made for the House of Guelph reveal no close connection with the decoration of the interior for which they were intended, as perhaps is evident when considering the circumstances of the commission. These items were made for Prince Maximilian Wilhelm's winter residence in Vienna, the imposing Palais Strattmann on the elegant Bankgasse. George I's ambassador, Daniel Erasmi von Huldeberg, reported from Vienna in 1726 – after Maximilian Wilhelm's death – that 'the state room in the house in the city, where His Highness

13 *Table top with the Fall of Phaethon.*
Johann Ludwig II Biller, Augsburg, c. 1725-6;
Ernst August Prinz von Hannover, Herzog zu Braunschweig und Lüneburg.
This treatment of the subject reveals clearly the outstanding mastery of the
Augsburg goldsmiths in the use of relief.

spent the winter, was appointed in an almost regal fashion. The bed alone cost 10,000 guilders and all the tables and mirrors were of solid silver, the wall coverings and chairs, however, [were] of red velvet and just as valuable as the bed.' These important pieces of silver furniture were not, then, to be found in the audience chamber, this last having a baldachin (canopied throne) and a smaller set of silver furniture; rather, they were placed in the prince's state bedroom. As the interior of the palace (which was only rented by the prince) could itself incorporate no reference to identity or status in its fixed decoration, the silver furniture had to serve as a means of glorifying Maximilian Wilhelm and the House of Braunschweig-Lüneburg.

Of particular importance were the two large mirrors (plates 26, 28, 29, 31) that would certainly have extended almost to the top of the wall between the windows of the state bedroom. In contrast to

the character of earlier Augsburg silver furniture, the heraldic aspects of the decoration are here almost overemphasized: the arrangement culminates in the prince's crown that is placed above the prince's cloak and coat of arms. Around the mirror itself are to be found the imposing figures of the heraldic beasts of the House of Guelph – horse, lion and leopard – alluding to the identity of the owner. This piece is a striking instance of the use of silver to transform items of furniture into vehicles for personal or dynastic glorification in a far more imposing way than might have been possible using only wood. The same end is served in the design of the tables belonging to the set (plates 26, 30): here too one finds the coat of arms with the prince's crown at the top of a shield held by lion and leopard, while the larger figure of the horse rests below.

The two complementary table surfaces, on the other hand, present a calculated political message. The embossed central re-

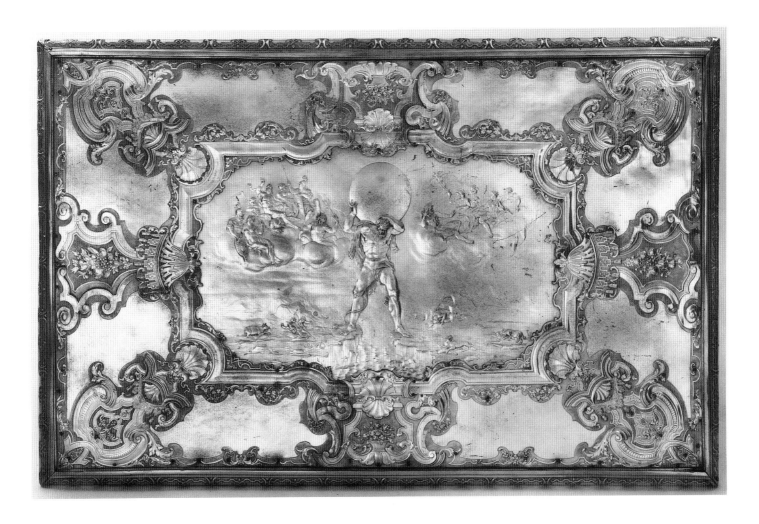

14 *Table top with Hercules as Bearer of the Celestial Sphere.*
Johann Ludwig II Biller, Augsburg, c. 1725-6;
Ernst August Prinz von Hannover, Herzog zu Braunschweig und Lüneburg.
The decorative frame, employing late forms of strapwork,
plays a signifiant part in the composition.

lief on one table, worked in a virtuoso manner (fig. 13), shows the fall of Phaethon. The Father of the Gods, Jupiter, accompanied by his eagle, deploys his thunderbolt to hurl down to earth the youth who has proved unable to master the horses pulling the Chariot of the Sun. Cities and fortresses are consumed in the blazing heat of the chariot as it falls. The image of Phaethon – the intemperate and immoderate son of the sun-god – is in fact used here in a spirit of propagandistic travesty: it alludes to the French king, Louis XIV, who liked to be celebrated as the *roi soleil* (Sun King). Such an interpretation is supported in particular by the evidence of contemporary medals based on the idea of France as adversary. A Dutch caricature medal, for example, struck on the occasion of the relief of the Siege of Turin in 1706 under Prince Eugene of Savoy, shows the Fall of Phaethon. Here the iconography is especially apt because Phaethon – according to Ovid's

account – fell into the River Eridanus, or Po, on which the city of Turin lies.

On the central relief of the other table top, conceived as a pendant to the first (fig. 14), we find Hercules (rather than Atlas) carrying the celestial sphere. He straddles a stretch of water probably intended as the Straits of Gibraltar. On both sides of the hero, the twelve gods of Olympus rest on banks of cloud. Hercules bearing the celestial sphere was a frequent figure in Austrian iconography at this period: with reference to the Emperor, in particular Charles VI, the motif alludes to the responsibilities of the monarch. None the less, as the relief also includes the Father of the Gods, Jupiter, the latter accompanied by the imperial eagle, this Hercules may, rather, be a mythically disguised representation of Prince Eugene, who was often given the features of Hercules in such iconographic homage. This hypothesis finds support in the

fact that Maximilian Wilhelm, in his youth, had fought against the army of Louis XIV alongside Prince Eugene and had subsequently maintained close ties with the latter.

Paradoxically, it would thus appear that this imposing item of furniture owned by Maximilian Wilhelm alludes both clearly and critically, in its iconography, to Louis XIV, even though the ensemble ultimately derives in both form and style from the silver fittings and decoration of the Palace of Versailles, decoration that had itself been lost by the late seventeenth century. In France under Louis XIV, the deliberate incorporation of figural elements into the overall decorative scheme of an interior was already a key feature of design. The different approach of the Augsburg goldsmiths is, of course, substantially influenced by South German Baroque. The heraldic beasts around the mirrors, for example (plates 29, 31), in their three-dimensionality and the vigour of their movement, prompt one to conclude that they may have been devised by an important sculptor. The tendency to employ animal figures imbued with enormous energy is even more apparent in the case of the Guelph steed serving here as a support for the tables (plate 30): this is among the most magnificent representations of a horse in German art of the eighteenth century. It is no coincidence that its nearest rival should be the impetuous beast on the sarcophagus designed by Andreas Schlüter in 1703 for the Guelph Princess, and Prussian Queen, Sophie Charlotte, which also braces itself spiritedly against the ground. The overall design of the tables has an arrangement marked by powerful curved forms that on the whole appear to negate the essentially static character of this category of furniture (plate 26).

The silver items made for Maximilian Wilhelm are also of particular significance in the context of the history of types, for they precede by about five years the pieces of silver furniture commissioned in 1731 by King Friedrich Wilhelm I for the Schloss in Berlin – the largest commission ever received by Augsburg goldsmiths (see pp. 14, 31, 33-4). Both the design of the imposing mirrors previously in Berlin, which were of a really colossal size, and their incorporation of iconography alluding to the House of Hohen-zollern, are already anticipated in the equivalent features of Maximilian Wilhelm's own silver furniture.

The additional items commissioned around 1729-30 by Maximilian Wilhelm's cousin, Duke August Wilhelm, are essentially distinct in style. Their comparatively simple shapes, and absence of any striking three-dimensional figurative or decorative elements, allow the emphasis to remain on the basic shape of the various pieces (plates 26, 27). Without doubt, the commission from Brunswick (where English influence was strong) would have insisted on this sort of design. The evidence of English influence on the furniture is clear, for example, in the use of powerfully curved legs resting on almost hooflike blocks, and the tall, narrow, slightly curved backs. Only the elaborate stretcher, in the form of a Saint Andrew's cross, with curving arms, may be defined as specific to silver furniture as such. The generous low-relief ornamentation of the surface is characteristic of the style of Philipp Jakob VI Drentwett.

Also belonging, albeit less centrally, to the category of silver furniture are the two three-branched candelabra, or girandoles, from the collection of the Princes of Thurn und Taxis, now in the Bayerisches Nationalmuseum (plates 32, 33). The vertical tendrils supporting the candles are held by two elegant figures shown as if turned towards each other. Striking graceful poses on relatively narrow bases, these are presumably to be identified as Pluto, God of the Underworld, and his consort Proserpina. These two candelabra effectively transform objects of practical use into decorative pieces of sculpture that would easily have blended with the surrounding *boiserie* decoration. They would have originally stood on *guéridons*, so that they were firmly incorporated into the ensemble of silver items once belonging to the Princes of Thurn und Taxis. In the astonishing lightness of each composition, one can already detect elements characteristic of porcelain sculpture. In the lively design of the two bases, moreover, with their rocaille and grotto elements, there are hints of early Rococo. Once again, Johann Ludwig II Biller emerges as probably the most important Augsburg goldsmith of the 1720s and 1730s.

Late Baroque Wall-Mounted Buffets in Berlin and Dresden

The Berlin silver buffet is probably the most extensive ensemble made by the goldsmiths of Augsburg in the seventeenth century. Astonishingly, this complex has survived all the commotion and destruction of war in its entirety (frontispiece, plates 34-39). The buffet was made in about 1695-8 by three members of the Biller family, together with a fourth Augsburg goldsmith who has not been identified. The commission came from the Elector of Brandenburg, Friedrich III, who in 1701 became Friedrich I, King of Prussia. Shortly before this event, in 1700, on the occasion of the betrothal of Friedrich's only daughter (from his first marriage), the buffet was provisionally installed in the Berlin Schloss. At the end of 1702 or the beginning of 1703, it was allotted a definitive place in front of a mirrored wall in the *Rittersaal* (Knights' Hall) – which stood at the centre of the sequence of state rooms built according to the plans of Andreas Schlüter – and integrated into the room's design. Martin Engelbrecht's copper engraving (fig. 15), showing the original installation, introduces a baldachin with elaborate drapery that was never executed.

In 1745 and 1757, because of severe lack of funds during the Second Silesian War and the Seven Years War, Friedrich I's grandson, Friedrich II (Frederick the Great), had individual parts of the silver buffet melted down. This meant the loss of the two outer sets of fountains and basins, which we may assume to have provided the most striking elements in the overall impression made by this construction. The gaps thus brought about were filled with other pieces taken from amongst the silver commissioned by Friedrich Wilhelm I, including the pie dishes made in 1731-3 (frontispiece, plate 38). During the Second World War the silver buffet was removed from Berlin for safe storage elsewhere and later taken to the Soviet Union. After its return, it was exhibited in the Schloss at Berlin-Köpenick as the Berlin Schloss in the centre of the city had been dynamited in 1950-1.

In contrast to the buffets of the sixteenth and seventeenth centuries, usually erected at short notice near to the table on the occasion of festive banquets and principally functioning as places from which food and wine might be served (plates 8, 10), this eighteenth-century example was largely intended for display. Several formal differences are immediately apparent too, notably the absence of either a stepped arrangement or of fabric hanging as a background. The silver gilt objects displayed on the Berlin buffet, both those resting below on the counter and those above, placed on brackets, are assembled into an imposing sculptural entity attached to the structure, and contributing to the overall decoration, of the interior. The original height of the buffet in the Berlin Schloss was about twenty-three feet, while its reconstruction for the exhibition in Munich was at least sixteen feet high. While it

should be noted that the massive fountains and basins of the lower section may have retained something of a practical purpose (this is suggested by the description of the festivities held in 1703 for the Knights of the Order of the Black Eagle), the objects in the upper sections are certainly intended purely for display, having no practical use at all.

Crucial inspiration was derived in this case from the buffets erected in France under Louis XIV, at whose court they had only ever been part of temporary decorations installed for festivities. In seventeenth-century France, however, the items displayed were not specially commissioned, but simply taken from the extensive holdings of the royal silver vaults. As a result, there was little of the stylistic homogeneity that distinguishes the later Berlin buffet. The earlier French buffets also tended to retain a slightly stepped form, with the result that objects were displayed less clearly there, and with greater overlapping, than was the case in the later design.

The objects from Augsburg displayed on the Berlin buffet have the additional interest of appearing to echo the form of French work in precious metals now known only through engravings, paintings and tapestries. Like the objects made by goldsmiths working in the Louis XIV style, those of the Berlin buffet have architectonically clear basic shapes with emphatic alternation of the concave and convex sections. In the Berlin arrangement, however, the underlying structure of the pieces is generally masked by decorative elements – such as the striking zoomorphic appliqué or the various crowning features – which were, indeed, characteristic of such arrangements in Berlin. Here one also finds a fantastical variety in the ornamental animation of the surfaces of individual items, which are extraordinarily densely decorated with the most varied scaled, rippled and shell-like forms. In addition, there is much distinct differentiation: in the two basins in the lower section (plate 36), already striking on account of their size, there are fan-shaped scallops separated by shell motifs; the four middle-sized and the three smaller basins above have gadrooning that runs in opposite directions; and the ewer and basin sets have bearded masks and the busts of eagles and lions, especially effective as alternating motifs around handle and spout.

The six identical pilgrim bottles (plate 35, left and right) in the centre and at the top of the structure do not belong to the original arrangement, having been incorporated in 1757 as replacements for silver objects that had been melted down. These objects, made in Augsburg in 1698, generally have smooth surfaces with relatively plain gadrooning, while the pilgrim bottles (plate 34, lower left and right) originally belonging to the buffet emphatically modified the traditional shape, in particular through the strong plasticity of their decoration. Unlike the replacement pilgrim bottles,

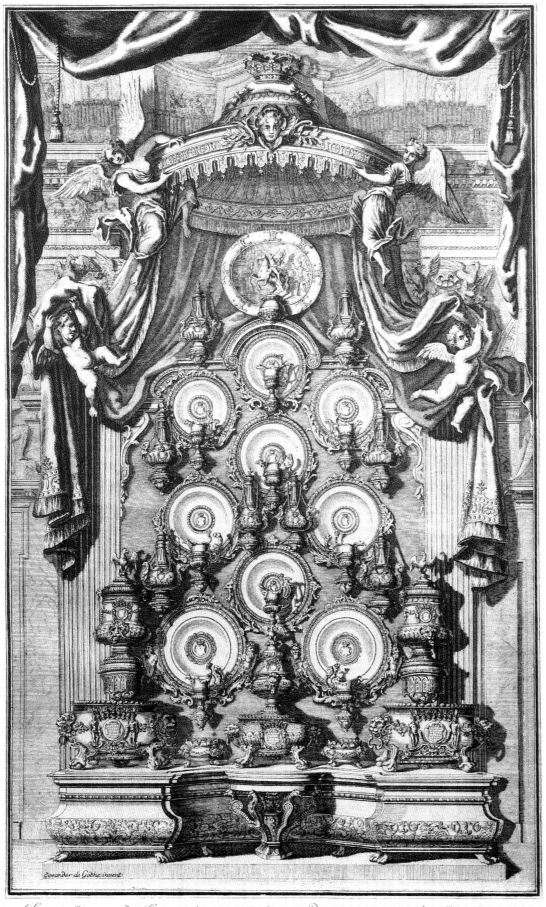

Corander de Göthe invent.

Dessein du grand Buffet de vermeil d'oré, dressé dans la Sale des chevalliers
au chateau Royal de Berlin.

M: Engelbrecht excud. Berlin.

15 *The silver buffet*
in the Rittersaal *of the*
Berlin Schloss.
Engraving,
Martin Engelbrecht after
Johann Friedrich Eosander
von Göthe,
probably Berlin, c. 1708.
This sheet, first published in
the Theatrum Europaeum
of 1717, provides the only
known representation
of the original arrangement
of the buffet.

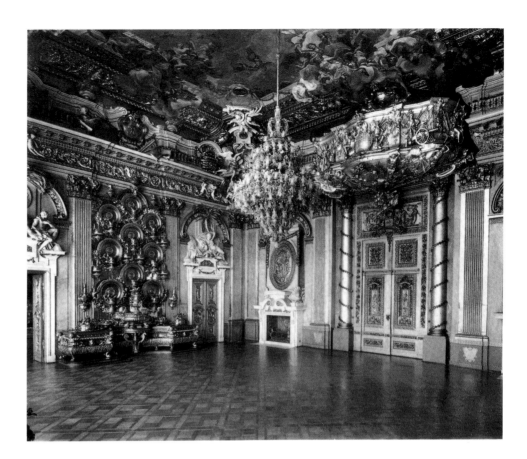

16 *The* Rittersaal *with the silver buffet.*
Andreas Schlüter, Berlin, c. *1703;*
formerly in the Schloss, Berlin.
This photograph of the most elaborate
state room in the Berlin Schloss shows the
emphatic presence of the counter in the
lower section of the buffet.

which have a relatively unobtrusive, engraved coat of arms, this feature on the original models takes on a strongly sculptural quality, especially in the treatment of the Elector's hat. This is also true of the cisterns or glass-coolers standing to lower left and right.

In accordance with the positioning of the Berlin buffet against the wall, the items displayed on it may be found to decrease slightly in size in relation to their distance from the ground. This arrangement, determined by variations and gradations of form, creates an image of overall unity. The range of motifs and style employed here may be regarded as entirely characteristic of work produced in Augsburg, even though the seemingly unstable form of the ewers goes far beyond the established Augsburg 'canon'.

There is currently much lively debate among scholars as to whether or not the specific character of the Berlin buffet – in particular the striking plasticity of aspects such as the eagle motifs crowning the fountains and the ewers (plates 35, 39), or the lion and mask elements – is derived from the extensive involvement of the sculptor and architect Andreas Schlüter. Whatever the conclusion eventually reached on this matter, it is at least certain that both the carefully devised overall arrangement and the rich variation in the detail strongly suggest the involvement at some stage of an important artist. The Hohenzollern dynasty's claim to the royal throne of Prussia is here as emphatically manifest in precious metal as it was in the paintings and sculptures, the tapestries and the festival decorations of about 1700. Today, the Berlin buffet strikes us as an almost overpowering example of the work produced by goldsmiths at this time, distinguished especially by its imposing overall structure, the plasticity of its individual elements and the opulence of its decoration.

The buffet for the Berlin Schloss should also be considered specifically as a constituent element of the *Rittersaal* (fig. 16). As revealed by the recently published colour photographs of the dazzling pre-war condition of the interior of the Schloss, the gilt metal of the objects displayed on the buffet had a direct connection with the gilded stucco work of this lavish chamber. The brackets with their circular tops, as well as the mountings of the basins, designed in the form of acanthus leaves, filled out the space between the objects on display and formally connected them to the counter below (once faced in lapis lazuli) and to the architecture of the hall.

The stylistic peculiarities of the objects dating from 1695-8 are especially clear if these are compared with the pie dishes commissioned by Friedrich Wilhelm I, made by Johann Ludwig II Biller in about 1731-3 (frontispiece, plate 38) and incorporated into the Berlin buffet in the middle of the eighteenth century. These vessels, each on its own stand, basically have a simple oval shape; to the smooth, entirely unornamented bodies there are added a number of boldly sculptural elements: the central cartouche, the

handles and the elaborate cover incorporating a coat of arms supported by an eagle and the Goddess of Fame and topped by the royal crown. As is already apparent from the lion masks, an attempt has been made to link the new work stylistically to the items made for the Elector Friedrich III, later King Friedrich I of Prussia. The borders of the cartouches too, with their vigorous acanthus-leaf decoration, appear distinctly old-fashioned; related designs are to be found, for example, in the stucco decorations of the Berlin Schloss, which date back to the time of King Friedrich I. Here too, the requirements stated in the commission from Berlin may have determined the character of the objects made in Augsburg; these were after all intended to serve as supplements to the silver furniture already commissioned by King Friedrich Wilhelm I (see pp. 14, 30).

About twenty years after the Berlin buffet was made, Augustus the Strong, Elector of Saxony and King of Poland, commissioned for his Dresden Residenz a silver ensemble that in many respects appears to be a Saxon answer to the stately buffet in Berlin, this last also having become widely familiar through engravings published in 1717 (fig. 15). There was, after all, a benevolent rivalry between the Hohenzollerns and the Wettins, the two German dynasties that had most recently attained royal rank. In 1718, in response to the imminent, and politically significant, betrothal of the Saxon Electoral Prince Friedrich August and Maria Josepha, daughter of the Habsburg Emperor (this took place in Dresden in 1718-9 and was marked by four weeks of festivities; see p. 43), Augustus the Strong had the state rooms in the Dresden Schloss thoroughly modernized. During this process, the second-floor

17 *Design for the installation of the silver in the*
warder's tower of the Dresden Residenz.
Drawing, Zacharias Longuelune, Dresden, 1718-19;
Kupferstichkabinett, Staatliche Kunstsammlungen, Dresden.
This design is particularly striking for the vividly pictorial character
of its representation.

18 *Design for the installation of the silver in the*
warder's tower of the Dresden Residenz.
Drawing, Zacharias Longuelune, Dresden, 1718-19;
Kupferstichkabinett, Staatliche Kunstsammlungen, Dresden.
This sheet shows the plan and the elevation of the buffet room
as it was foreseen at the planning stage.

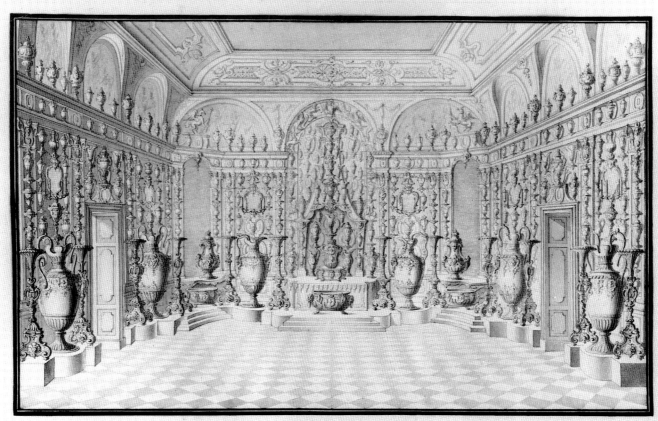

Decoration de la Salette precedente, d'un deffein plus fini

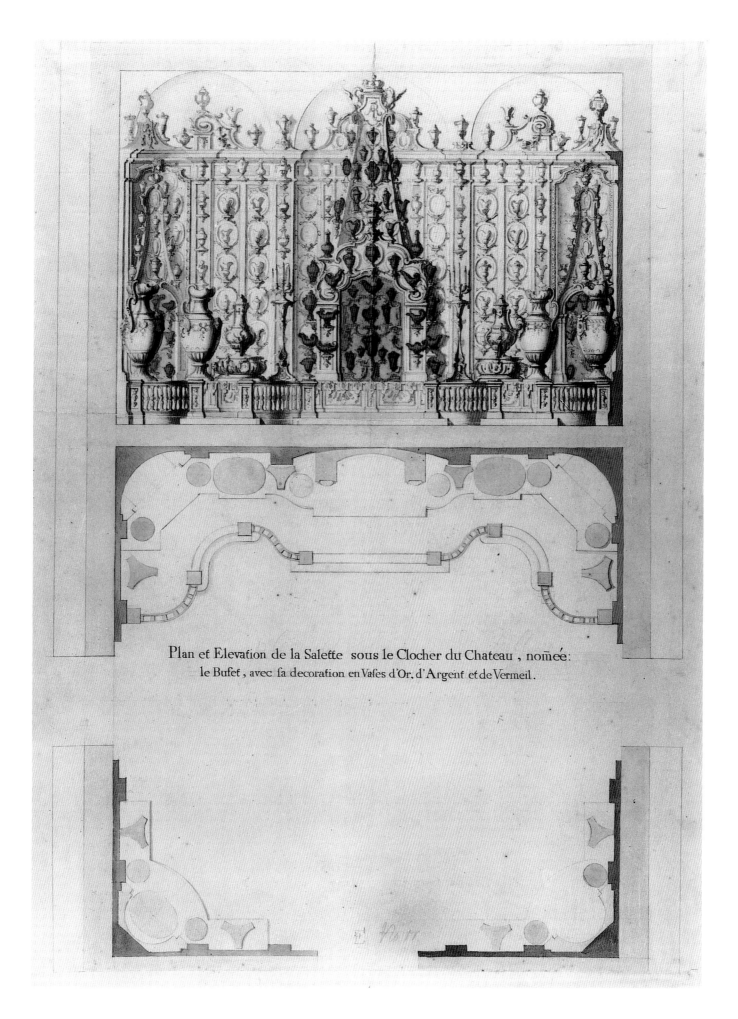

Plan et Elevation de la Salette sous le Clocher du Chateau, noṁeé:
le Bufet, avec sa decoration en Vases d'Or, d'Argent et de Vermeil.

room that lay beneath the warder's tower (*Hausmannsturm*) – a square-shaped cabinet with thick walls – was refashioned to accommodate a wall-mounted buffet (figs. 17, 18). (This room was also intended to serve as a waiting-room to the neighbouring hall, which was itself used as a dining-room on the occasion of court festivities.)

This interior, its unified decoration incorporating many mirrors, was able to accommodate numerous works of precious metal: items made in gold and in both gilt and ungilt silver. Below, massive vases, tall *guéridons* and broad cisterns stood along a ledge that ran around the room, the positioning of the cisterns probably in part determined by their implied relation to the fountains standing on the tables above them; the preparation of drinks to be brought into the neighbouring dining-room might take place here. The walls themselves displayed numerous ewers and cups, reaching up as far as a continuous cornice, along which further vessels were placed in a rhythmic sequence.

This particular type of arrangement clearly took its cue from that of contemporary porcelain cabinets, for example the one in the Schloss Charlottenburg in Berlin; this was doubly true of the Dresden room, in so far as it enhanced the effect of an imposing abundance through the use of mirrors. In correspondence with the prevailing tendency in Dresden to incorporate displayed collections into the overall design of the room in which they were contained, the items of precious metal displayed on the Dresden buffet tended to be much less prominent in their own right than was the case with the items displayed in the Berlin Schloss. Moreover, no new items were commissioned specifically for the Dresden buffet; pieces were selected, rather, from the collection of precious metal objects already available for use at the Dresden court. As this was stock that had been supplemented through extensive purchases at the Leipzig fair, items made in Augsburg inevitably dominated the Dresden display. (The goldsmiths of Dresden, while highly qualified, had much more restricted scope for production and so could by no means meet the Dresden court's high demand for items of precious metal.)

The buffet in the Dresden Residenz only remained in existence for a few years. In the first half of the 1720s the arrangement was already being dismantled in order to transfer the displayed items to the Grünes Gewölbe on the ground floor. There, however, it was possible to resume a comparable arrangement, albeit on a much larger scale and of an even more ambitious character. The room on the second floor that had previously housed the buffet continued to be used as a porcelain cabinet, thus in effect returning to the origins of the mirrored chamber reserved for displaying porcelain.

Drawing on the designs for the Dresden buffet (figs. 17, 18), and using the surviving collection from the Grünes Gewölbe, a silver wall was reconstructed in the Munich exhibition of 1994 (plates 40, 41). This, of course, was only able to display the works of precious metal themselves, and had to dispense with decorative elements such as consoles and inset mirrors. In comparison with the

objects included in the Berlin buffet, those displayed in Dresden, entirely in silver gilt, were mostly restrained in their decoration, to some extent still possessing a certain functional character. The ewer and basin sets (plate 40) are especially characteristic of the Augsburg designs that became widely familiar in the second decade of the eighteenth century. The ewers, conceived essentially with a side-view in mind, are notable for their range of figurally or ornamentally decorated handles. The set displayed above appears more old-fashioned in style, the ewer having a circular base, while the basin has a twelve-lobed border. The two lower sets are more modern and are distinguished by the alternation of straight and curved segments; the engraved strapwork ornamentation too, with its appliqué medallions, corresponds to the *Régence* style.

The decorative pilgrim bottle, a type of vessel ultimately deriving from the medieval pilgrim's flask with its swollen belly and elongated neck, is present in two forms: firstly as pure metalwork with flat relief decoration in the lower section of the body and with masks at each side, to which the chains are fastened (plate 40, centre left and right); secondly, made out of ribbed ruby glass (first produced in about 1690), with Augsburg metalwork mounts (plate 40, top). An equally traditional form is found in the two covered beakers supported on three lions and crowned by a lion statuette; the engraved figures show Roman emperors on horseback (plate 40, upper left and right).

The two wine-coolers placed below are, however, entirely indebted to contemporary taste (plate 40, lower centre): they are of a type that emerged in France and England towards the end of the seventeenth century, when it first became fashionable to cool single wine bottles in smaller vessels, these vessels then being placed not only on the buffet but also, in the case of more intimate meals, on the table. The bucket-like container is directly derived – in its clear form, strictly divided sections and foliage decoration in low relief – from French models. (Admittedly, the latter have largely been preserved in silver-plated brass, and only very rarely in precious metal.) Stylistically comparable are the tureens from the Thurn and Taxis Collection, similarly influenced by work of the late Louis XIV style (plates 52, 53).

Artistically, the most remarkable of the objects displayed on the Dresden wall are the two decorative vases (plate 40, lower left and right) placed at either side of each wine-cooler. These represent a category now only known through a few surviving examples (decorative vases without any functional use being invariably melted down). Abraham II Drentwett – an Augsburg draughtsman, engraver and goldsmith of extraordinary sculptural abilities – here

19 *Cisterns and fountain from the plate 'Summer'.*
Engraving, Georg Heinrich Schifflin after Abraham II Drentwett, Augsburg, early 18th century.
To left and right there stand glass-coolers with loosely scalloped rims; in the foreground there are two pilgrim bottles.

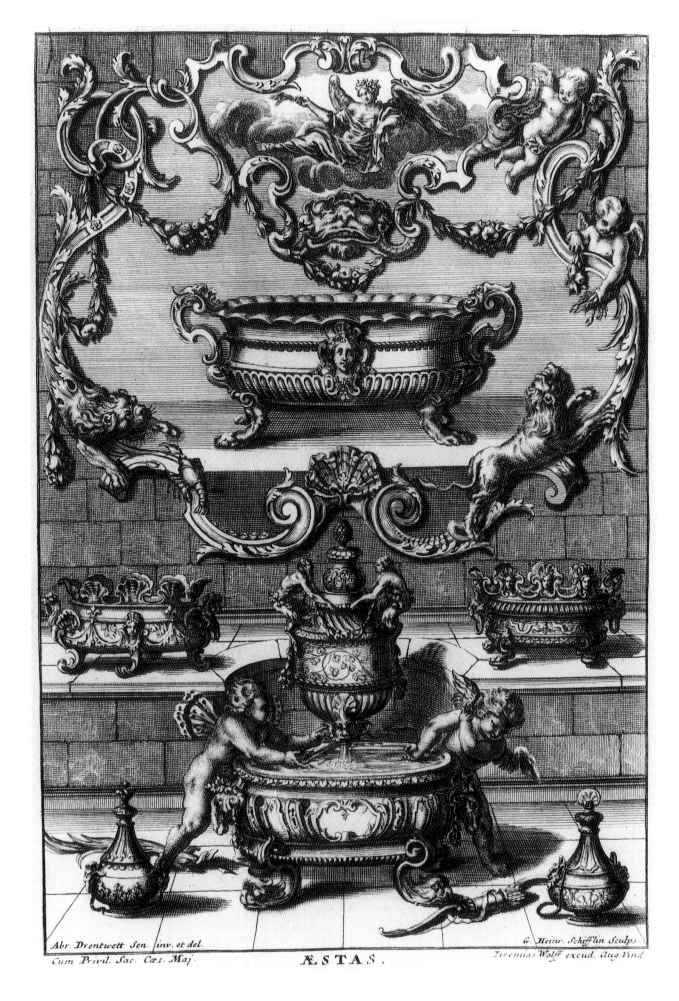

Abr. Drentwett Sen. inv. et del.

Cum Privil. Sac. Cæs. Maj.

ÆSTAS.

G. Heinr. Schifflin Sculps.

Ieremias Wolff excud. Aug.Vind.

contrasts the classically strict vase body, animated by means of restrained decoration, with cast, sculptural elements such as the tritons serving as bearers and the upper pair of putti. Thanks to the casting technique, the same models could thus be used several times. The reliefs on the body of the vases, with their virtuoso embossing, show classicizing scenes, for example of sacrifice or wedding celebrations.

The central section of the buffet wall (plate 40) is framed by larger objects (plate 41). The two candle stands, or *guéridons*, made in 1708-10 by Johann Ludwig I Biller, were incorporated into the ensemble of silver furniture in the audience chamber of Augustus the Strong in 1719. This was the only extant set of silver gilt furniture to be supplied by Augsburg. In the elaborate gilding – which was also a means of preventing the oxidization (and therefore blackening) of the silver surface – is expressed the high self-esteem of the royal personage commissioning the work. In comparison with the *guéridons* of the Guelph ensemble (plate 26), which were made about fifteen years later, the strikingly large candle stands of the Dresden Residenz represent an earlier stage of stylistic development, as is especially clear in their shallow circular bases and their altogether simpler and calmer outline.

The two large fountain and basin sets date from the period of the brother and predecessor of Augustus the Strong, the Elector Johann Georg IV of Saxony. They represent a basic element of princely silver rooms (cf. fig. 19). In the illustration (plate 41) one set is represented. These items, distinguished by their powerful curved forms, have smooth sides without ornamental decoration, out of which the partially ribbed and partially vesicular lobes emerge. Such embossed work, also serving as a means of providing the vessel with additional weight and stability, is a technique specific to the goldsmith's art. The generous forms of the broad-based basin are emphasized through the emphatic, curved handles attached to the sides of the body with dolphin masks. The spout of the vase-shaped fountain also takes the form of a dolphin. We here encounter an excellent example of the work of the Augsburg goldsmiths from the era of the Baroque, when it had not yet been influenced by a Louis XIV style that favoured classicizing forms.

Dressing-Table Sets of the *Régence* and the Rococo

In the eighteenth century dressing-table sets were among the most important and most widely known products of the Augsburg goldsmiths' art. Ensembles of this sort were made in other cities too; but, in terms of both the quantity and the quality of the items manufactured, Augsburg held the undisputed position as the leading centre. As numerous Augsburg dressing-table or toilet sets have survived – about thirty are known dating from the period 1690 to 1770 – we are able to understand more of stylistic evolution and differentiation in this area than in others.

During the second half of the seventeenth century, there emerged a tendency to adapt precious objects to each other with regard to both form and decoration and so to unite them into formally self-contained complexes. It was by this means, of course, that dinner services evolved. But those commissioning work from goldsmiths might also request various combinations of objects for use or display on the dressing-table. Among the types of object

that such sets might comprise, one can detect two categories: utensils for grooming and the conservation of beauty in the broadest sense, and equipment for serving the first meal of the day, or exotic hot drinks such as tea, coffee and chocolate, taken while the lady being served was still in her bedroom. Desk utensils too might often be included. The elements made of precious metal, always intended exclusively for the use of one person, were not only linked through their design but also made so as to fit together well enough for the set to be kept within a valise- or casket-like container. Thanks to these, the items making up a dressing-table set – as precious as they were sensitive – could, if necessary, also be safely carried about. The principal purpose of the containers was, however, to offer long-term protection from dirt and oxidization. Usually such sets were only rarely taken out of their cases and displayed. As far as we can tell by reference to written records, dressing-table sets primarily served as gifts that a princess or an

20 The Morning Toilet.
Porcelain,
in the style of
Johann Joachim Kaendler,
Meissen, soon after 1761;
Residenz, Ansbach.
Porcelain, the material characteristic
of the eighteenth century,
was also used to render subjects
from everyday life with appealing
refinement.

aristocratic lady might receive on the occasion of her betrothal or from her husband on the morning following their wedding (the so-called morning-gift).

Numerous paintings, engravings and drawings, but also small-scale sculptures, record the ways in which such toilet sets might be arranged in the bedroom or dressing-room (figs. 20, 21). Usually, the objects were to be found on a table, which would be draped in white muslin or lace and placed in front of a window. A mirror, also variously draped in veil-like material, would be placed along the rear, long side of the table. It is also clear from these images that candlesticks were usually placed symmetrically to the left and right of the mirror. A prominent place was reserved for the various boxes, arranged in order of size, and for the bottles and other cosmetic accessories; but this was rarely true of the utensils for eating and drinking, which are usually not represented in such contemporary images of dressing-tables.

It was in France, where the courtly cultivation of luxury in the style of the Baroque attained its earliest and highest flowering, that dressing-table sets in the strict sense first appeared, probably around the mid-seventeenth century. Soon there followed comparable products from Dutch and English workshops. In Augsburg the first examples were not made before the last decade of the seventeenth century, and these initially clearly echoed western European models. Only a few examples from this period have survived, one being a dressing-table set from St Petersburg, datable to 1695-1700. Greater numbers of Augsburg toilet sets have survived from the second and third decades of the eighteenth century, and these represent the *Régence* style. Here, rigid forms undergo a moderation and a dissolution through the use of undulating lines. Straight segments contrast with softly waving curves, both concave and convex. At the same time, the planes are animated by the combination of delicate strapwork ornamentation and relief medallions.

Among the Augsburg products of the 1720s a prominent place is occupied by the dressing-table set largely made by Johann Erhard II Heuglin in about 1725 (plates 42, 43), which comes from the collection of the Grand Dukes of Mecklenburg and is now in the Hamburg Museum für Kunst und Gewerbe. This is especially important as it has survived in its entirety (including its case), except for two bottles. A distinguishing characteristic here is the fact that almost all parts of the work offer examples of the highly elaborate form of decoration in the technique of *émail de Saxe*. This consisted of painting in soft colours, using sensitive vitrifiable pigment on a ground of white, opaque enamel; delicate reliefs of stamped gold leaf further increased the precious appearance of the metalwork itself. Traditionally, the use of *émail de Saxe* is associated with the Berlin manufacturer of luxury goods, Froméry; but it is also possible that in this case Augsburg might have been the source.

The noble elegance of the dressing-table set from the Hamburg collection, distinguished through the harmony of its silver gilt and its gleaming white enamel, is splendidly set off against the dark red lining of the original case. Especially notable is the conti-

nuity of the design and the careful gradation of the scale of individual objects, exemplified in the sequence of four boxes. Such boxes usually contained toilet articles, such as artificial curls, beauty plasters and make-up in the form of paste and powder. For eating the first meal of the morning, which usually consisted of a bouillon, there was a small covered bowl on its own plate, of the type known as *écuelle*; in the reproduction this stands before the mirror. (This type was also known as the 'maternity bowl' because it was in such vessels that a woman recovering from childbirth would be fed with invigorating meals.) The cover itself is mounted with three small feet so that it can be set down in an inverted position to serve as a receptacle, for example for marrowbones. In front of this there lies a slender egg-spoon, its handle merging into a grooved marrow-scoop; with the help of this object, marrow could be removed from the bones. At the extreme left stands the tazza with a covered beaker. A drinking vessel might be ceremonially offered on such raised salvers; they were also used for presenting gloves or fans.

As part of a dressing-table set, the ewer and basin ensemble (provided in other contexts for ceremonial hand-washing; see p. 44) was probably intended only for sprinkling the face and the hands. Also for use in grooming are the brush, here lying on a tray, and the funnel placed alongside it, with which bottles could be filled with perfumed water. The candle-snuffer used for snuffing out burning wicks belongs with the two candlesticks which can be seen in the chest. Last but not least, we find the small bell, made of silver gilt, which the distinguished lady would use to call her maid.

We may identify the high point in the manufacture of dressing-table sets made in Augsburg during the eighteenth century with the gold service made in 1736-40 for Tsarina Anna Ivanovna, the niece of Peter the Great (plates 44-47). This is the only surviving gold dressing-table service to come from the Augsburg workshops. For the city's goldsmiths it signified a particular honour, as well as a special challenge, to receive the commission for a set that was already precious by virtue of its very material. It had no doubt been to Augsburg's advantage that the Tsarina was both politically and culturally orientated towards Germany. The gold set, now in the Hermitage in St Petersburg, consists of nearly fifty surviving parts. It is possible that Anna Ivanovna originally possessed two gold dressing-table sets from Augsburg and that these were later combined to form a single ensemble. It is at least possible to distinguish two stylistic tendencies within what survives.

The gold objects in all probability made by Johann Ludwig II Biller are much more elaborate in both form and decoration and much more clearly take their cue from French models. Thus, the

21 Lady at a Dressing-Table.
Painting, Johann Heinrich Wilhelm Tischbein, northern Germany, 1778;
Niedersächsisches Landesmuseum, Hanover.
The representation of the morning toilet at the dressing-table is here linked
with an almost genre-like treatment of maternal affection.

unusual oval box (plate 46), resting on four supports in the form of two lion's paws, follows engraved furniture designs from Paris. Similarly, in the two candlesticks with triangular stems rising from circular bases, we may detect a formal solution in the tradition of the work of French goldsmiths. The ewer, also probably made by Biller (plate 47), has a handle that takes the form of a nereid – as an allusion to the element of water – and a hinged lid, the latter a device found often in France but unusual in Germany. Closer to the style of Augsburg, however, is the overall form of the ewer, very bulbous in the lower section of its body, and the animated outline of the accompanying basin. The octagonal covered beaker by Johann Ludwig II Biller (plate 44, left) refers directly to examples of the Louis XIV style. It is comparable to the sugar and mustard containers of the table piece, similar to French models and also from the Hermitage in St Petersburg, that Johann Ludwig II Biller made in about 1731-3 for Anna Ivanovna's favourite, Ernst Johann Reichsgraf von Biron, Duke of Courland.

On the other hand, the gold objects made by Johann Jakob Wald – the oval box and the circular covered beaker (plate 44, right; plate 45, right) – are entirely in the tradition of South German goldsmiths' work of the early eighteenth century with their lightly moulded bases and their rounded outlines. The circular covered bowl of the *écuelle* type (plate 45, foreground), which has a softly stepped profile, bears Wald's master's mark. Thus it is similarly representative of his style; it is also notable in the less emphatic character of the strapwork ornamentation. The sections formed by such borders are mostly filled by heads in profile view and imperial eagles. Biller's objects, however, employ various animal and hunting motifs (with the addition of the monogram AI topped by the Russian imperial crown); such devices are only exceptionally encountered in Wald's work. Every one of the items made by the two Augsburg craftsmen is, however, distinguished by the excellence in the handling of its surface so as to achieve a careful differentiation between gleaming, polished and matt, chased areas. The dressing-table set made for the Tsarina Anna Ivanovna may thus be regarded as a truly imperial ensemble, all the more memorable for the attractively warm tones of its darkly radiant gold.

From the stylistic point of view, the dressing-table set in the Hermitage in St Petersburg must none the less be regarded as remarkably old-fashioned, even retrograde, as is especially apparent if we consider the strapwork ornamentation. The tradition-bound character of these gold objects, which may have been intended to fulfil a particular wish expressed in the terms of the commission, becomes clear by comparison with the dressing-table set made for the princely house of Thurn und Taxis a few years later, around 1741-3 (plates 48, 49), and now in the collection of the Bayerisches Nationalmuseum in Munich. Even though this set is relatively lightly worked and gilded, the style of early Rococo is already signalled in the lively moulding of the boxes, as also in the rocaille quality of the chiselled decoration. This is especially the case with the mirror, with its distinct volutes and shell motifs and the asymmetric shape of its crowning cartouche.

A later stylistic stage – that of fully developed Rococo – is found in the dressing-table set made largely in 1755-7 and now in the Württembergisches Landesmuseum in Stuttgart (plates 50, 51), with a total of thirty-seven pieces, all in an excellent state of preservation. This set was possibly commissioned by Duke Carl Eugen von Württemberg for presentation to his mistress. It is of the highest quality, not only in terms of both the casting and the chiselling technique, but also in the resort to double gilding and in the brilliant carving of the wooden handles. Similarly, the carved frames on the inner sides of the two doors of the chest, with their almost flame-like rocaille, virtually themselves assume the forms of goldsmiths' work. Consequently we may presume that, when the set was formally presented to its recipient, the chest was left open, its dark red velvet lining and the powerful glow of the gold uniting in an image of festive harmony.

The ewer, with its gently swelling form, and the boxes with pierced oval bases were made by Gottlieb Satzger, the leading Augsburg maker of dressing-table sets at the height of the era of Rococo. The sculpturally chiselled bold rocaille decoration, to which are added a variety of floral motifs, shows that this work was made after the mid-century. Similar decoration was adopted by the Augsburg goldsmith Johann Georg Klosse for the three pots intended to hold chocolate, coffee and tea, and carefully graduated in their sizes. Klosse was a well-known specialist in Augsburg of such items. The large mirror, which bears no master's mark, represents a stylistically advanced type of Augsburg production. Its form is remarkably vigorous, particularly in its supports, the bold rocaille volutes at the upper sides and the floral festoons set off against the glass.

The Eighteenth-Century Dinner Service

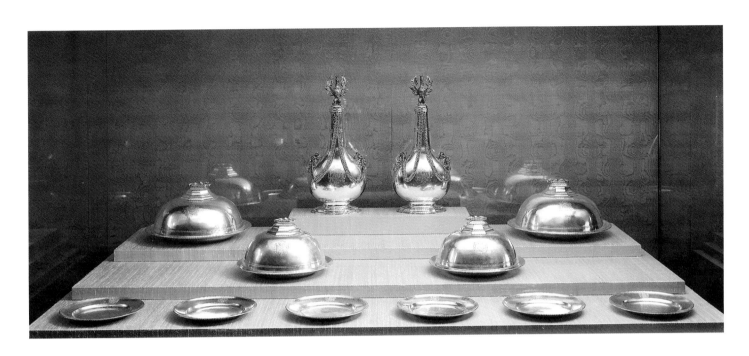

22 *Silver gilt dinner service made for Augustus the Strong.*
Pilgrim bottles: Christian Winter, Augsburg, c. *1718;*
dish covers: Christian Winter and Gottlieb Menzel, Augsburg, c. *1729-30;*
plates: Gottlieb Menzel, Augsburg, c. *1729-30.*

In the dinner service, which may be regarded as the most varied creation of profane goldsmiths' work in the eighteenth century, all the individual parts adhere to the same principles of design in terms of both form and decoration. Such an achievement was, however, the final outcome of a long process of evolution, a process that first got underway in the seventeenth century, as goldsmiths responded to developments in the realm of ceramics and glass since the Renaissance. It was probably at the court of Louis XIV that formally cohesive dinner services first emerged, these being small in extent and mostly consisting of items intended for the exclusive use of the monarch and the highest nobility. It is no coincidence that the formal unity of a set of objects for use at the table embodies the principle of the subordination of individual parts within a strong formal hierarchy. This was a principle applied widely during the reign of Louis XIV, be it to architecture or to the configuration of court society. It is telling in this respect that the dinner service gained in importance at this time while the buffet erected near the table became increasingly insignificant.

The largest and most prominent item in the dinner service, and one that was also a noteworthy innovation, was the centre-piece, or *surtout de table.* This would be used as a combined container for the mustard, vinegar, oil, salt and spices that remained on the table throughout the meal, for the sugar needed especially for the dessert, and often for candles too. Next in size came the tureens, in their early development circular in form and still ermed *pots-à-oille*, after the Spanish meat dish *olla podrida.* Then followed the dish covers and the various dishes, then the plates and the cutlery, and lastly the candelabra and candlesticks.

The double gilt dinner service commissioned in 1718 by Augustus the Strong (following the example of Louis XIV) to mark the betrothal of his son Friedrich August (see p. 34 ff.), and produced in Augsburg, is probably the earliest large surviving German service to be made in precious metal. In the eighteenth century this service comprised several hundred pieces; now only widely dispersed individual items can be traced (fig. 22). The silver objects used on the imposing table of Augustus the Strong, all of them engraved with the Polish-Saxon king's coat of arms, are important because of the combination of their balanced proportions with the remarkably high degree of precision in their execution. In the emphatic reduction of many of the pieces to simple geometric forms

– in particular the circle and the octagon – the design probably takes its cue from the early services made for Louis XIV, as is also suggested by the absence of any very elaborate decoration and the clear preference for smooth surfaces. It would, indeed, appear that the visit made by Augustus the Strong to the court of the Sun King in 1687-8 had left a lasting impression. At the Dresden court, accordingly, the custom of ceremonial dining *en public* was instigated: the sovereign, seated at his dazzling table and accompanied only by the closest members of his family, would be surrounded by the court society (fig. 23).

The round plates and the covers on their circular dishes (fig. 22) may be said to have set the tone for the character of the dinner service made in Augsburg for Augustus the Strong. The dish covers, which were easy to lift, allowed meals to be prevented from cooling too rapidly as they were being brought from distant kitchens and laid on the table. According to contemporary sources, they also had the purpose of protecting the food in the dishes from contamination, for example by being inadvertently sprinkled with wig powder. Apart from their practical function, the dish covers would appear to have provided one of the most striking compositional elements in this service because of the sheer simplicity of their almost semi-spherical form (its only element of decoration being the handle hinged to a centrally stepped base).

The tall pilgrim bottles (fig. 22), their tops crowned with the Polish eagle, do not belong on the table itself but rather on the accompanying buffet. Their design none the less corresponds with that of the service: their surfaces, rising from a lightly moulded base, are entirely smooth. The only emphasis is found in the placing of the masks, which act as clasps for the chains.

The set of vessels from the silver collection of the Princes of Thurn und Taxis, made only a few years later, in about 1725 (plates 52, 53), and now in the collection of the Bayerisches Nationalmuseum, embodies an essentially more modern formal language. French examples again serve as direct models, although in this case items of the 1720s rather than of the late seventeenth century. In the Thurn und Taxis ensemble we in fact encounter very slight variants on items from a Parisian dinner service that itself derives from the styles favoured by French goldsmiths during the last years of the reign of Louis XIV. The two pairs of large, circular, tureen-like covered vessels, distinct in their design though each with strong relief decoration, may be classified as *pots-à-oille*. In the case of the larger vessels (plate 52, outer edge), elongated leaf forms and ornamented blossoming sprigs are combined with the classical architectural motif of the Vitruvian scroll. The smaller vessels (plate 52, centre background), by contrast, are decorated with boldly modelled fruit festoons, strung between leaf masks; these *pots-à-oille*, exceptionally elegant in their proportions, are without doubt a stylistically advanced form.

Also extremely unusual are the almost rectangular-shaped objects, which were used as pie dishes (plate 52, centre foreground): these probably correspond to the containers that, in France, were termed *caisses-à-pâté*. (Although no French examples have sur-

vived, having been lost especially during the French Revolution along with so many other products of French goldsmiths' work, these Augsburg imitations appear to have recorded their form and decoration even down to the details.) The compositional strictness of the overall shape is here combined with clearly disciplined relief decoration, which generally takes up the motifs found on the larger *pots-à-oille*, for example the classicizing elements of the Vitruvian scroll and the egg-and-dart decoration. The extraordinarily high quality of the workmanship is evident in the treatment of detail (plate 53), and in the effectiveness of the contrast of matt and polished planes.

The six covered vessels made by Johann Ludwig II Biller, and bearing his master's mark, carry the inscription 'Französisch Silber' (French silver) in place of the Augsburg town mark (see p. 14). Here, 14 to 14½-lot silver (i.e. 875-906/1000), rather than 13-lot silver was used, the former approximating the standard prescribed in Paris. It may thus be assumed that these unusually heavy vessels were intended to complement objects made in Paris that were already to be found in the silver room of the Princes of Thurn und Taxis.

Among the objects used at the table but not, strictly speaking, part of the service itself, were the ewer and basin sets used for the ceremonial washing of the hands both before and after the meal. They provided a means of honouring the most distinguished personages. Aristocratic representatives of the court would use the ewer to pour water over the hands of the host or of his high-ranking guests, collect the water in the basin and finally offer a table napkin so that the hands could be dried. The ewer and basin set made in about 1739-41 by Johann Christoph Stenglin (plates 54, 55), from the Thurn und Taxis collection and now in the Bayerisches Nationalmuseum, was probably used in this way in the princely palace in Frankfurt am Main completed in 1740. The guests honoured in this fashion there may have included the Wittelsbach Emperor Charles VII, who, in 1742, on the occasion of the Diet held in Frankfurt, appointed Prince Alexander Ferdinand his principal commissioner. Later the silver gilt ensemble was used as baptismal vessels by the Princes of Thurn und Taxis.

The remarkably large and heavy pouring vessel alludes in various ways to the lively element of water: reed and shell motifs are employed, for example, and the vertical body of the ewer is set in a kind of basket with predominantly undulating lines. The sculptural quality of this item and its decoration – the ewer is cast in its entirety – culminates in the figure of the vigorously gesticulating putto incorporated into the boldly projecting handle. The bell-shaped base of the ewer appears to melt into the hollow marking its place in the basin; this, in turn, acts like a concave mirror, collecting and reflecting the light so as to further emphasize the sculptural quality of the vessel it contains. This dazzling creation, distinguished as much through the impact of its overall form as through the variety of its cast and chiselled decoration, may be regarded as an artistic high point in the development of Augsburg ewer and basin sets.

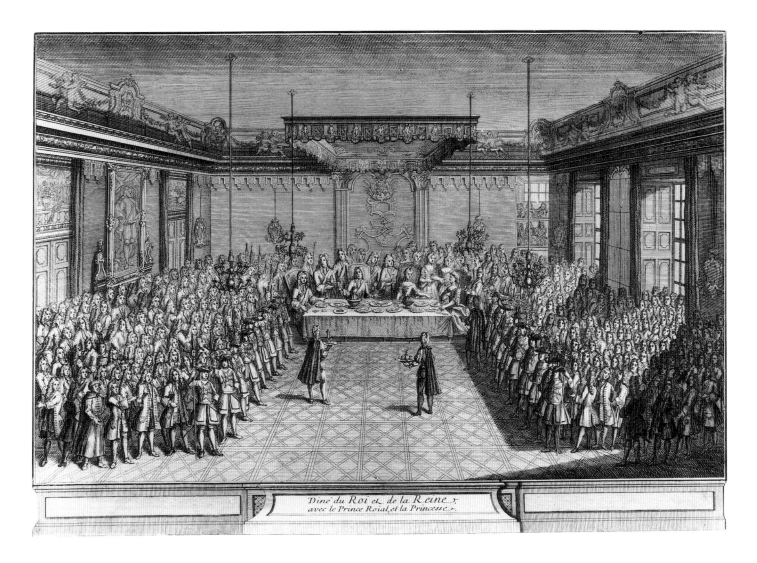

Diné du Roi et de la Reine,
avec le Prince Roial, et la Princesse.

23 *The 'public table' of Augustus the Strong, who is seated*
with his consort and with the Electoral Prince and his bride.
Engraving, probably Dresden, 1719.
In front of the assembled court, two courtiers present carafes and
glasses on salvers to the monarch and his family.

Also from the silver collection of the Princes of Thurn und Taxis is the series of six covered tureens (plates 56, 57). These too are now in the Bayerisches Nationalmuseum, which acquired them in 1993. They were made in about 1759-61 by Johann Wilhelm Dammann and Emanuel Gottlieb Oernster, and acquired in 1763 by Prince Alexander Ferdinand von Thurn und Taxis, together with an entire dinner service, for use in his summer residence near Heidenheim, Schloss Trugenhofen, after 1819 called Schloss Taxis. (In the eighteenth century, the Princes of Thurn und Taxis possessed a substantial stock of silver, which was kept from 1750 at their Residenz in Regensburg; but it was necessary for the princely summer seat, which had a court numbering 350, to have its own impressive silver service of the latest fashion.)

The set of tureens has particular charm because it combines two larger circular vessels with four smaller oval ones; the former

were probably intended for soup, the latter for ragout. Each of the vessels rests on its own stand, and each has its own insertable liner, with handles at the sides, as well as its own lid. It was thus possible to bring hot dishes to the table in the comparatively plain liners and then to lay these in the already waiting tureens.

The overall design of the tureens is notable for its elegant combination of convex and concave forms and for the subtly enlivening contrasts introduced through elements of decoration. The matt surface of the lemon rising vertically from surrounding foliage – this serves not only as a handle but also rounds off the composition – contrasts with the sparkle of the polished areas. The rocaille decoration on the surfaces, executed by embossing rather than by casting, is limited to the cartouches with the engraved coat of arms of the Princes of Thurn und Taxis, in each case placed at the centre of the front (plate 57). The design as a

whole is especially pleasing on account of the vigour of the curving lines, also a feature of the side-mounted handles, and the four ladles originally belonging to the set. We are probably justified in seeing this ensemble as the highest in quality of its type to be made in Augsburg during the Rococo.

While the tureens are all that survives of the Trugenhofen service, the silver dinner service also made in 1763, for the prince-bishop of Hildesheim, Friedrich Wilhelm von Westphalen, has been preserved almost in its entirety (plates 58-63). It is by far the most complete of the surviving dinner services from Augsburg. On his election as prince-bishop in 1763, Friedrich Wilhelm found that there was no table silverware at the Hildesheim court, because his predecessors, from the House of Wittelsbach, had never lived at Hildesheim and so had had no need there of a silver dinner service befitting their rank. To ensure that his (admittedly modest) principality was adequately represented as sovereign in Hildesheim, Friedrich Wilhelm commissioned from Augsburg (where he enjoyed good credit with the silver dealers Wilhelm Michael Rauner [fig. 3] and Klaucke und Benz) an extensive dinner service, though it should be added that this was also intended for the use of his presumptive successors. In 1763, accordingly, the silver objects

Hildesheim *Hofkammer* from the family collection of Friedrich Wilhelm von Westphalen.

In 1802, when the bishopric of Hildesheim was secularized and came under the jurisdiction of the kingdom of Prussia, the dinner service became the temporary property of the last prince-bishop, Franz Egon von Fürstenberg – a nephew of Friedrich Wilhelm. After Franz Egon's death in 1825, it became the property of the kingdom of Hanover, to whom the bishopric's former territory had been awarded in 1815. In 1980 the dinner service, then in a private collection, was auctioned in Geneva; it contained approximately the same number of items as it had in 1825. It was thus possible for the Bayerisches Nationalmuseum to acquire (in 1981) most of the items supplied by Augsburg in 1763. Further significant parts of the service were acquired by the Roemer-Museum in Hildesheim.

In the Munich exhibition of 1994 it was for the first time possible to present the Hildesheim dinner service arranged in a historically correct manner (plate 58), items from the Bayerisches Nationalmuseum and the Roemer-Museum being supplemented by loans from private collections. The damask tablecloths, made in about 1900, were lent by the Thurn und Taxis family. The

24 *Table-layout for a dinner service. Drawing, Augsburg, c. 1760; Graphische Sammlung, Städtische Kunstsammlungen, Augsburg.*
This drawing, which combines plan and elevation, does not show plates, cutlery or candelabra.

supplied by Augsburg were entered in the *inventarium perpetuum* (eternal inventory), signifying that the service was not the personal possession of the prince-bishop, but rather the inalienable property of the bishopric – that is to say of the ecclesiastical principality of Hildesheim. The dinner service supplied in 1763 was supplemented with various silver objects from Augsburg workshops (mainly of about 1750); these were purchased by the

reconstruction of the service – which, according to archival records, could be laid to a maximum of thirty places – was based on schemes for a table-layout of the sort presented to princely patrons by Augsburg silver dealers when encouraging them to commission such sets (fig. 24). Corresponding to the carefully staggered form of the vertical composition, we find a tightly organized horizontal arrangement for items placed on the table.

Lengthwise, these would occupy a place in one of five rows (one marking, and four parallel to, the centre), with strict symmetry observed throughout. The centre of the entire composition received special emphasis. Here the largest centrepiece would be surrounded by four smaller, diagonally placed tureens and their respective ladles (plate 61). Smaller *surtouts* distinguished the midpoint of each lengthwise half of the table (plate 62), while larger tureens, with their ladles, placed along each of the shorter sides appear (to judge from the Augsburg table-layouts) to have marked the outer limit of the service (plate 60). The spaces between the principal centrepiece and the four diagonally positioned tureens were occupied (according to the Augsburg plans) by four square dishes; while the spaces surrounding the smaller centrepieces contained the variously sized circular and oval dishes that were used for the meal served *à la française*. By means of avoiding either too large or too narrow a space between one item and the next, there emerged a balanced transition throughout. This contributed in no small measure to the overall harmony of this stylistically homogeneous dinner service.

As the candlesticks originally belonging to the service have not all survived, it was decided to exhibit various examples from the Hildesheim collection, with one, two and three branches (plates 58, 60-62). To emphasize the centre and the corners of the table, larger girandoles with two or three branches were used; compositionally, these were integrated with the centrepieces. Also included in the service were the sauce-boats; in our own arrangement these were aligned in relation to the candlesticks.

Alongside each of the thirty plates – these having a lively, curving outline corresponding to that of the dishes we have already mentioned – there lay the cutlery, each set consisting of a knife, a spoon and a four-pronged fork. At the Geneva auction of 1980, the cutlery belonging to the Hildesheim service was entirely dispersed; it was thus not available for the Munich exhibition. An acceptable substitute was therefore found in the very similar three-part sets of cutlery from the silver service acquired in Augsburg in 1764 by the Abbot of Neresheim, Benedikt Maria Angehrn. In 1993, these came, by way of the House of Thurn und Taxis, into the collection of the Bayerisches Nationalmuseum. In the Munich exhibition, the cutlery was laid following the pattern found in the painting from the studio of Martin van Meytens of the banquet held to mark the election and coronation of Joseph II as King of the Romans in 1764 in the Römer in Frankfurt am Main (fig. 25): spoons and forks lie with their bowls and tines facing downwards, so that the coats of arms engraved on their backs can be seen.

In each of the inner corners of the room there was a tall buffet, placed diagonally (plate 58, right background). The reconstruction of the silver objects from the Hildesheim dinner service used in the Munich exhibition was a very simplified form of the arrangement found on the buffets in the painting by Martin van Meytens. Below, the silver vessels used for serving drinks at the table – fountains and basins, wine-coolers and salvers – are placed on the buffet counter. According to archival records, there also

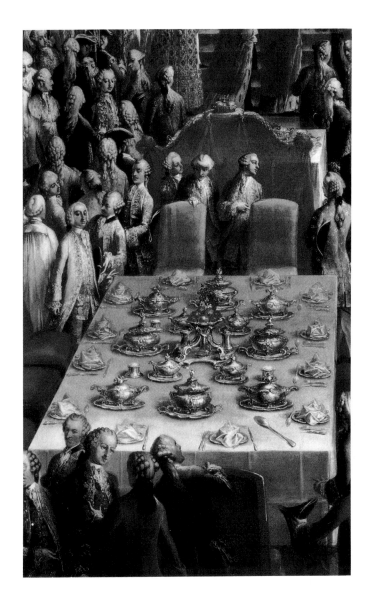

25 *Banquet in the Römer in Frankfurt am Main to mark the election and coronation of Joseph II as King of the Romans in 1764; detail. Painting, workshop of Martin van Meytens, after 1764; Kunsthistorisches Museum, Vienna. This detail from a vast painting reveals the high degree of precision employed in rendering the table.*

existed at the Hildesheim court a buffet near the table, from which wine in particular might be served.

The various objects belonging to the silver dinner service of the Hildesheim princely house were thus related to each other and compositionally assembled into a true ensemble – as if still under the eye of Prince-Bishop Friedrich Wilhelm von Westphalen, who had commissioned the service, and who, in Johann Georg Ziesenis's portrait (plate 58, background), smiles gently as he looks at the imposing festive table as it may have been displayed for the first time in October 1763, on the occasion of his enthronement.

Throughout the Hildesheim dinner service, we find lively modelling and markedly sculptural decoration – qualities charac-

teristic of the Augsburg goldsmiths' work of the High Rococo. These qualities are, of course, more restrained in the shallow plates at the edges, more pronounced in the candelabra, sauceboats and tureens, and culminating in the centrepieces along the central axis (plates 59, 62, 63) with their putti and, in the case of the largest, a group of musicians apparently entertaining court society with a table concert (plate 59, 63). Because of the persistence of floral and vegetable motifs in the decoration – particularly marked in the entwined tendrils of the girandoles – the table takes on the appearance of an artificial garden: here, then, exterior and interior may be seen to merge. The intense play of reflections also contributes to the overall liveliness of the ensemble: the alternately convex and concave silver surfaces, studded with sculptural forms, were designed with precisely such effects in mind. Certainly, the impression would have been even more striking if viewed by the flickering gleam of candlelight: the evidence of contemporary paintings strongly suggests that this was an important aspect of formal dining at the courts of Europe. Nor must we forget the contribution of the dazzling whiteness of the damask tablecloths, both in setting off the silver and in intensifying the effect of the reflections.

The distinctive character of the Hildesheim dinner service in the layout we have considered was due not only to the Augsburg silver dealers who served as middlemen but also, in effect, to the outstanding goldsmith Bernhard Heinrich Weyhe, who made the centrepieces and the tureens. The splendid principal *surtout*, which would once have held exotic fruits in its upper baskets (fig. 26), and even now still displays its accessories on its base, combines transparent trellis-work with lively rocaille, and unites motifs taken from real garden architecture with abstract ornamental forms. The childlike musicians, dressed in an eighteenth-century notion of 'savage' costume, play their instruments beneath decorative arches (plate 63). In the goldsmith's skilful *mise-en-scène* (its basic principles perhaps prompted by the specifications of a draughtsman or a painter) such apparently opposed elements achieve a happy synthesis in the spirit of lightness and grace.

Weyhe's tureens, made in two different sizes (plates 60, 61), are far less rigidly composed than are the covered vessels of the Thurn und Taxis service, the design of which is as elegant as it is clear (plates 56, 57). They tend, rather, towards powerfully swelling forms and to vigorous and only minimally structured rocaille

ornamentation. None the less, here too, as a result of the formal proximity to the centrepieces, and in the spirit of the harmony invoked by the music-making putti, the tureens are integrated within the overall stylistic character of the dinner service.

Having eaten its full during the course of the evening, court society would throw itself into games that were not only diverting but also potentially ruinous. For this purpose, numerous tables would be set up in the neighbouring state rooms. In princely silver holdings one finds, accordingly, numerous candlesticks intended to provide the lighting essential for such gaming tables: in Dresden alone 124 examples of one particular type from the third quarter of the eighteenth century are listed. The scalloped corners of these tables were intended to accommodate the candlesticks, most of which consisted of a short shaft resting on a relatively large base. As the latter generally had raised borders – in the case of the Augsburg candlesticks, they have an irregularly curved lobed form (plate 64) – it would seem reasonable to conclude that the players kept their counters there. The gaming-table candlesticks listed in the inventory of Hildesheim silver drawn up in 1763 were long untraced, but they were found in a private collection in 1993. The Bayerisches Nationalmuseum in Munich and the Roemer-Museum in Hildesheim were thus able to acquire them for their collections.

The incomparable ensemble of the Hildesheim dinner service may be seen as the dazzling culmination of the Augsburg goldsmith's art in the era of the Rococo. Soon, however, with the growing spread of Neoclassicism in the 1770s, the importance of Augsburg work in precious metal declined. As part of an increasing concentration of local trade, the princes of German-speaking Europe preferred to commission work from goldsmiths in the nearest centre of production, be this Berlin, Dresden, Munich or Vienna. Even beyond the German-speaking sphere, whether in Paris, London or Stockholm, the local workshops now presented fierce competition to those of Augsburg. Throughout Europe, furthermore, there was a general reduction in courtly display. In 1806, as a result of the political upheavals of the early nineteenth century, the former 'Free Imperial City' of Augsburg was absorbed into the kingdom of Bavaria. This loss of independence was soon reflected in a change in the position and status of the Augsburg goldsmith's art, effectively marking the end of a unique tradition that had flourished for nearly three centuries.

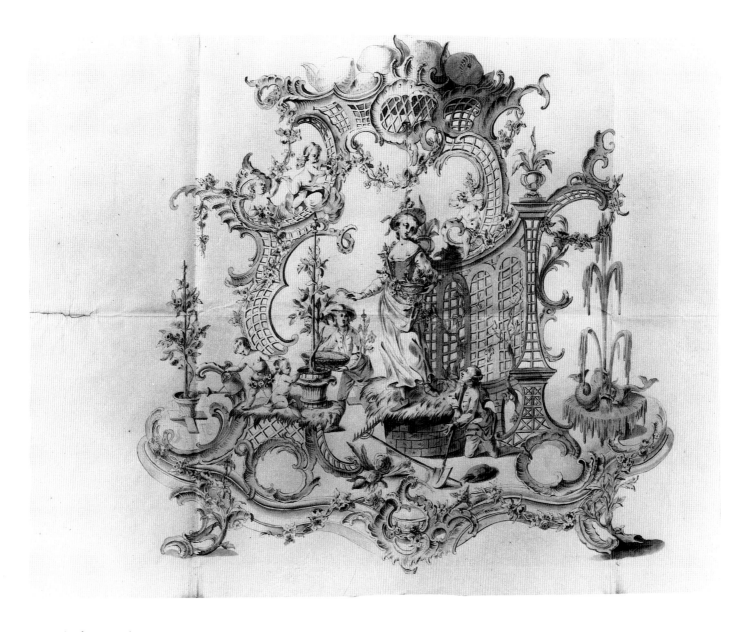

26 *Design for a centrepiece.*
Drawing, Augsburg, mid-18th century;
Graphische Sammlung, Städtische Kunstsammlungen, Augsburg.
A centrepiece made by Bernhard Heinrich Weyhe and corresponding
to that shown in the drawing was formerly in Weimar.

PLATES

1 Drinking vessel in the form of a strutting stag,
Albrecht von Horn, *c.* 1616 - 17

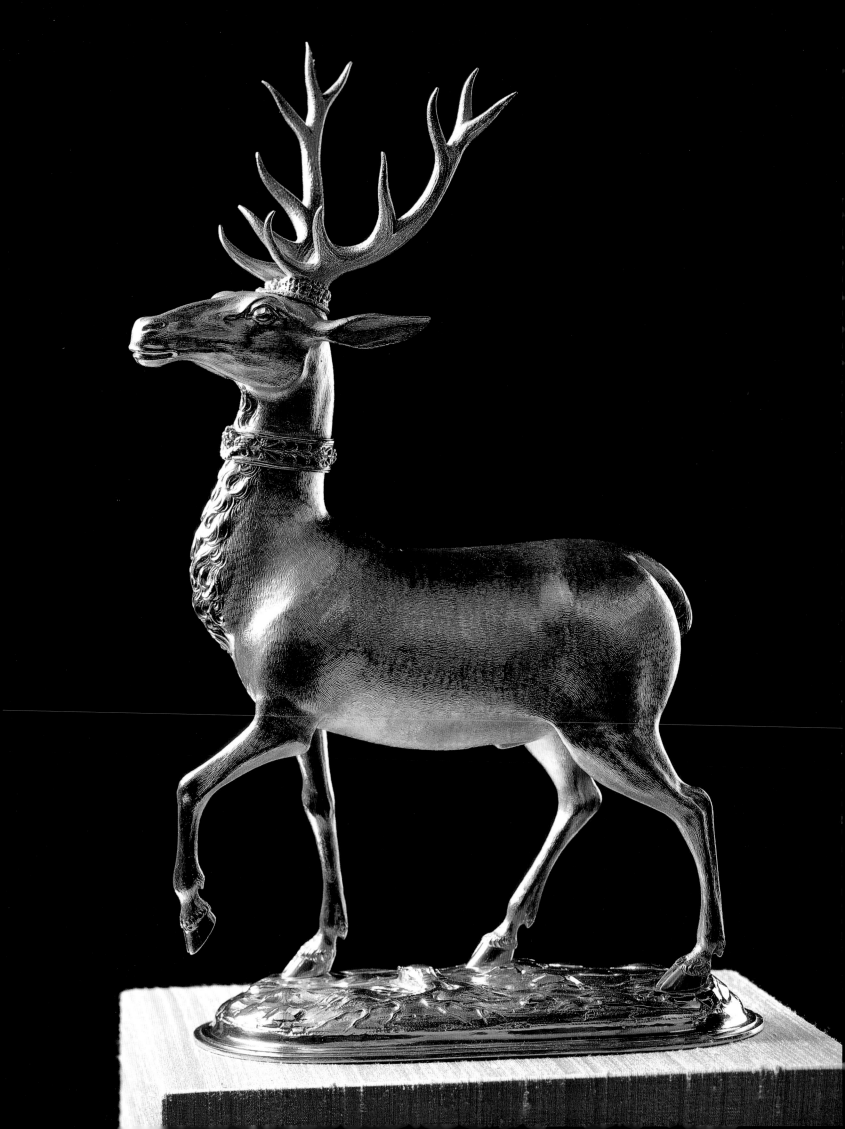

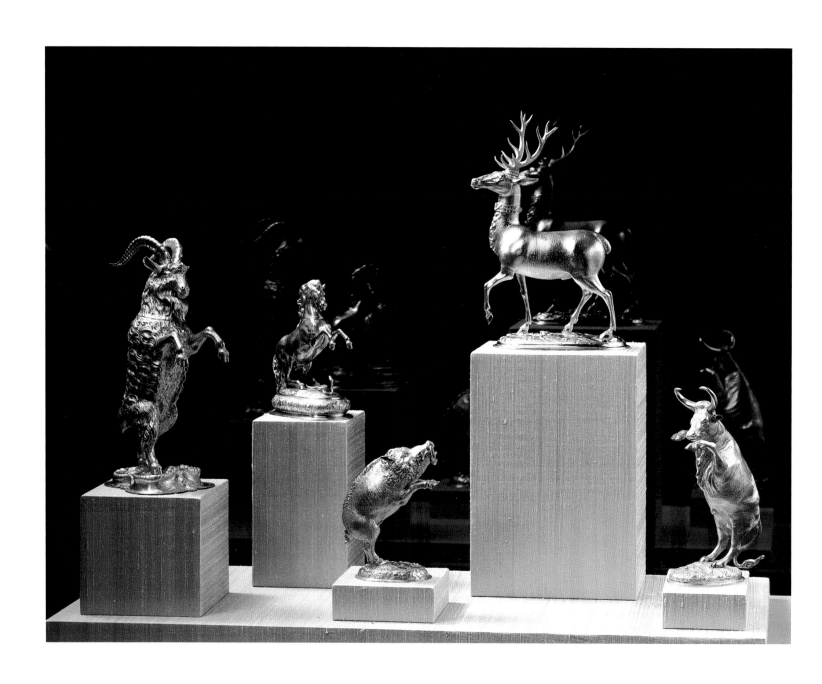

2 Five drinking vessels in the form of various animals,
between 1591 and 1641

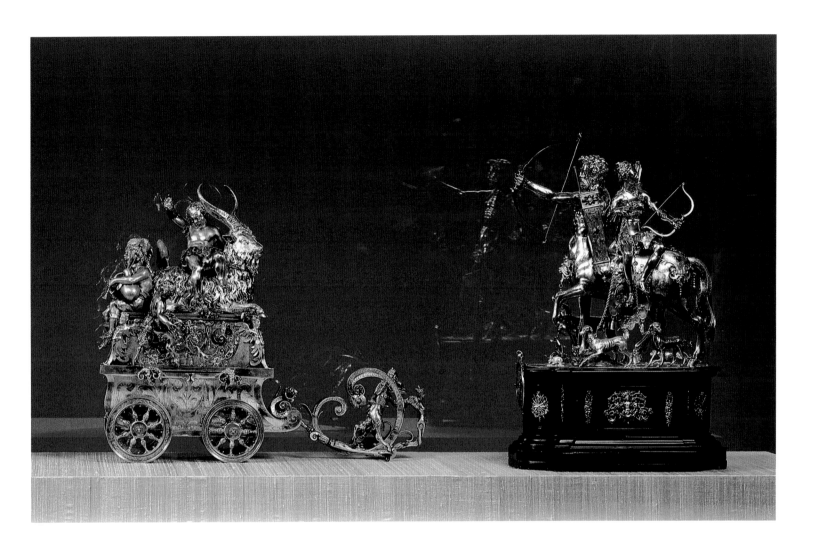

3 Two table automata with figures: The Triumph of Bacchus, Sylvester II Eberlin, c. 1604 - 10;
Diana mounted on a centaur, Melchior Mair, c. 1610

Overleaf:

4 - 5 Two table automata: Saint George, Jakob I Miller, c. 1618;
Diana mounted on a stag, Joachim Fries, c. 1615 - 20

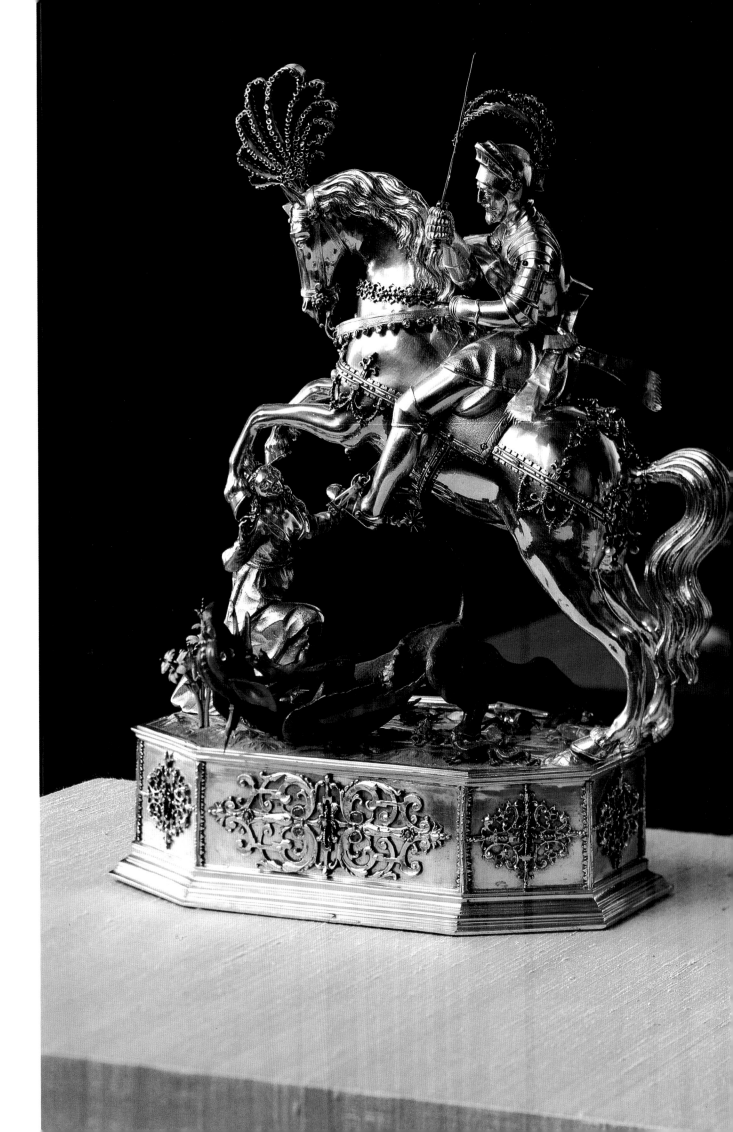

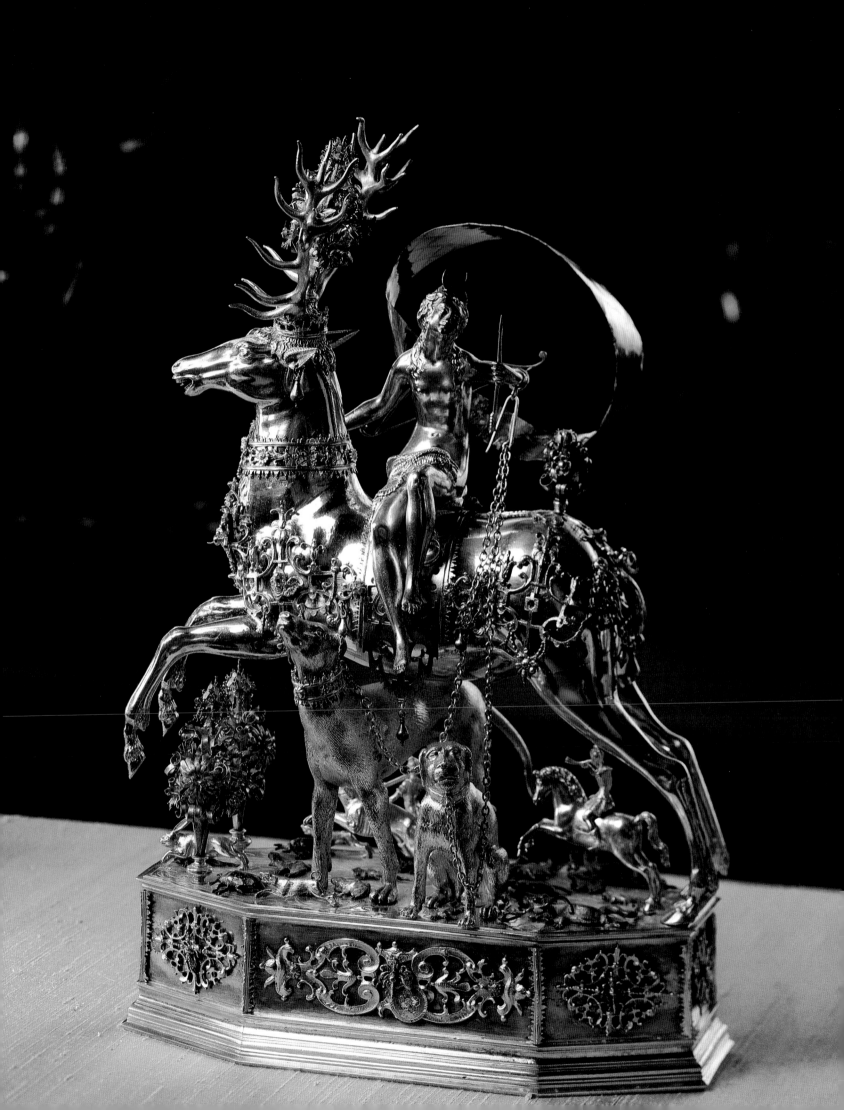

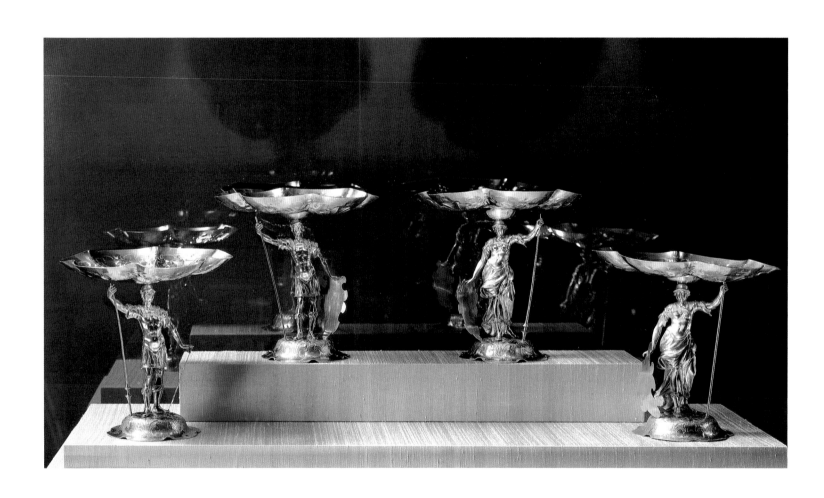

6 Four sweetmeat salvers, probably Hans Jakob I Baur, *c.* 1653

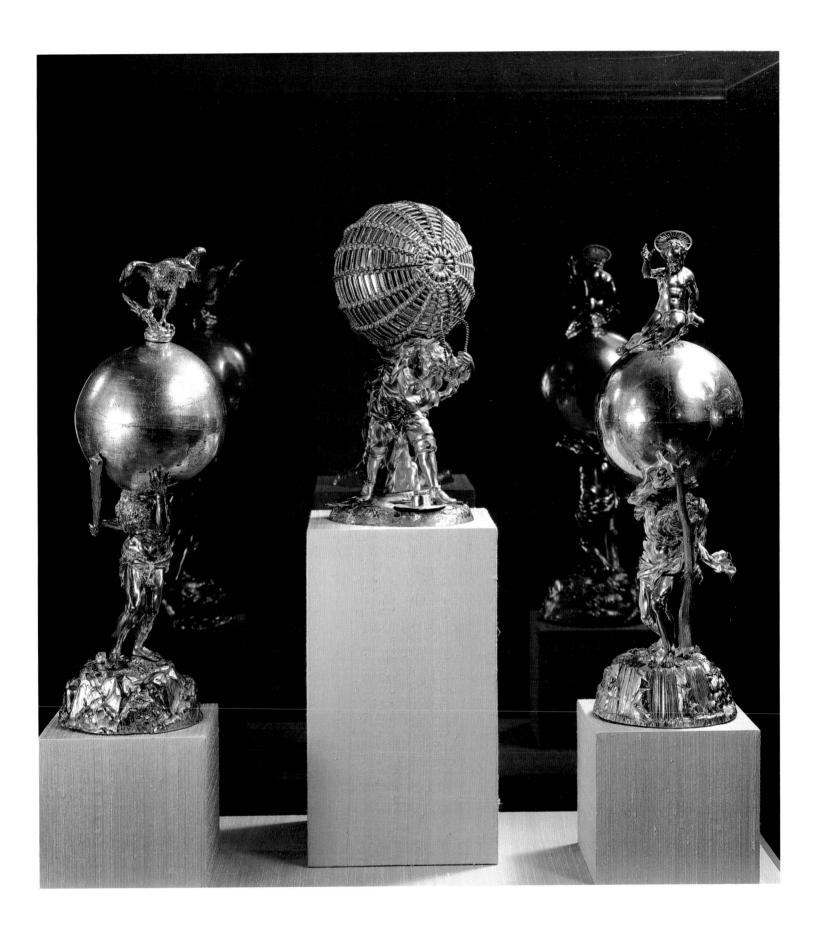

7 Two cups with Hercules and Saint Christopher, Elias Lenker, *c.* 1626-9;
man carrying a bale of merchandise or a bomb (centre), Heinrich Mannlich, *c.* 1695-8

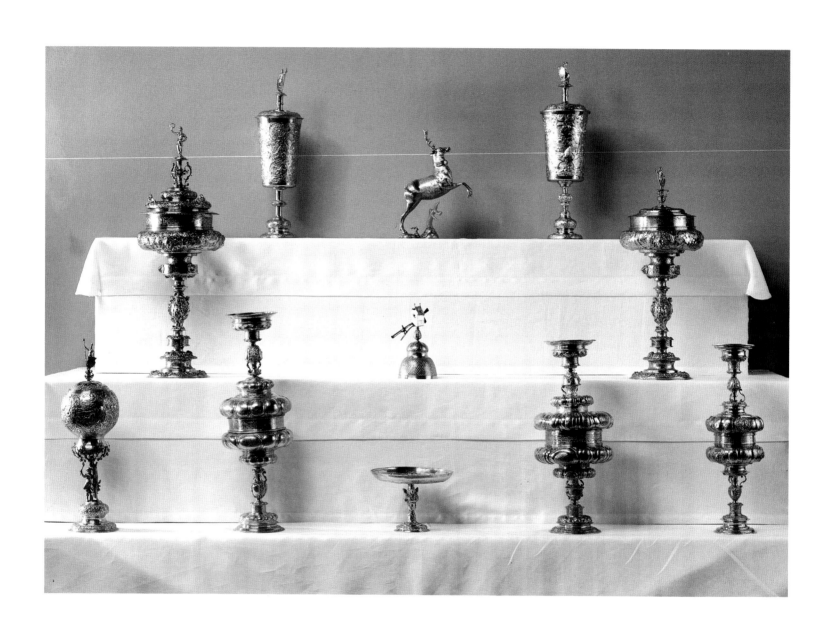

8 Buffet with double standing-cups,
covered standing-cups and other drinking vessels,
between 1550 and 1615

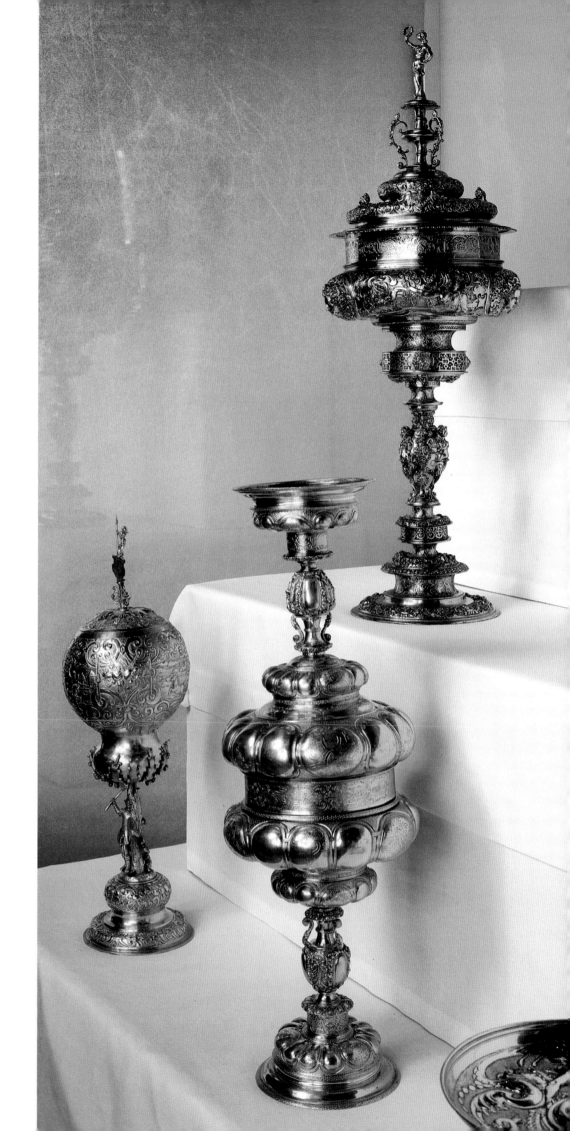

9 Two double standing-cups and
a standing-cup in the form of a gourd,
between 1550 and 1605

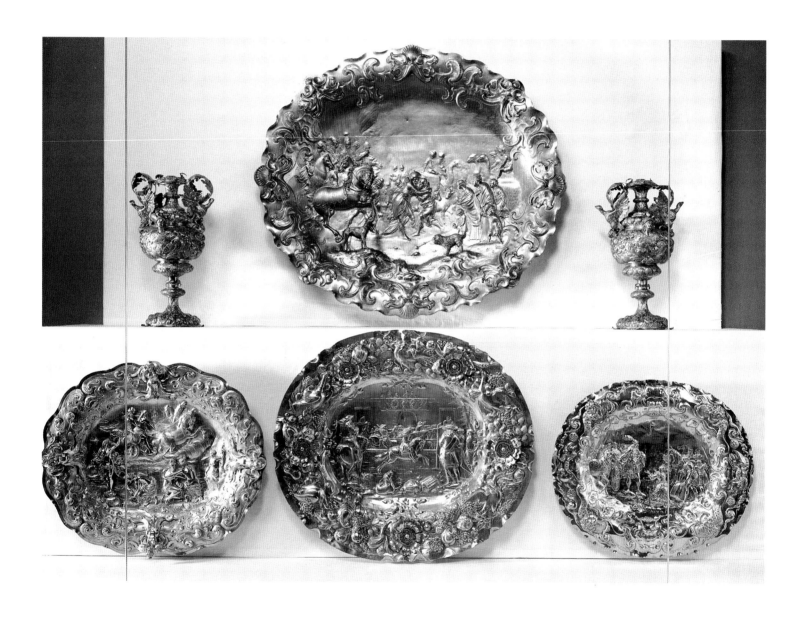

10 Buffet with two decorative vases and four display platters,
between 1645 and 1683

11 Display platter: The Reconciliation of Jacob and Esau,
detail, Hans Jakob I Baur, *c.* 1645 - 7

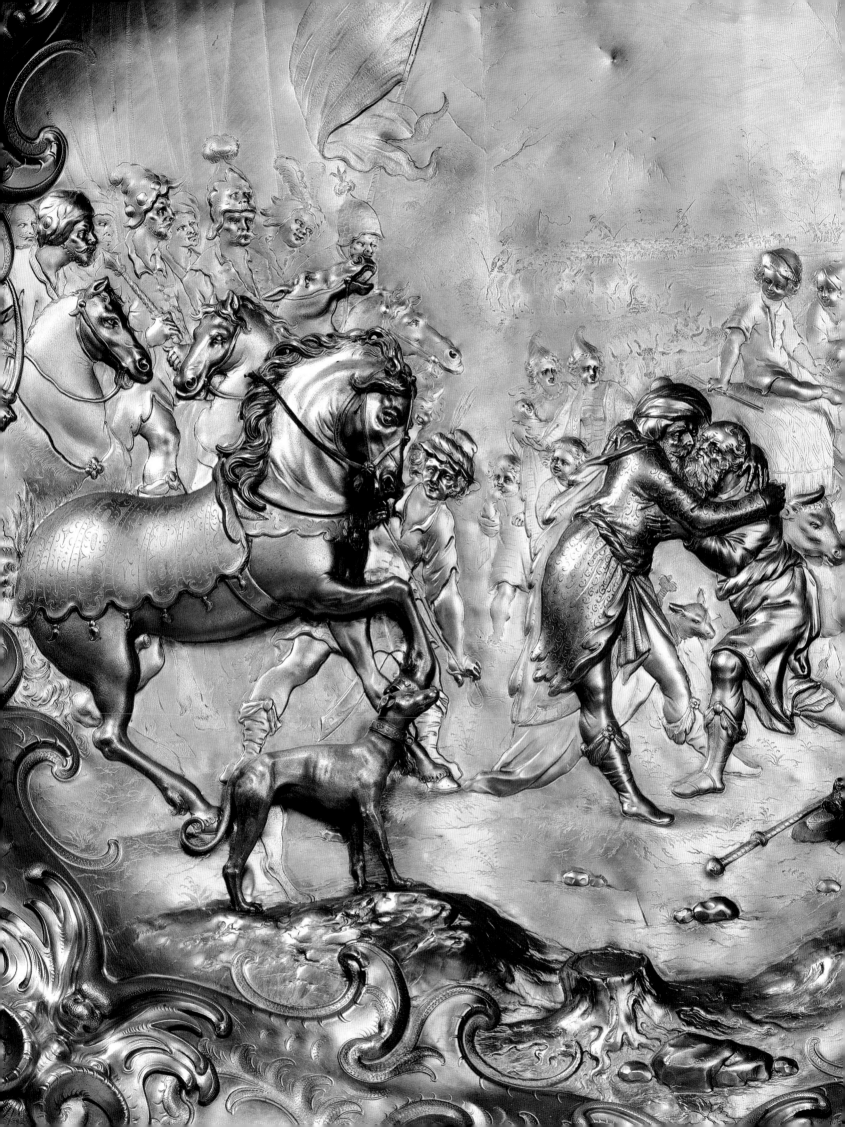

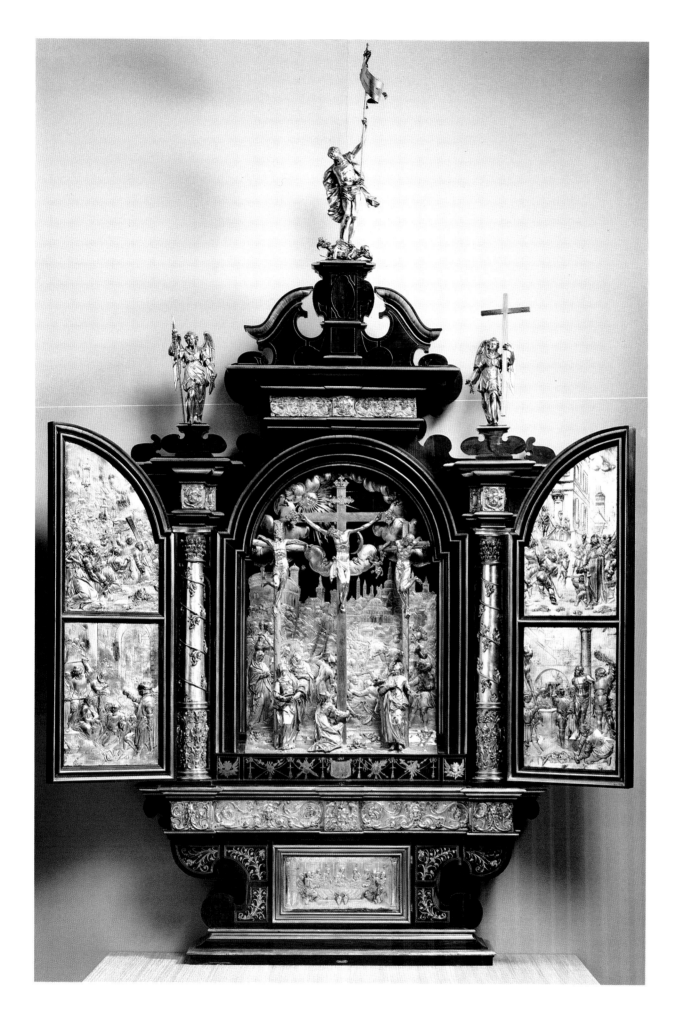

12
Altar from
Schloss Husum,
Albrecht von Horn,
1620

13
Altar from
Schloss Husum:
The Crucifixion,
detail of plate 12

Overleaf:

14 Altar from
Schloss Husum:
relief with
Christ carrying
the Cross,
detail of plate 12

15 Altar from
Schloss Husum:
central group from
The Crucifixion,
detail of plate 12

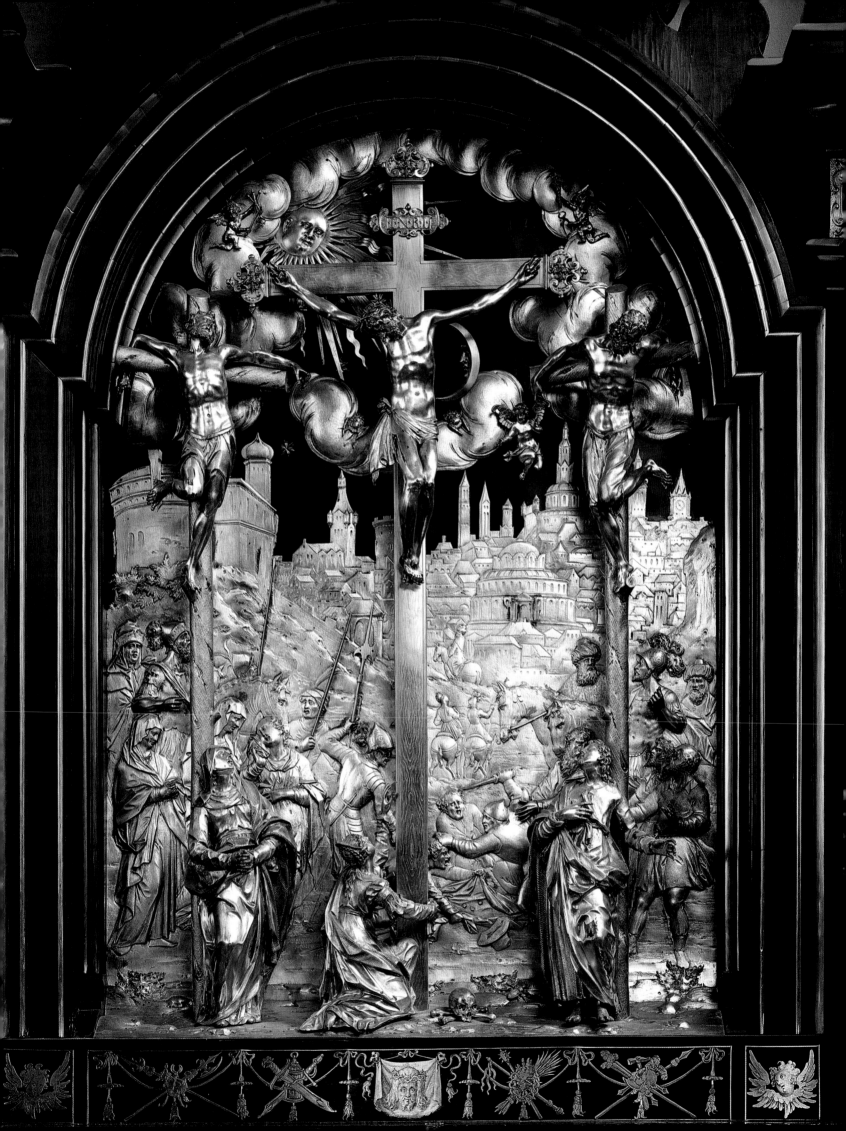

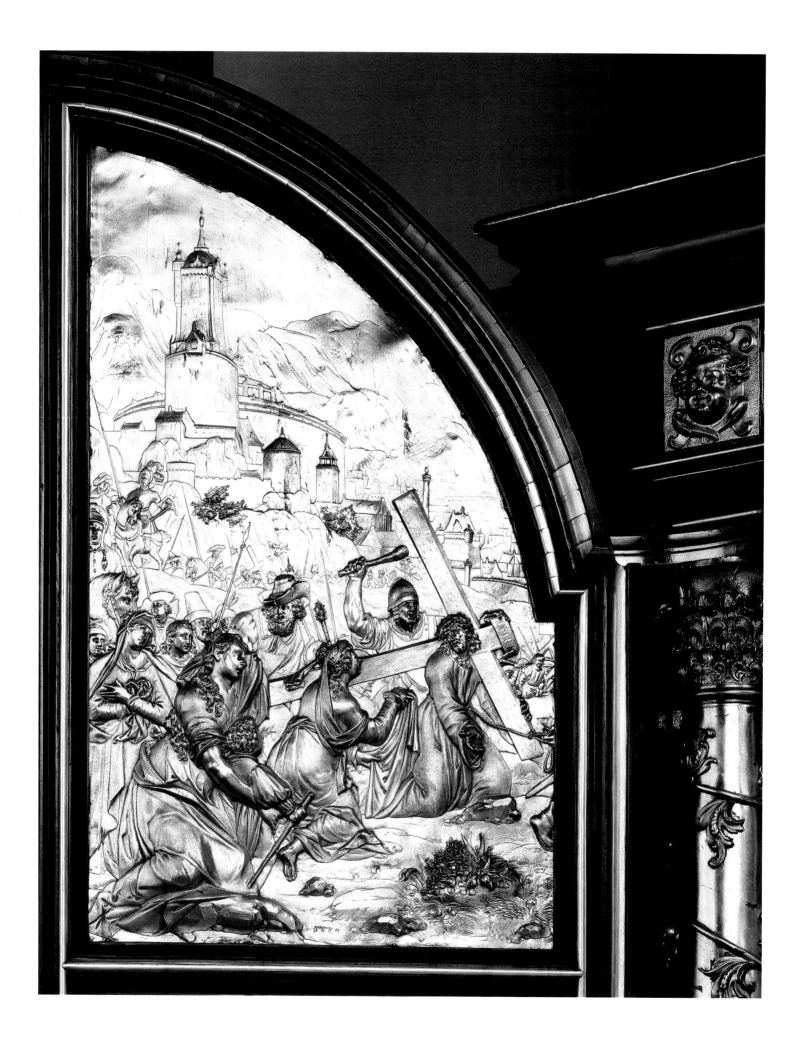

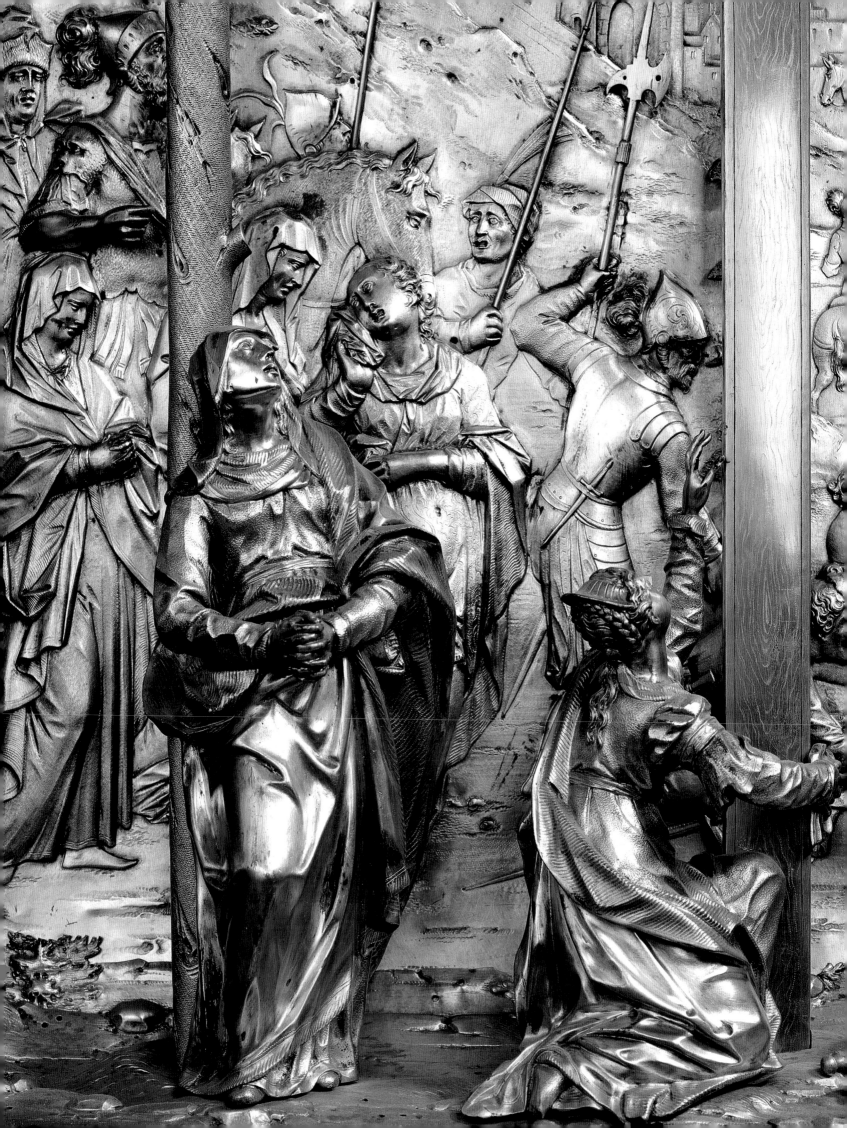

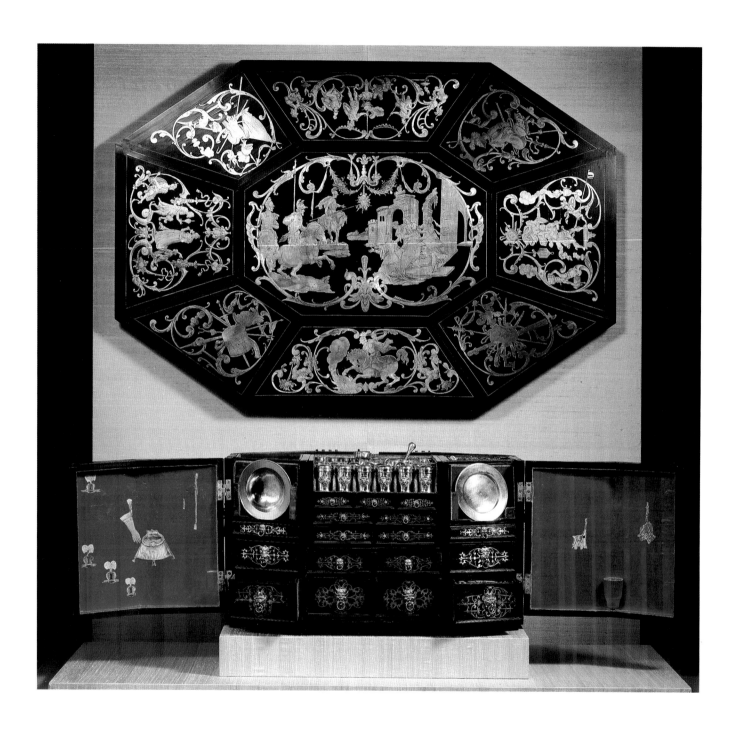

16 Working and hunting table made for the Elector Johann Georg I of Saxony,
Christoph Wild and Tobias Leucker, *c.* 1620 - 5

17 Working and hunting table made for the Elector Johann Georg I of Saxony, detail of table top

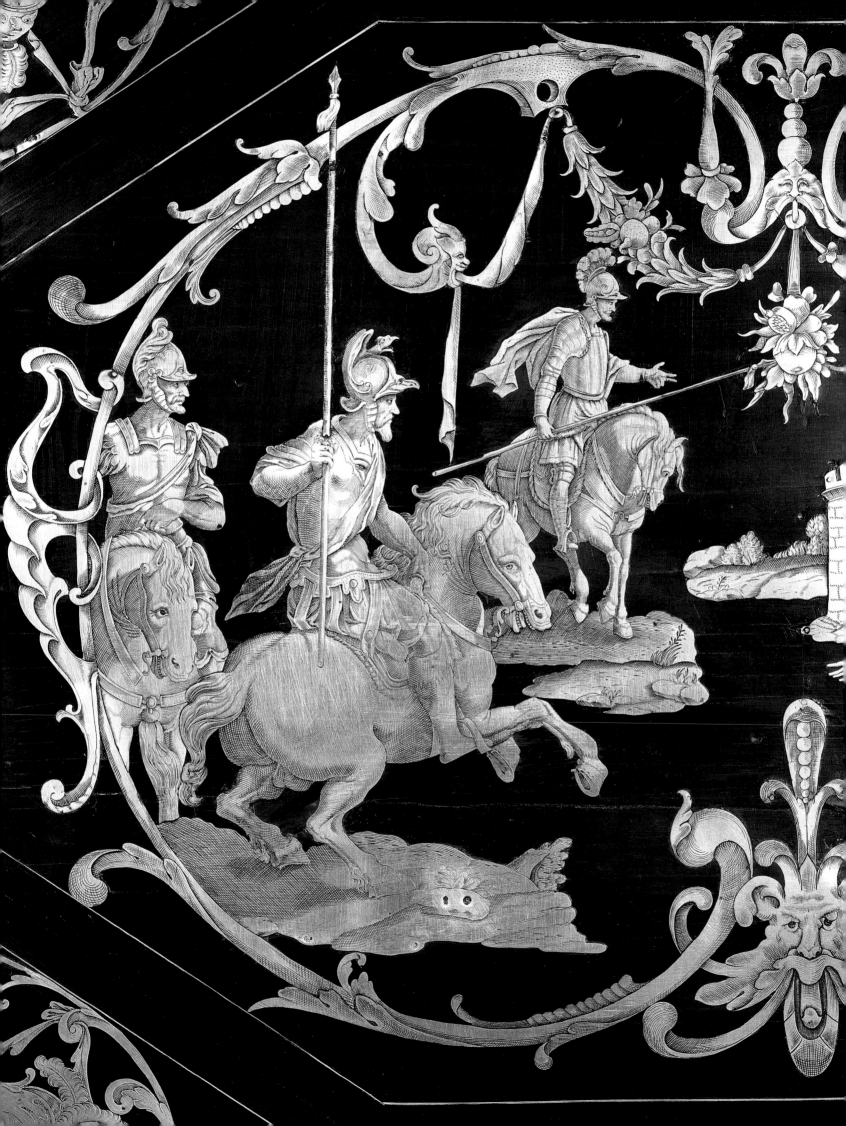

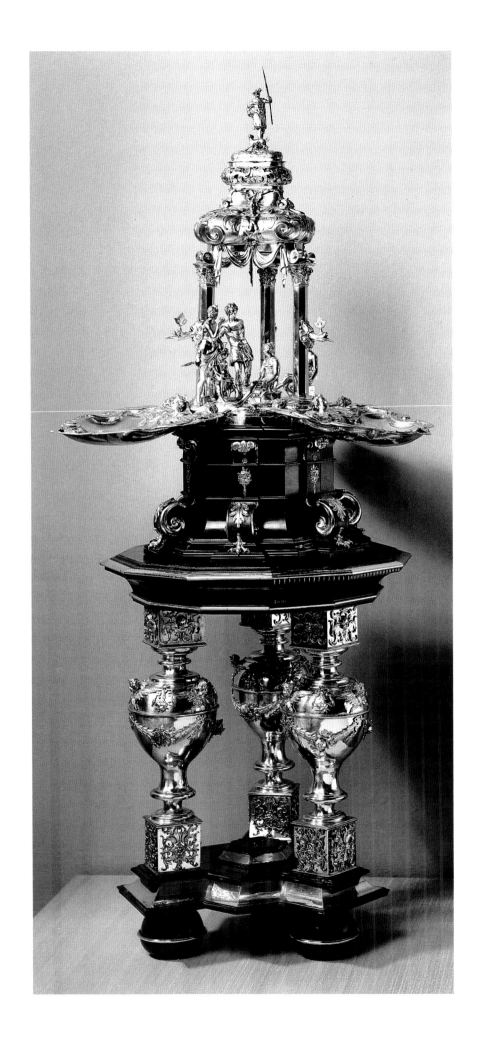

18 Fountain,
Hans III Petrus
and Daniel Zech,
c. 1648-9

19 Group of figures
from the fountain:
Actaeon surprises Diana
and her companions
as they bathe,
detail of plate 18

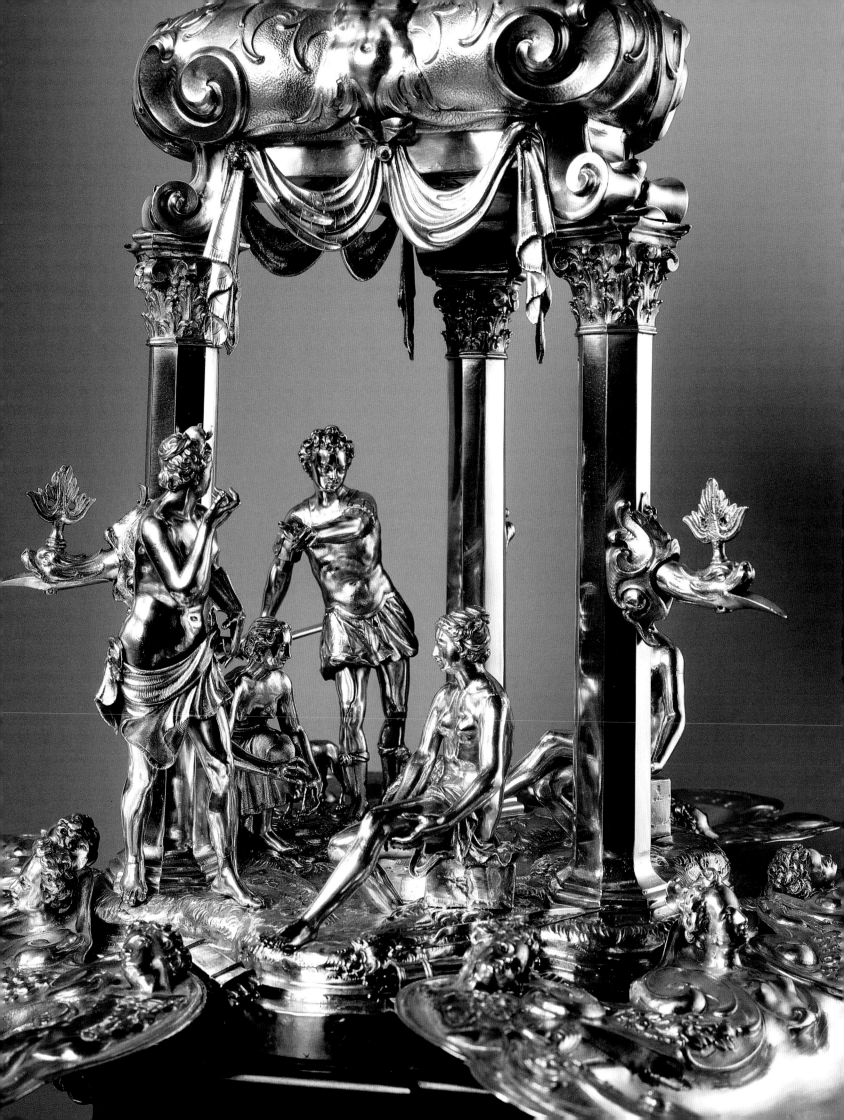

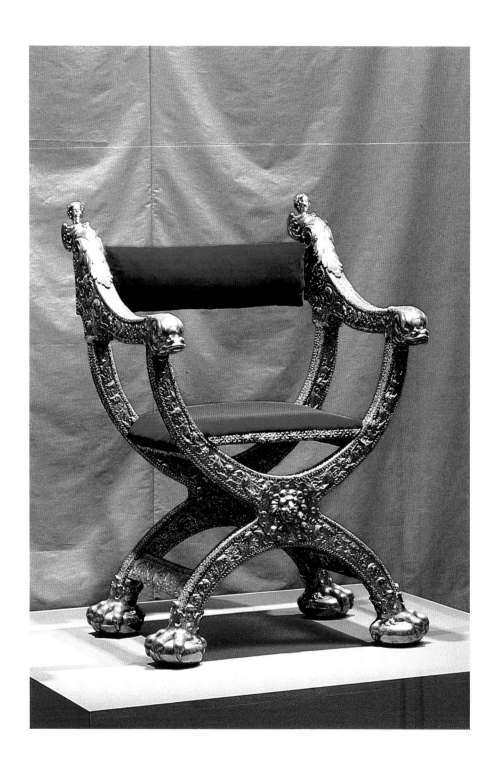

20 Armchair,
David I Schwestermüller,
c. 1670 - 4

21 Arm of armchair,
detail of plate 20

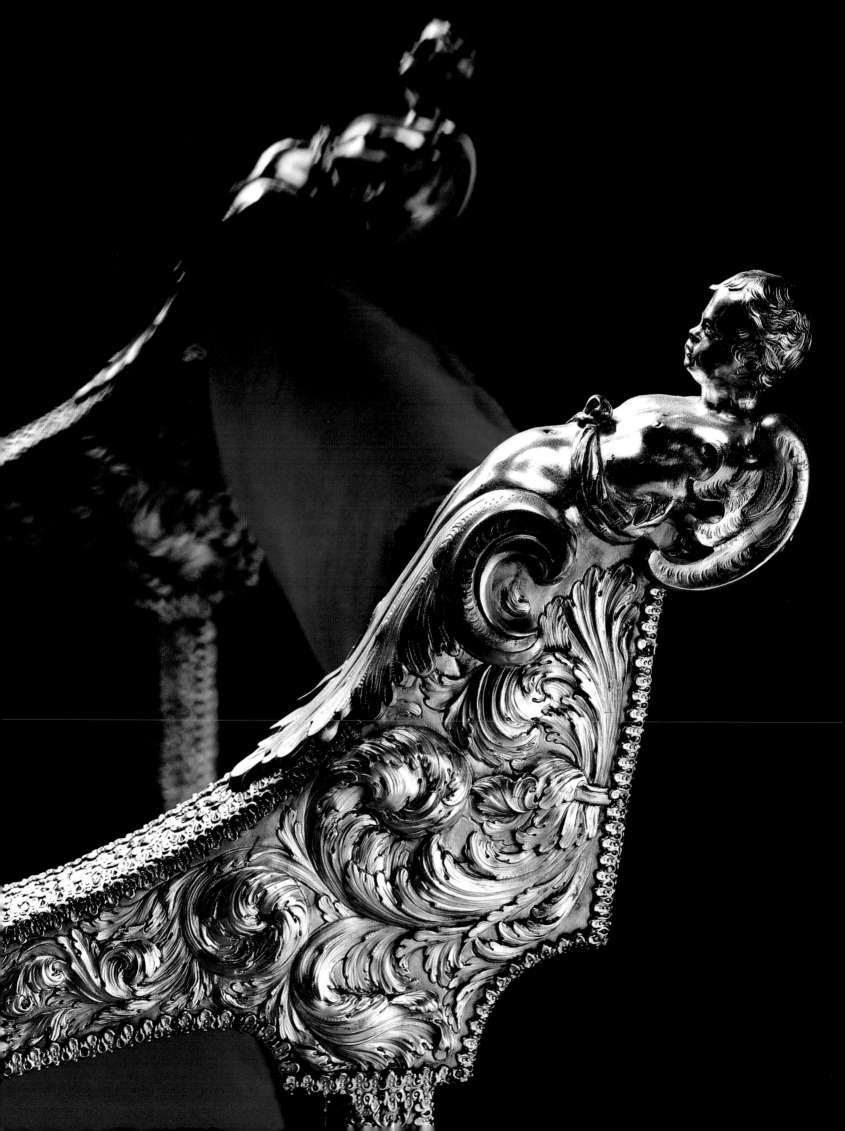

22 Fire-screen, Johann Ludwig I Biller and Lorenz II Biller, *c.* 1690 - 4;
pair of andirons, Johannes Kilian and probably Lukas Lang, *c.* 1680

23 Crowning motif of fire-screen, detail of plate 22

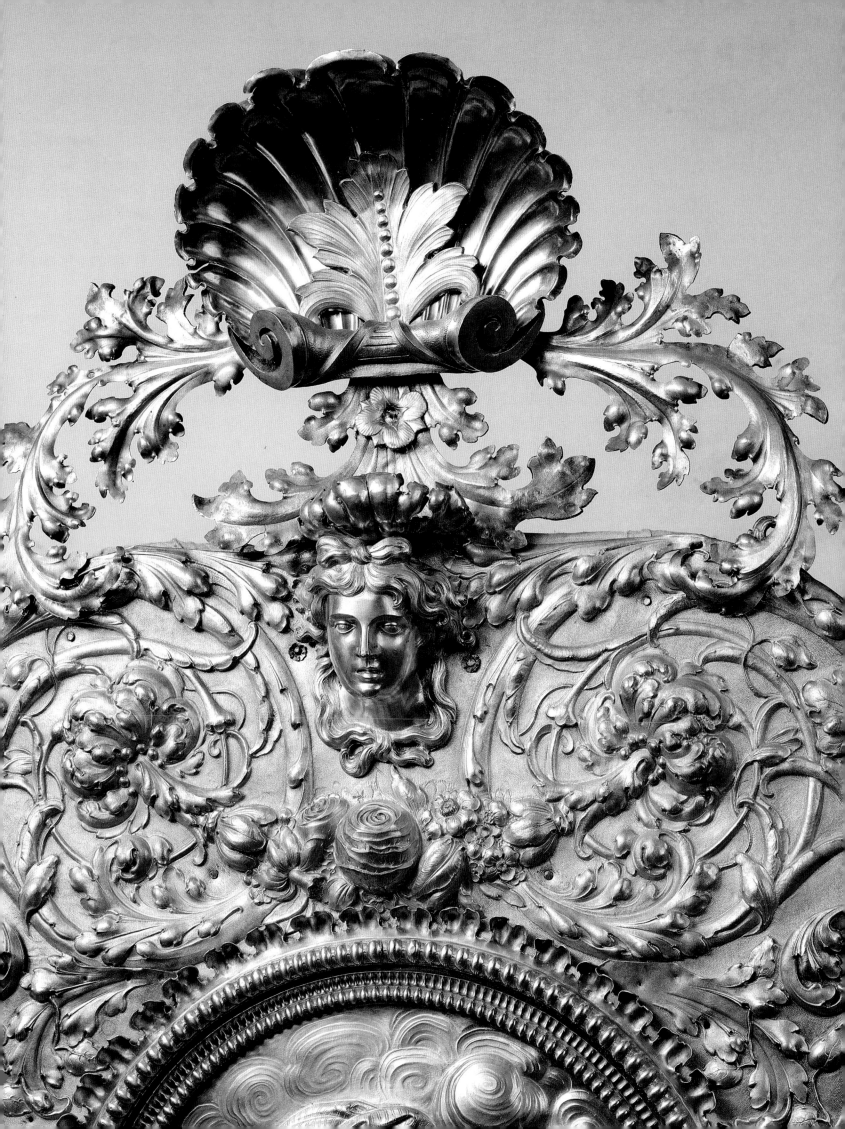

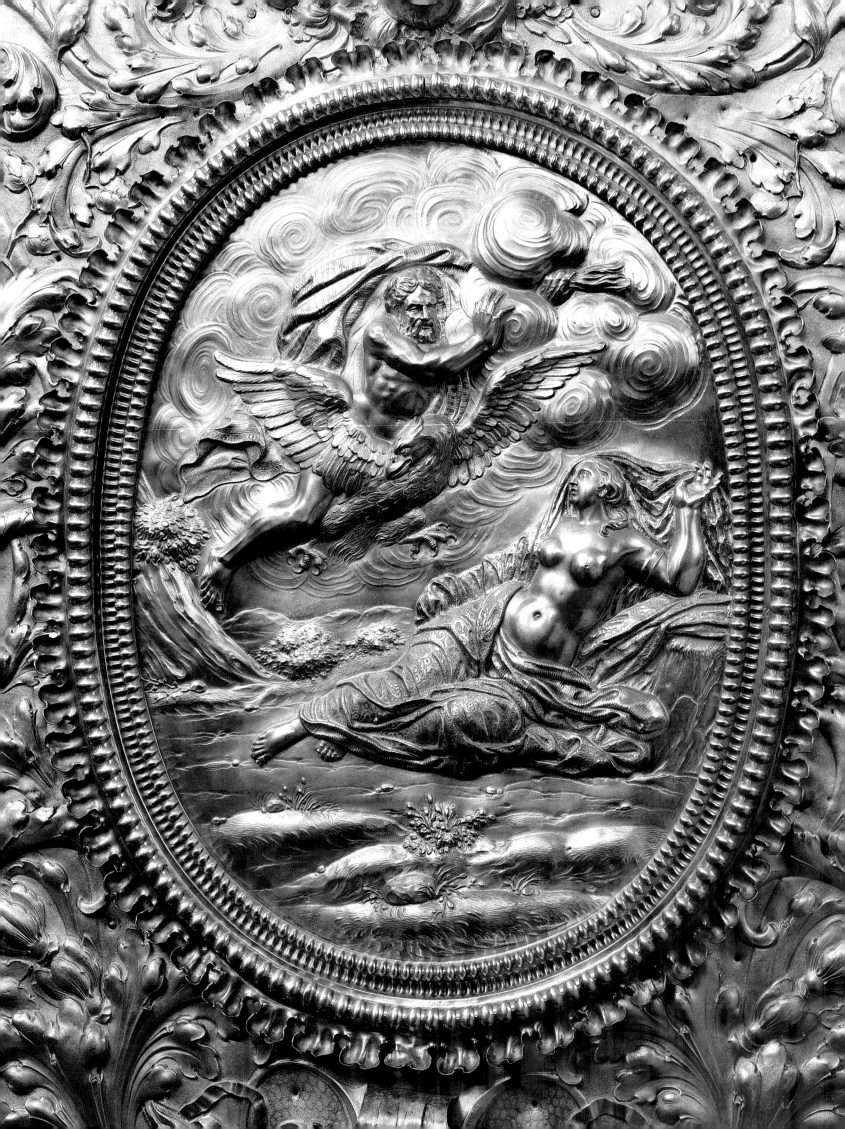

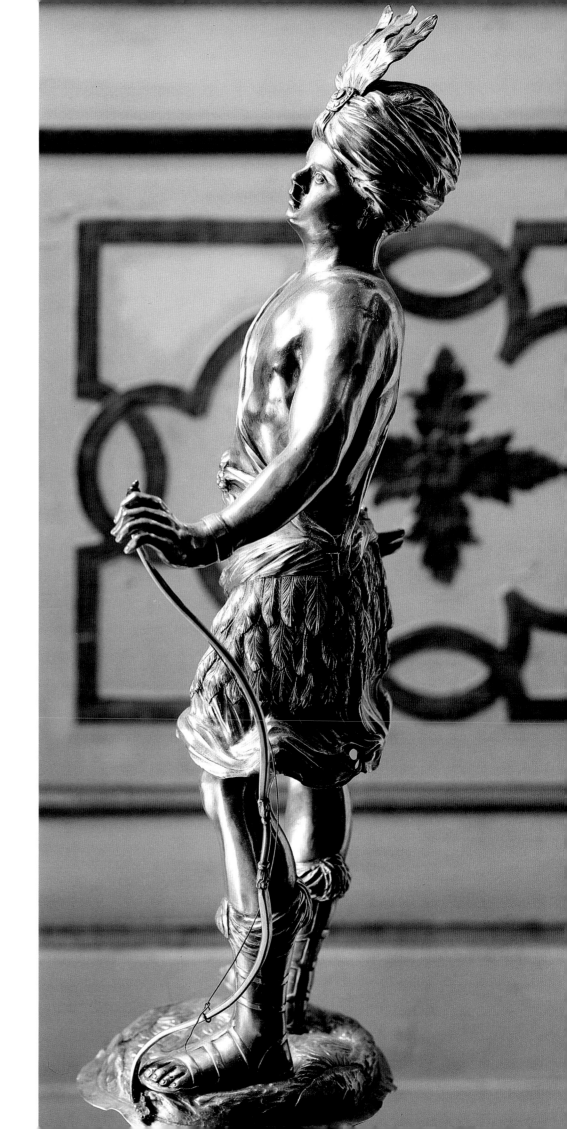

24 Relief on fire-screen:
Jupiter appears to Semele,
detail of plate 22

25 Andiron: Asia,
detail of plate 22

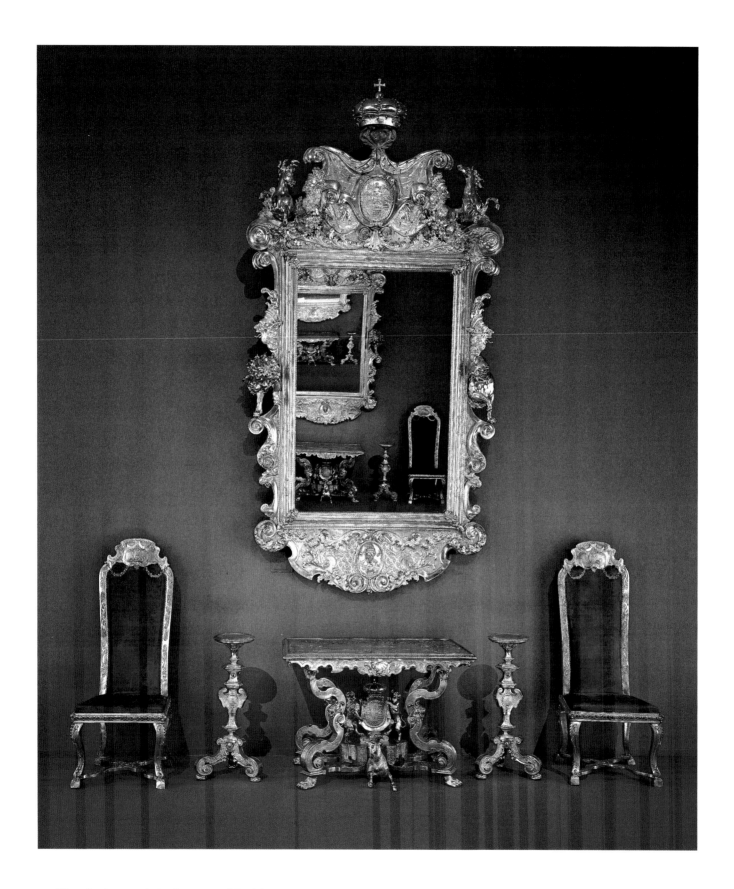

26 Silver furniture made for the House of Guelph, *c.* 1725 - 30

27 Armchair, Philipp Jakob VI Drentwett, *c.* 1729 - 30

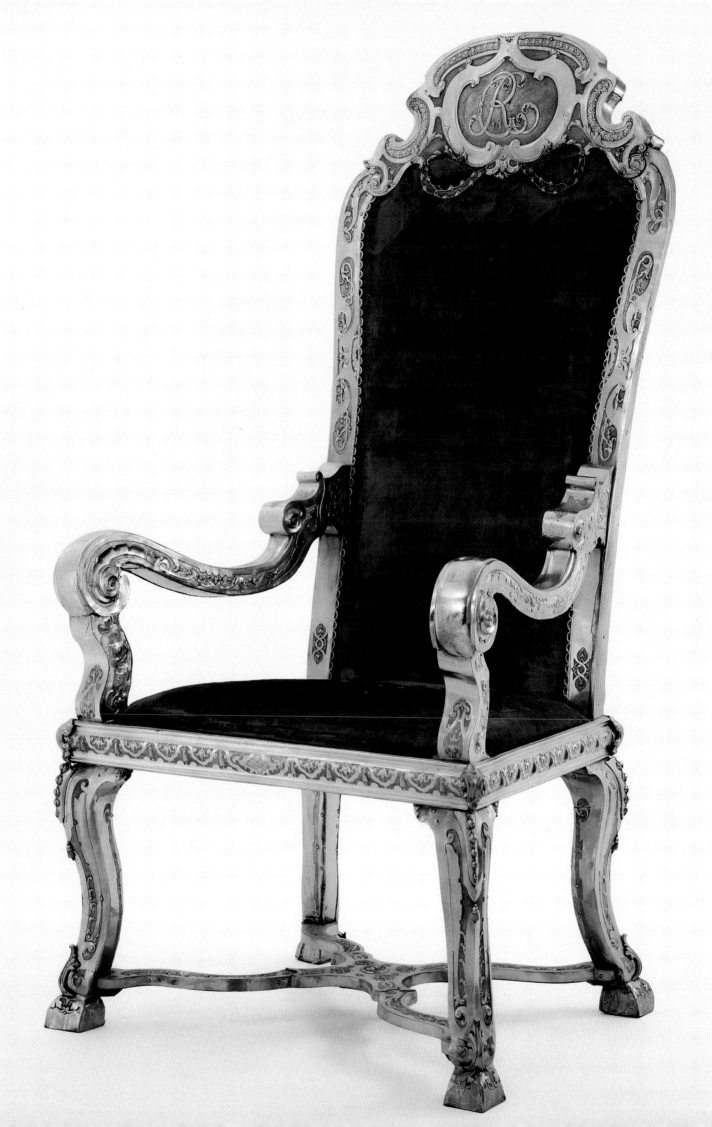

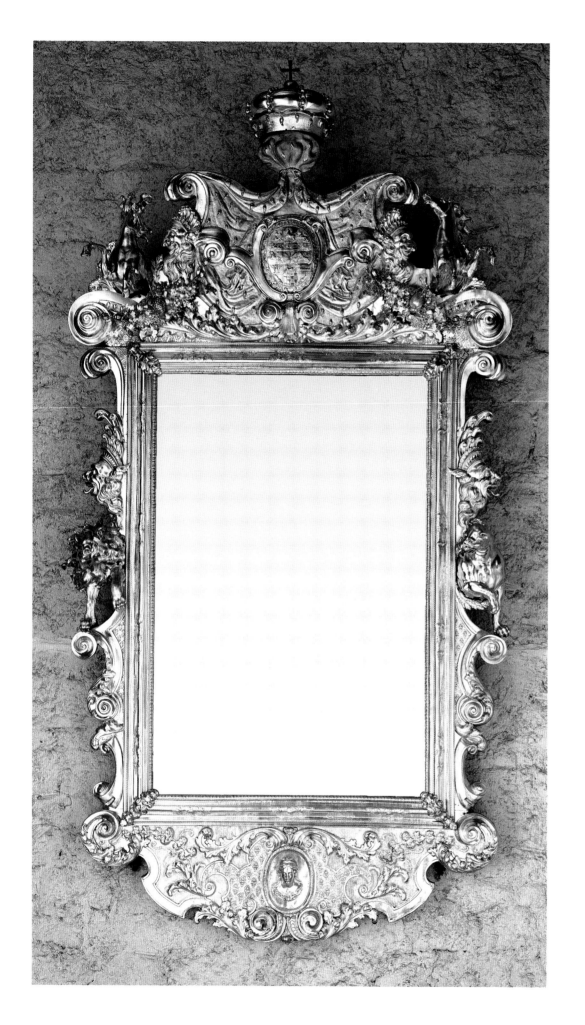

28 Mirror from the ensemble
of silver furniture made
for the House of Guelph,
unknown Augsburg goldsmith,
c. 1725 - 6

29 Crowning
motif of mirror,
detail of plate 28

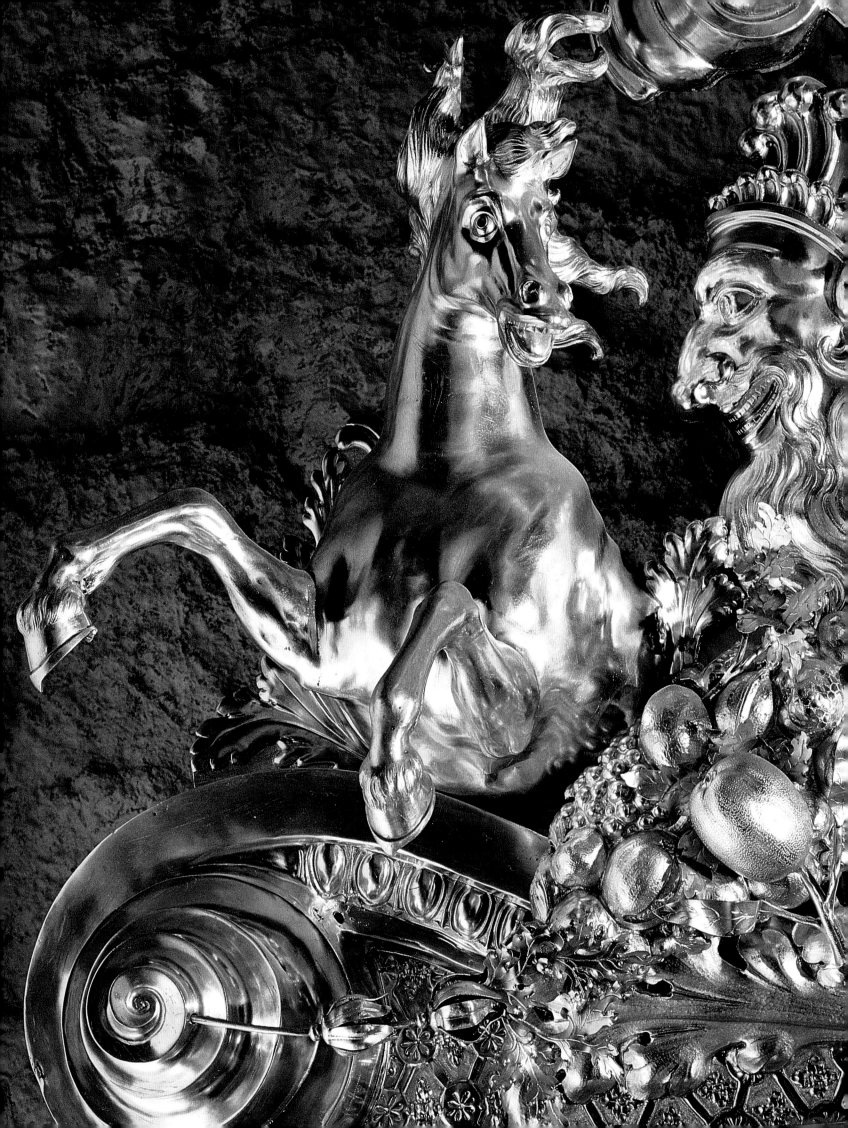

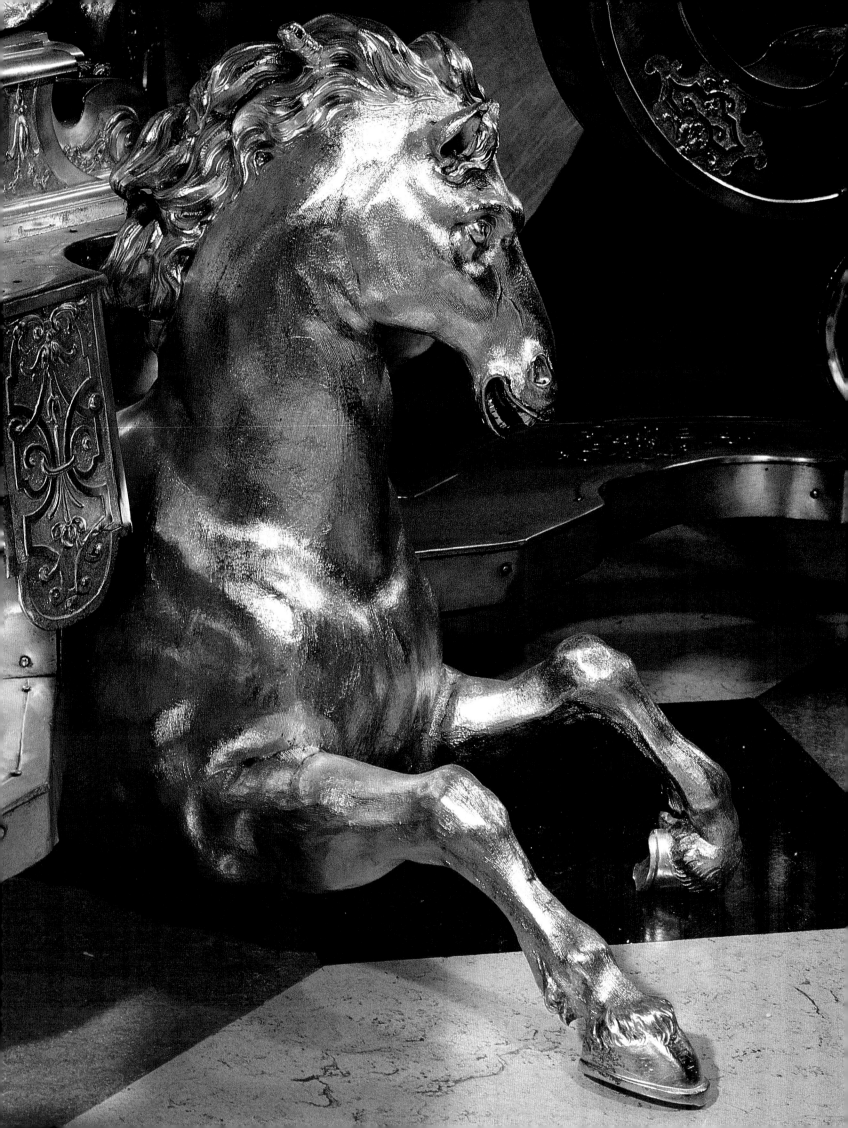

30 Detail of the table,
from the ensemble
of silver furniture made
for the House of Guelph,
Johann Ludwig II Biller,
c. 1725 - 6

31 Detail of mirror frame,
detail of plate 28

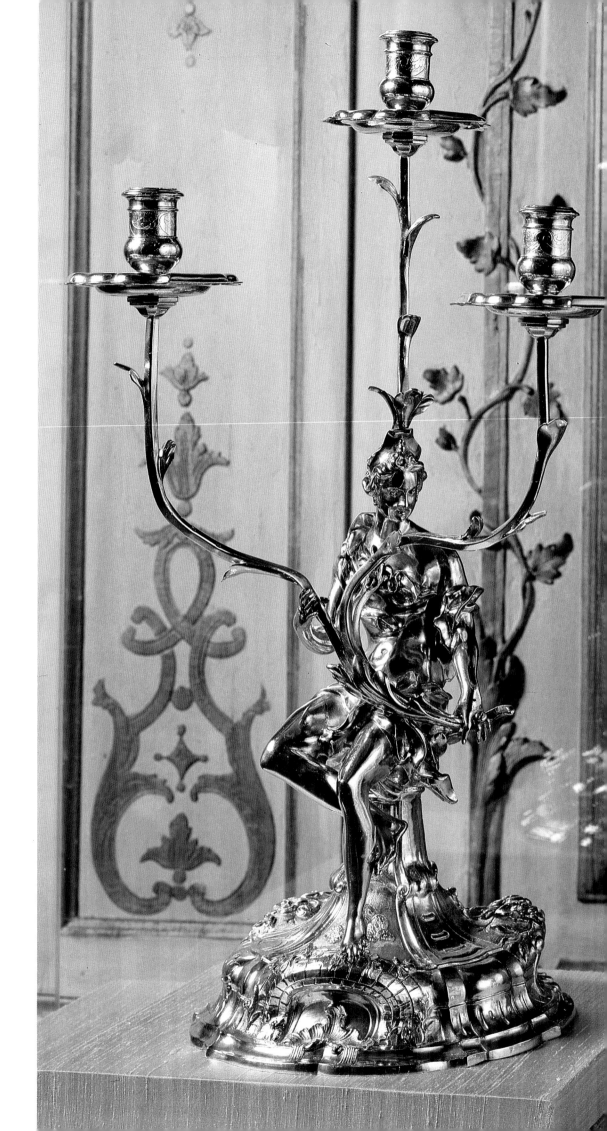

32 - 33 Two candelabra,
Johann Ludwig II Biller,
c. 1725

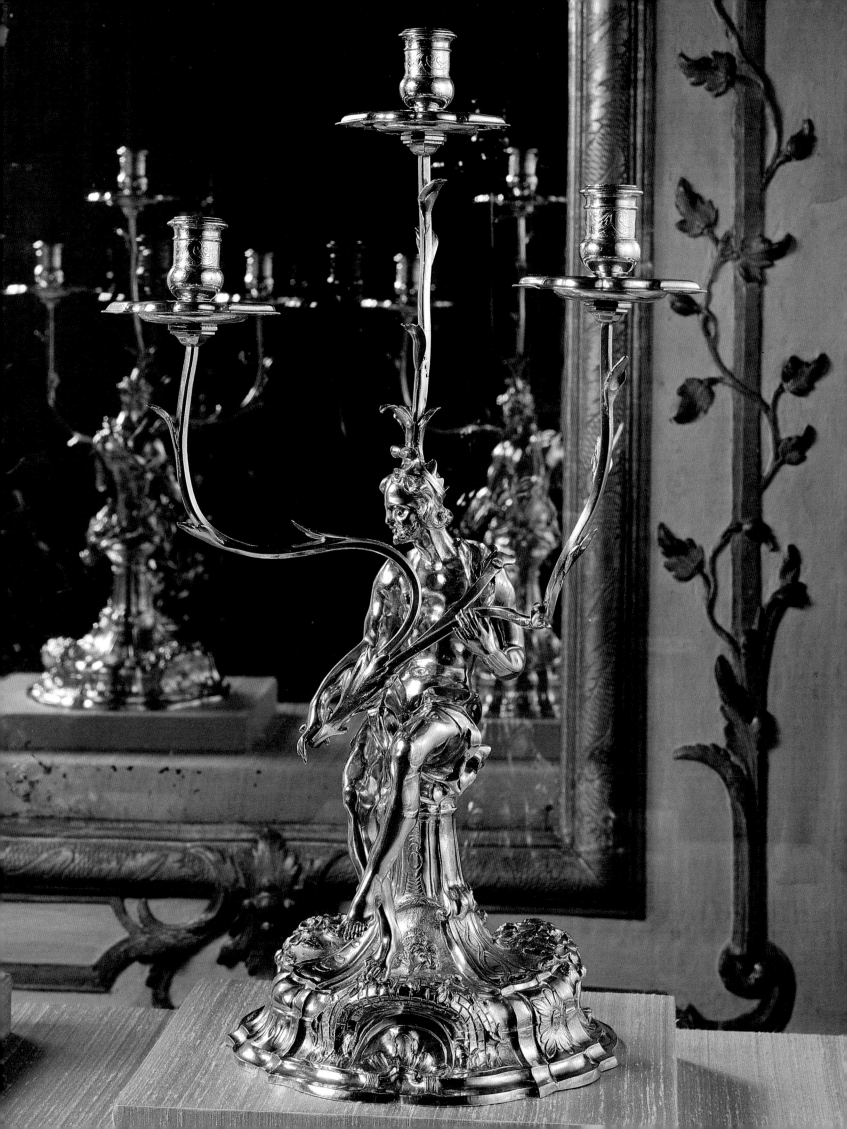

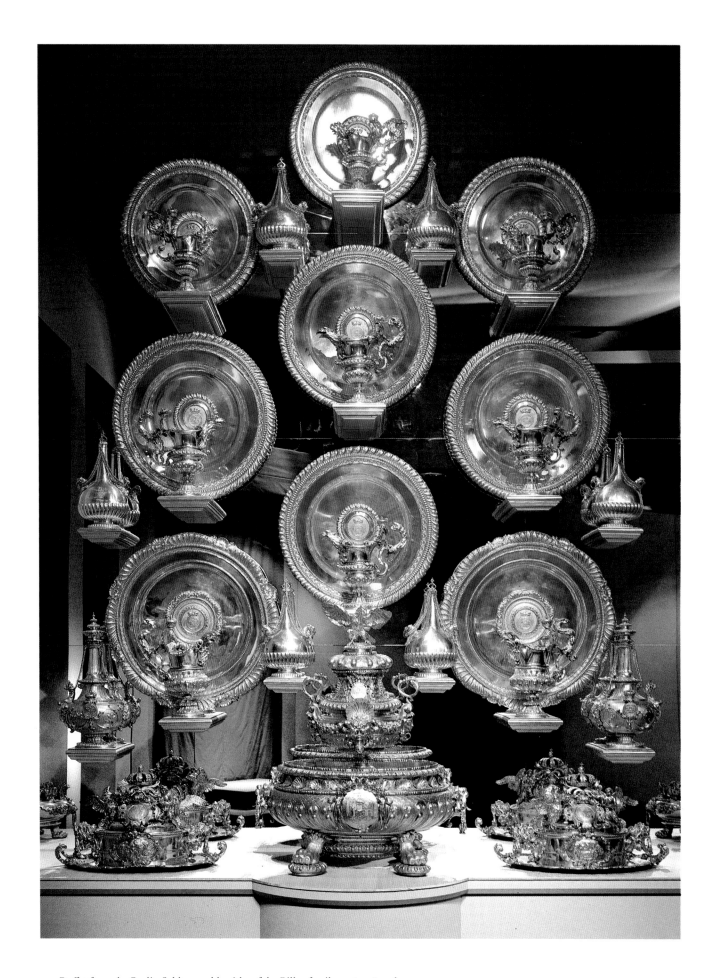

34 Buffet from the Berlin Schloss, goldsmiths of the Biller family, *c. 1695 - 8* and *c. 1731 - 3*

35 Fountain and ewer and basin set between two pilgrim bottles, Johann Ludwig I Biller, *c. 1695 - 8*, and Christian Winter, *c. 1698*

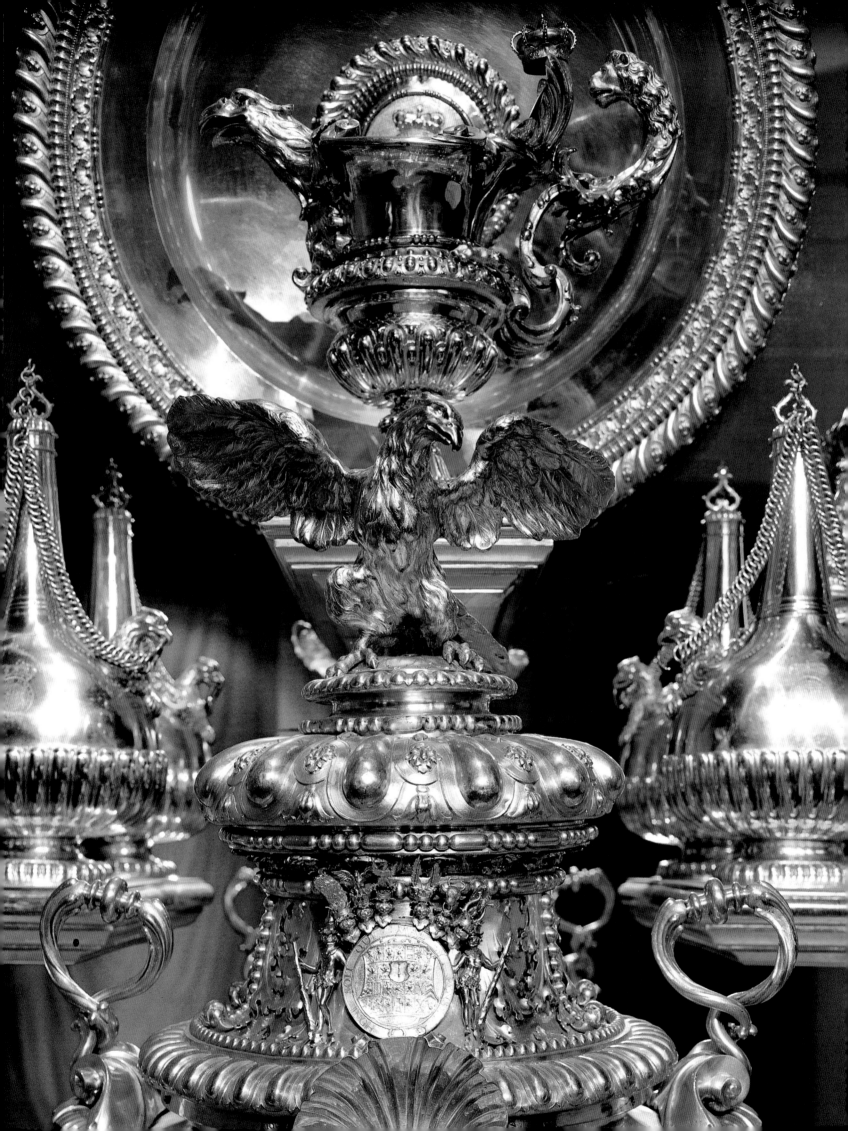

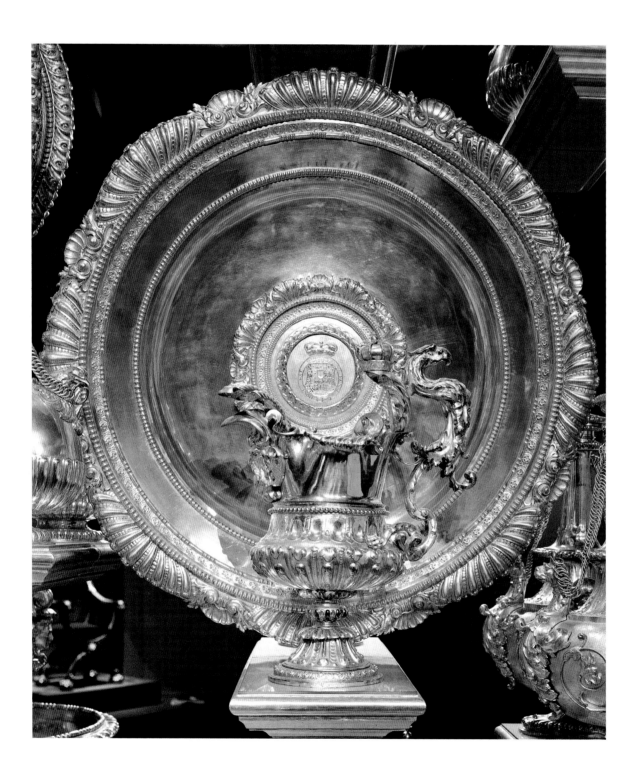

36 Ewer and basin set, Albrecht and Lorenz II Biller, *c.* 1695 - 8

37 Lower part of the Berlin buffet

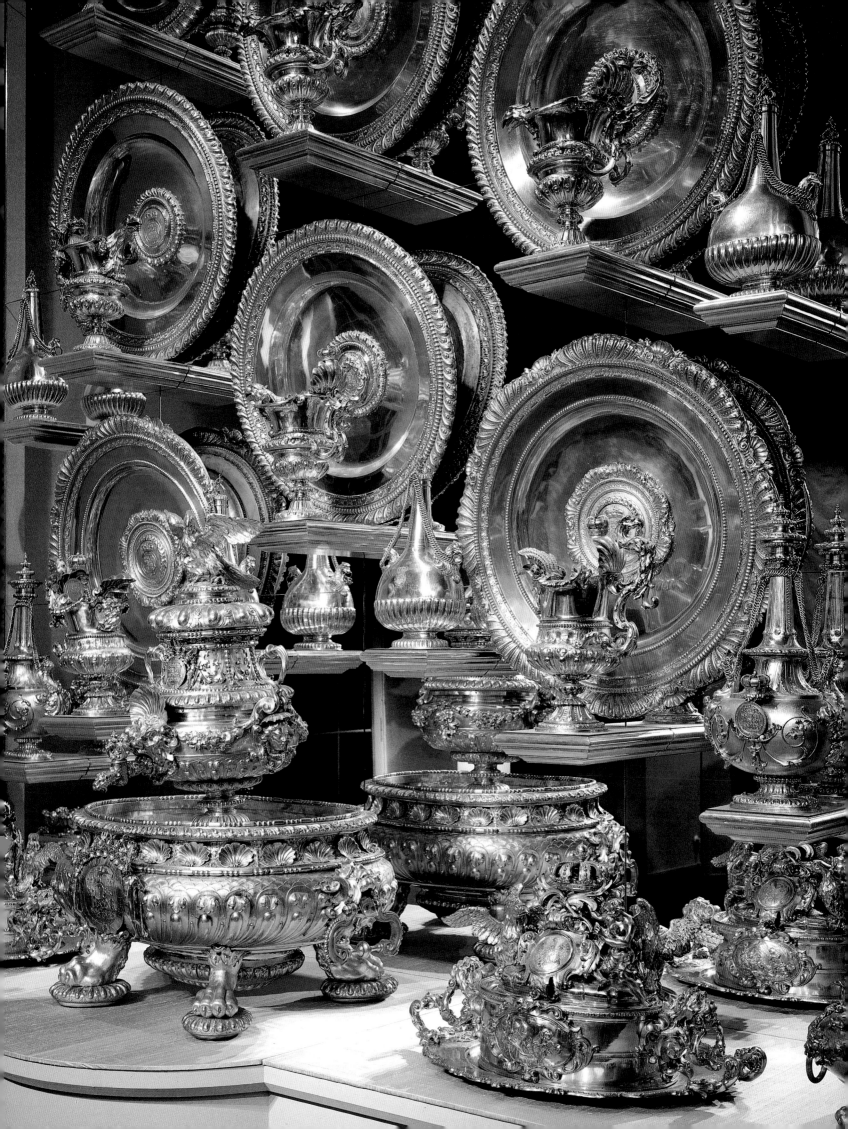

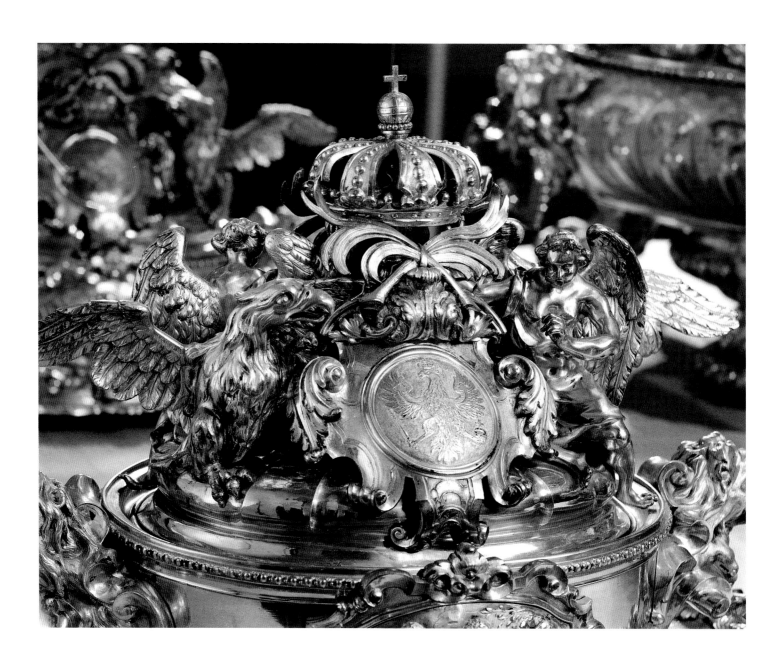

38 Pie dish, Johann Ludwig II Biller, *c.* 1731 - 3

39 Top of the fountain from the Berlin buffet, Johann Ludwig I Biller, *c.* 1695 - 8

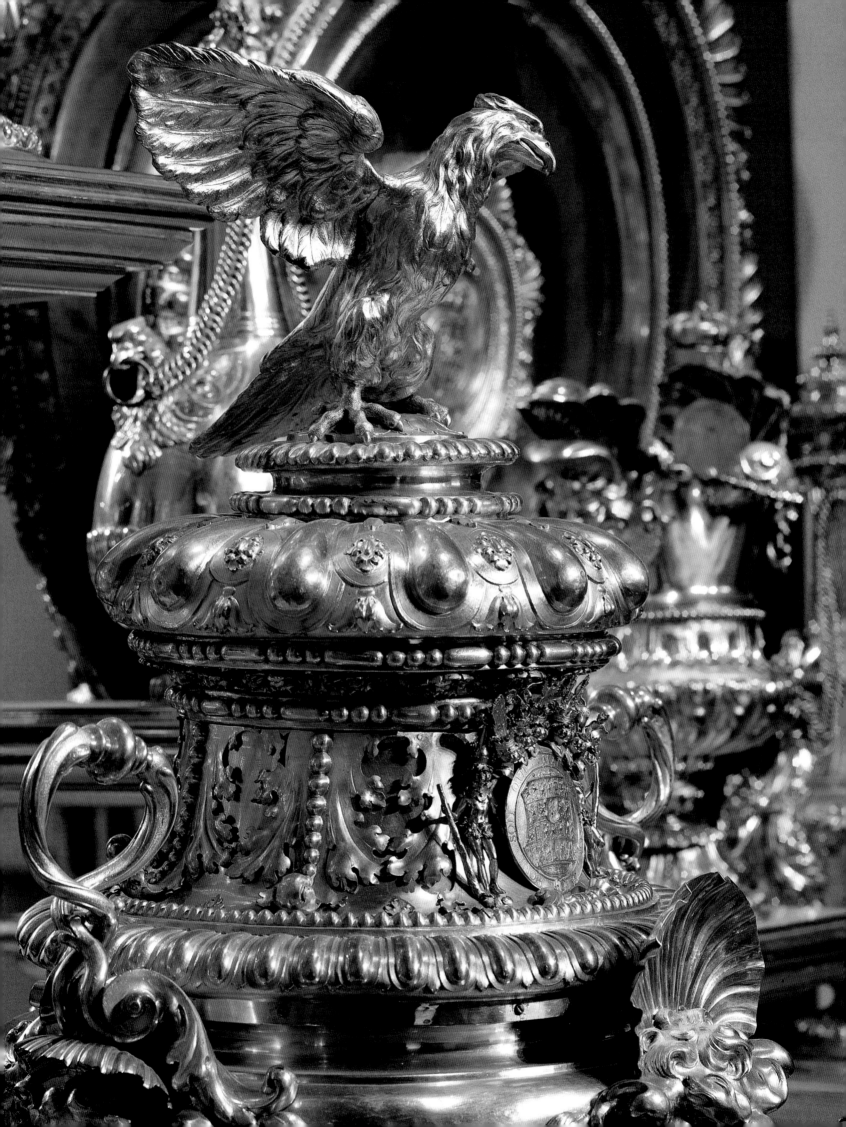

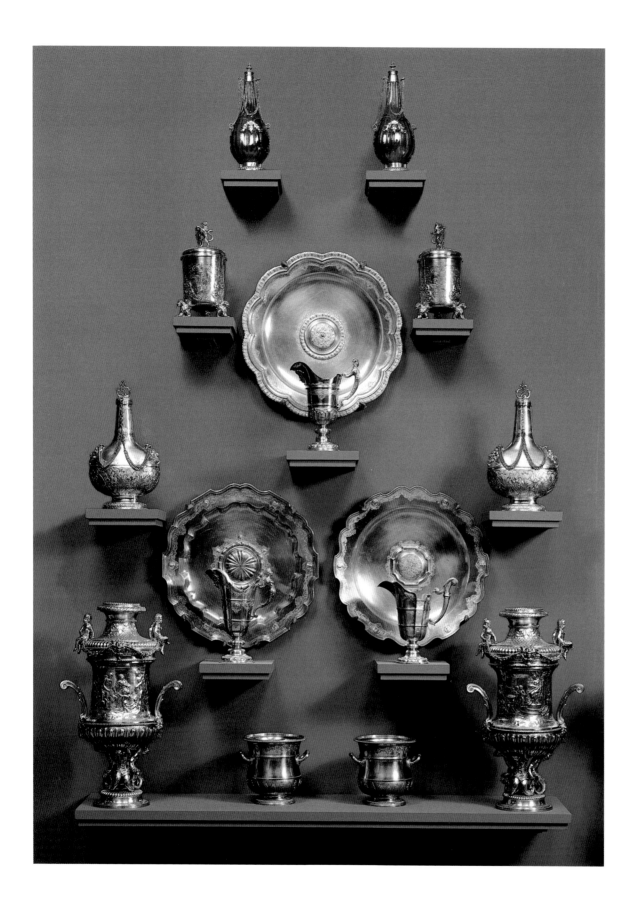

40 Central axis of the wall modelled on the Dresden buffet room, between 1689 and 1718

41 Lateral axis of the wall modelled on the Dresden buffet room, between 1690 and 1710

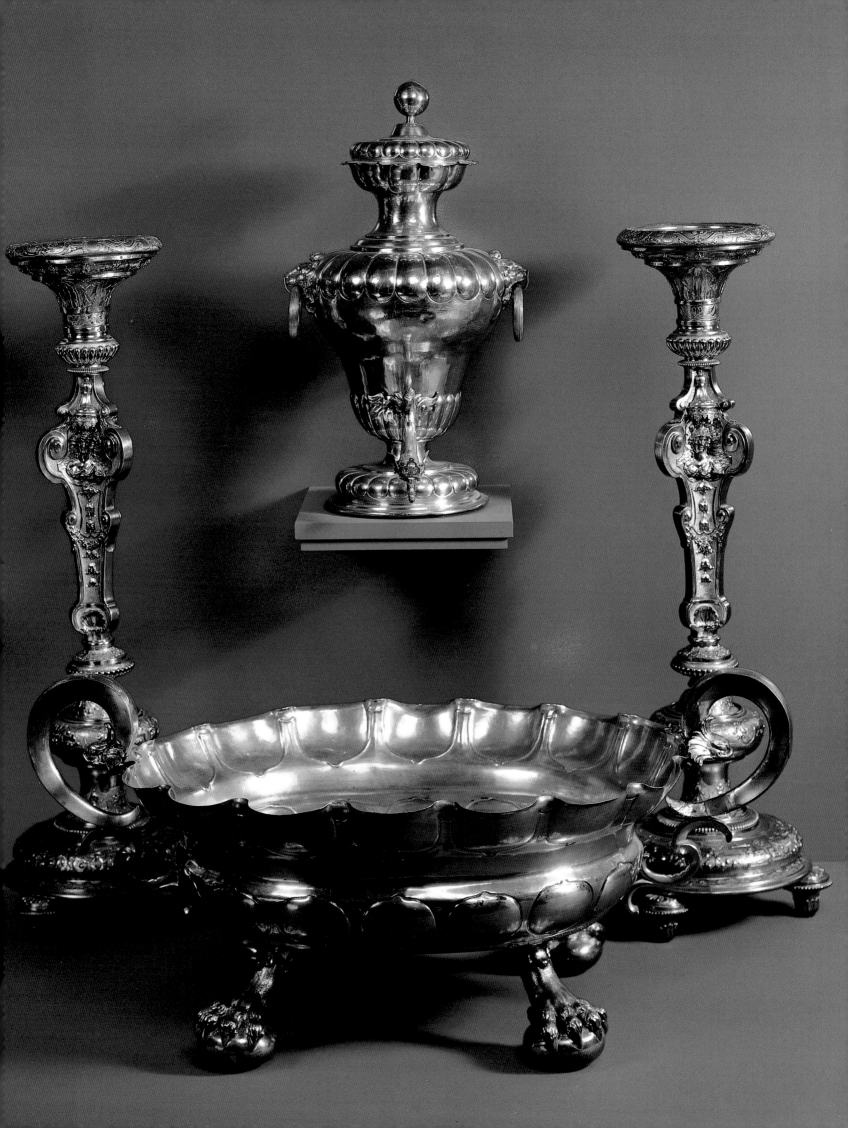

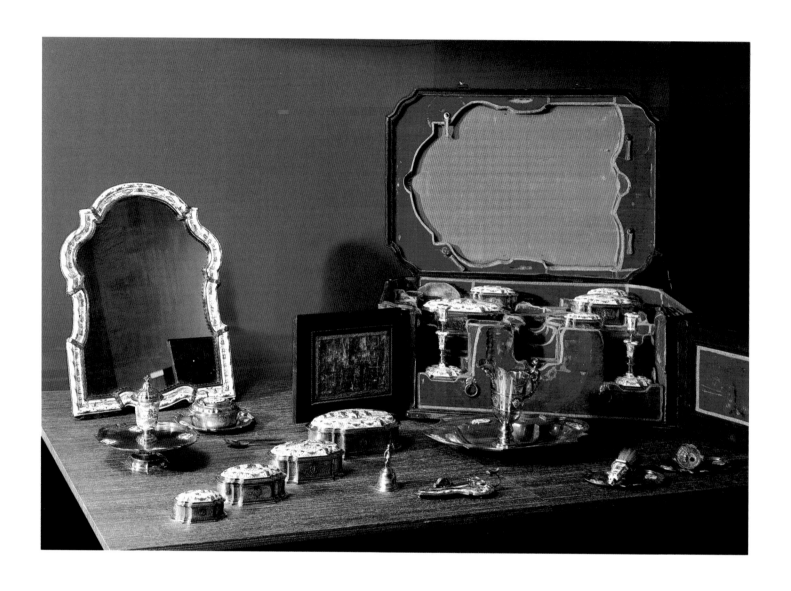

42 Dressing-table set, Johann Erhard II Heuglin and others, *c.* 1725

43 Items from the dressing-table set, Johann Erhard II Heuglin and others, *c.* 1725

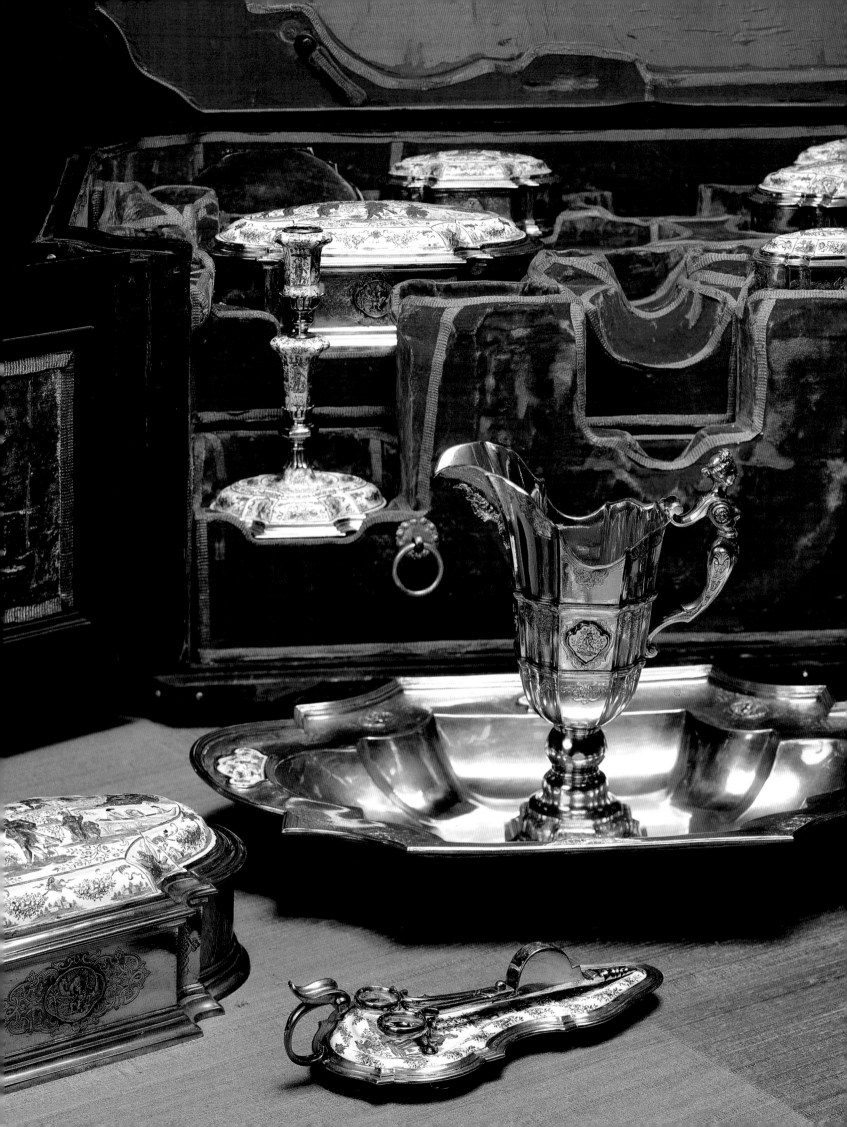

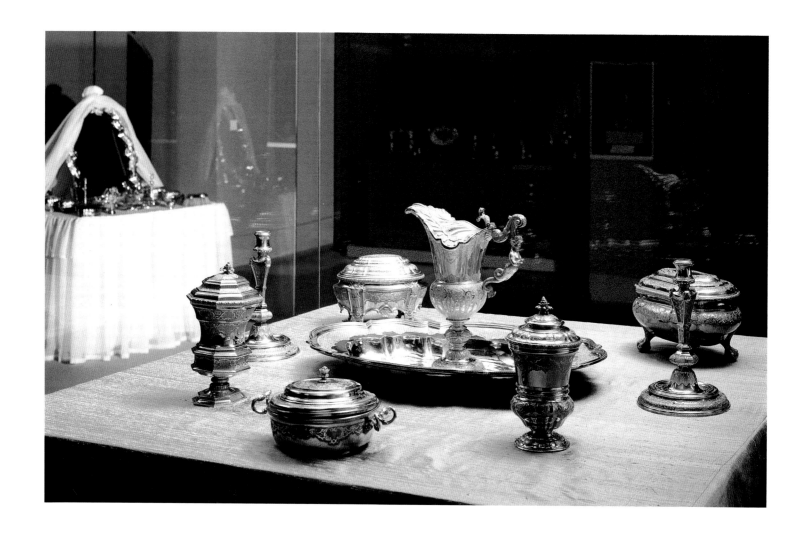

44 The gold dressing-table set made for the Tsarina Anna Ivanovna,
Johann Ludwig II Biller and Johann Jakob Wald, c. 1736 - 40

45 Items from the gold dressing-table set made for the Tsarina Anna Ivanovna,
Johann Ludwig II Biller, c. 1736 - 40

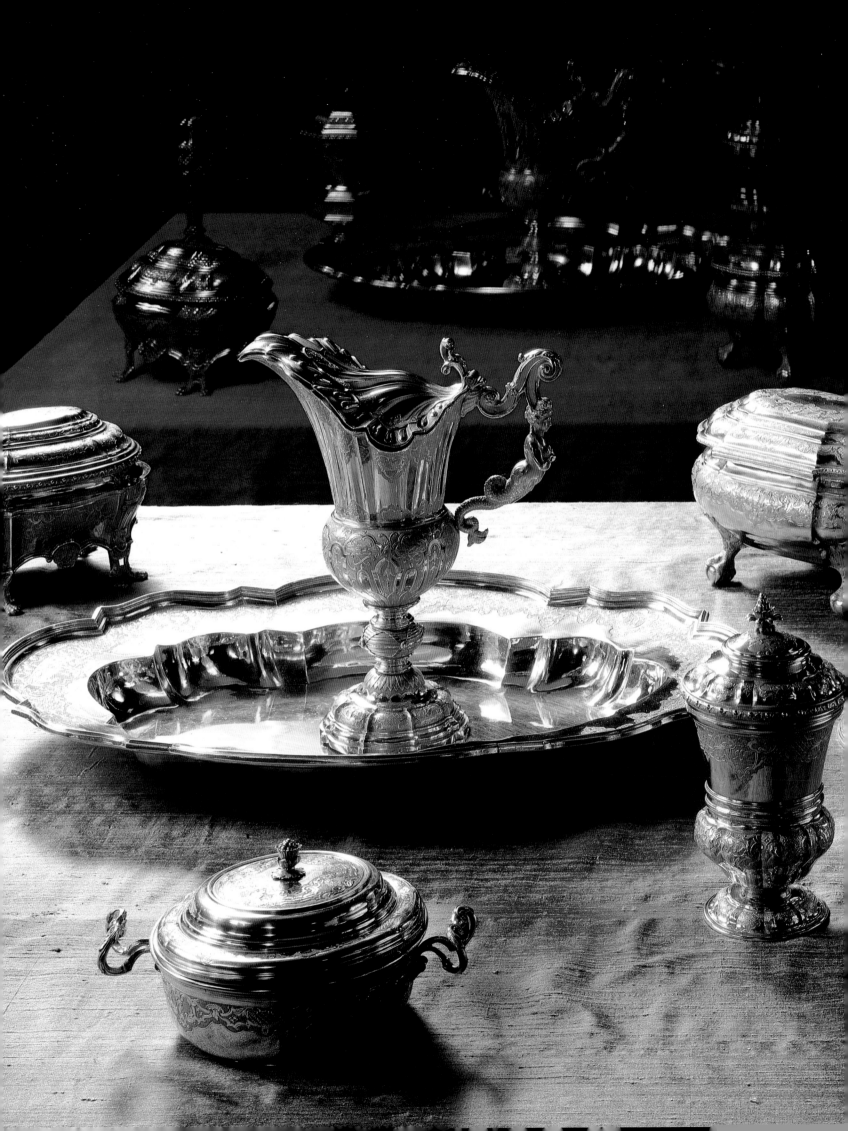

46 Box from the gold dressing-table set made for the Tsarina Anna Ivanovna,
Johann Ludwig II Biller, *c.* 1736 - 40

47 Ewer and basin from the gold dressing-table set made for the Tsarina Anna Ivanovna,
Johann Ludwig II Biller, *c.* 1736 - 40

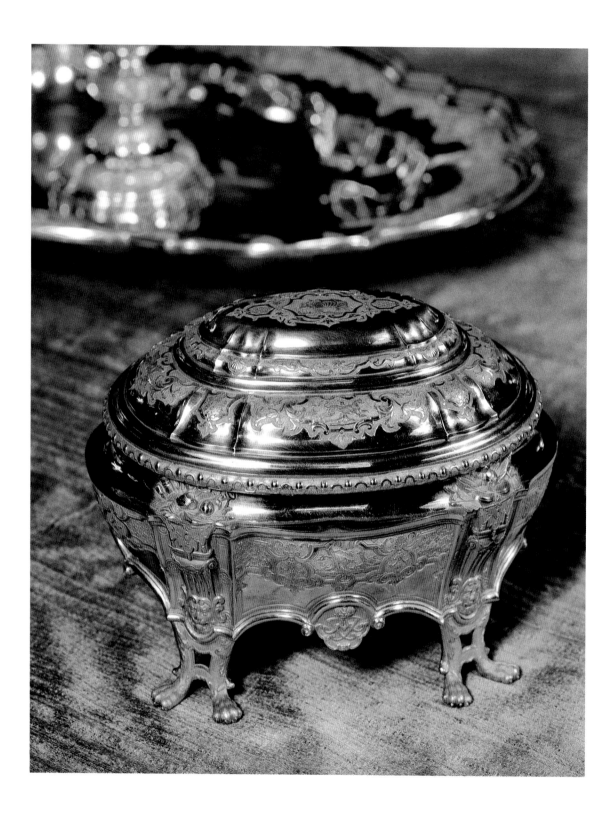

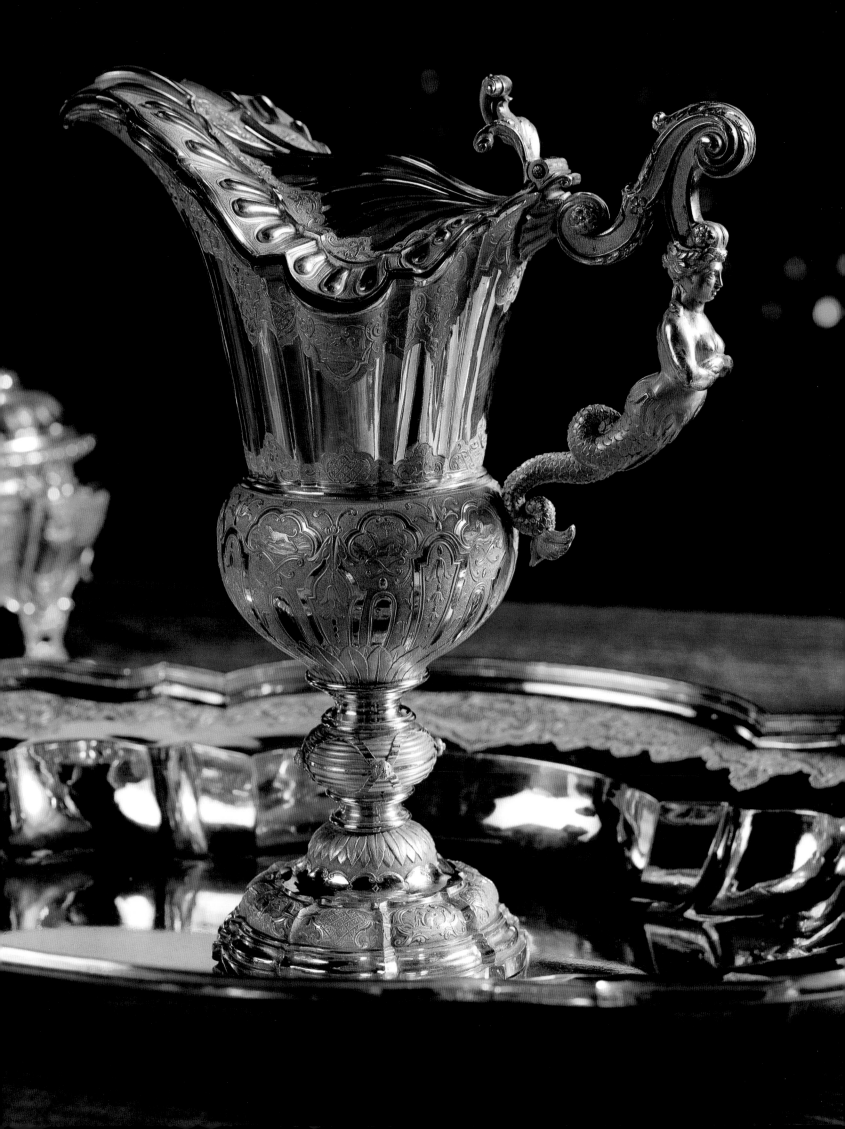

48 Dressing-table set, probably Franz Christoph Saler and others, *c.* 1741-3

49 Items from the dressing-table set, probably Franz Christoph Saler and others, *c.* 1741-3

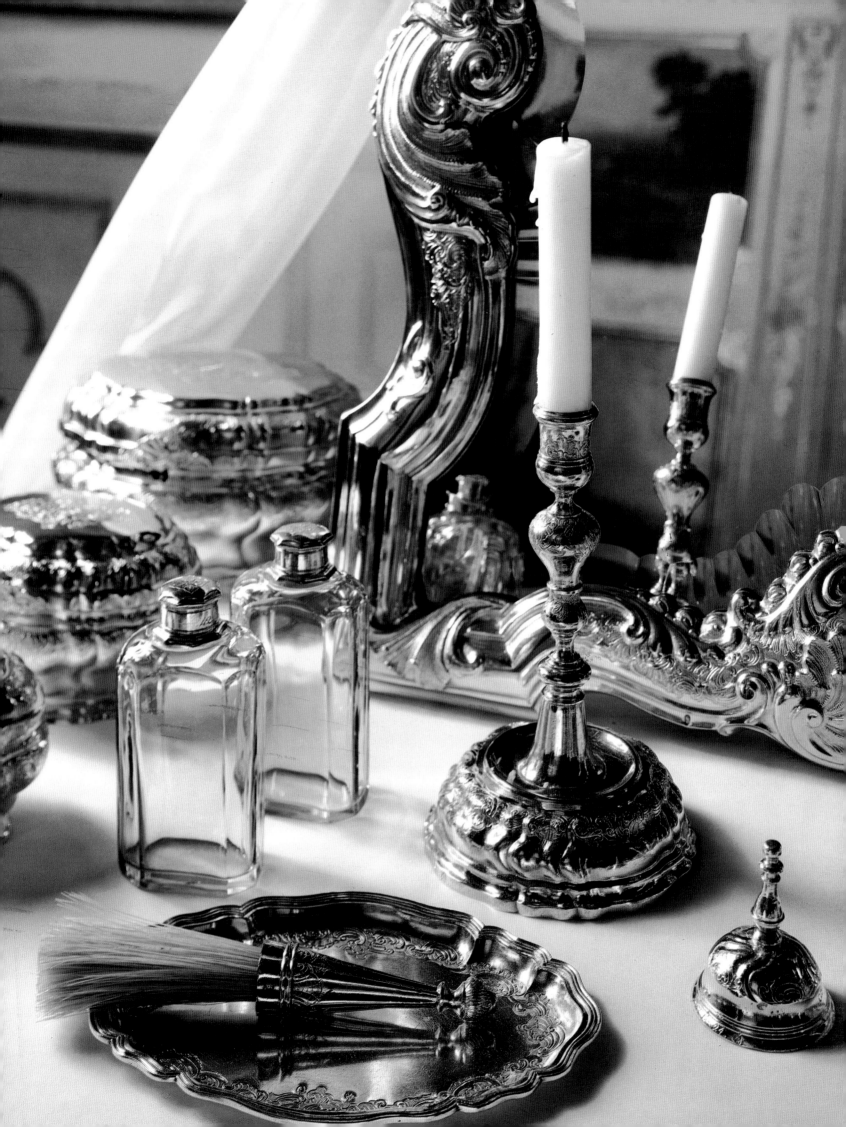

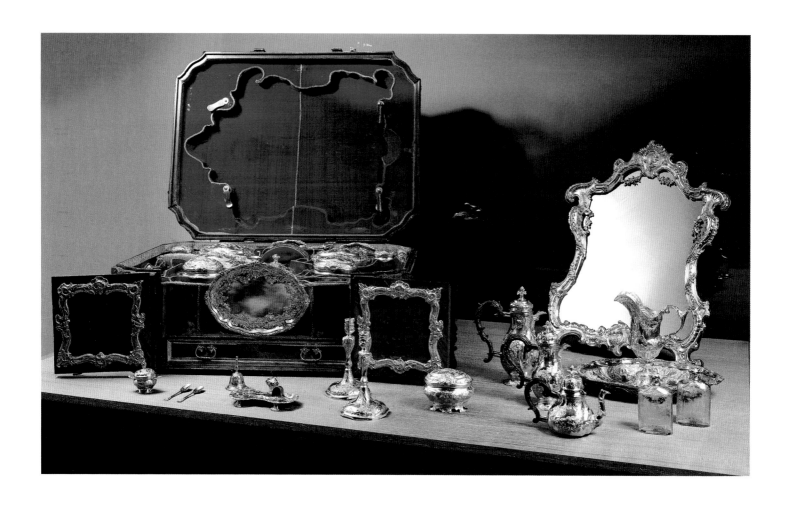

50 Dressing-table set, Gottlieb Satzger and others, *c.* 1755 - 7

51 Items from the dressing-table set, Gottlieb Satzger and others, *c.* 1755 - 7

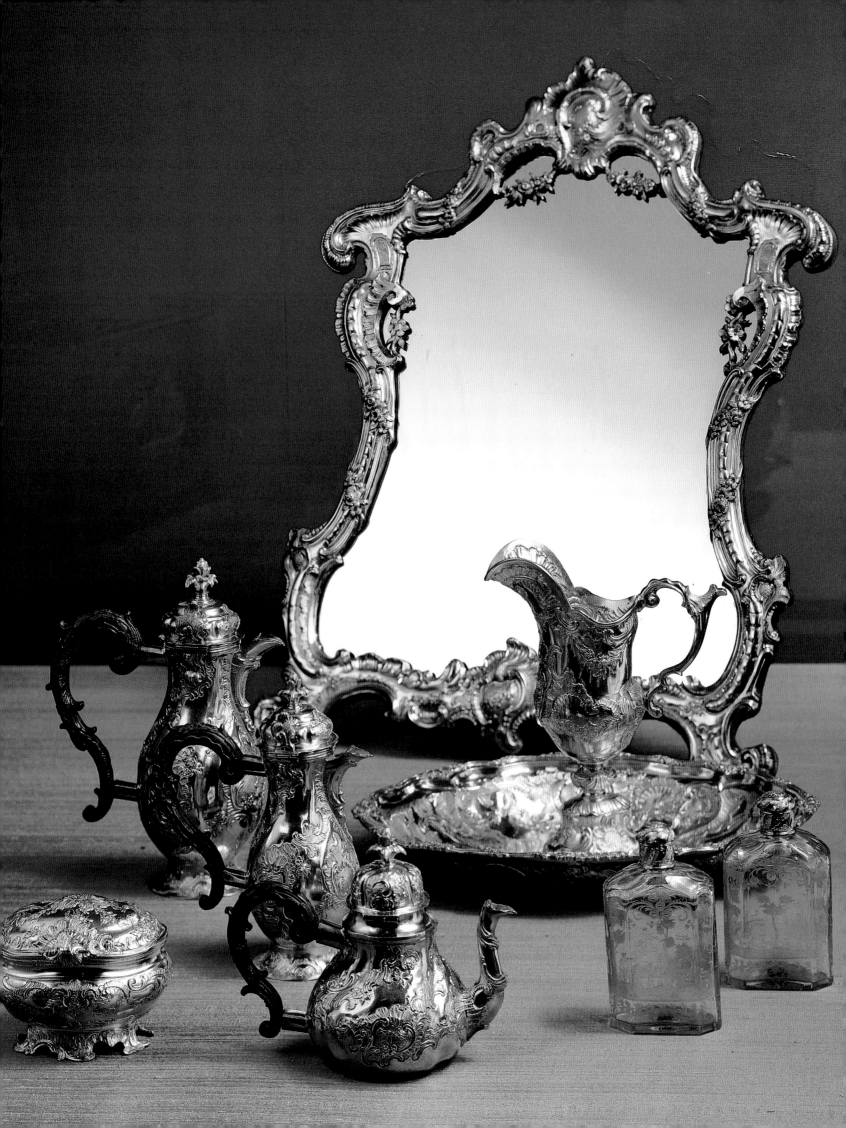

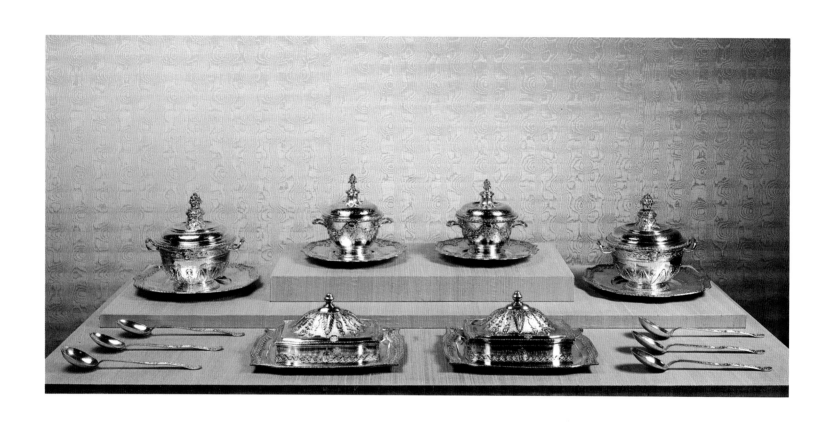

52 Tureens and covered dishes from a dinner service,
Johann Ludwig II Biller and others, *c.* 1725

53 Detail of one of the covered dishes,
Johann Ludwig II Biller, *c.* 1725

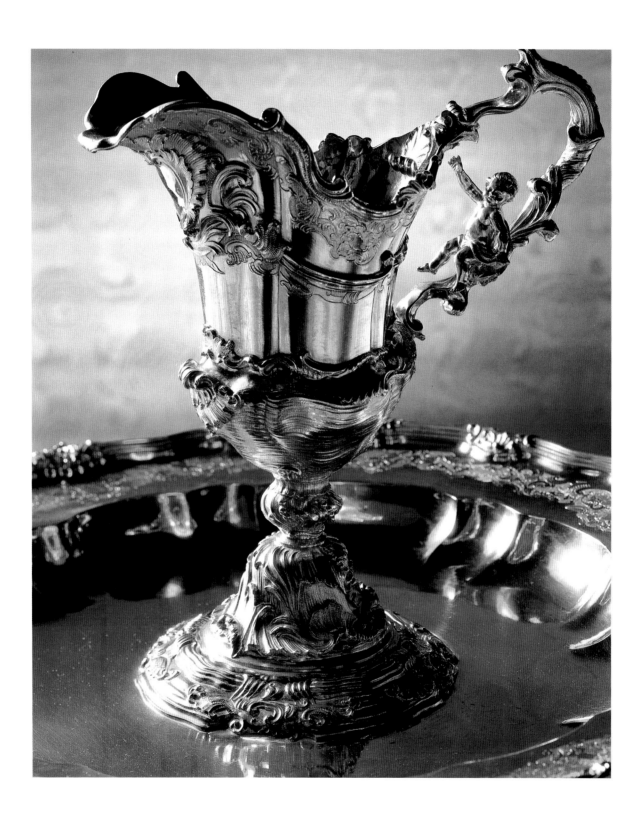

54 Ewer and basin set, Johann Christoph Stenglin, *c.* 1739 - 41

55 Detail of the ewer and basin set, Johann Christoph Stenglin, *c.* 1739 - 41

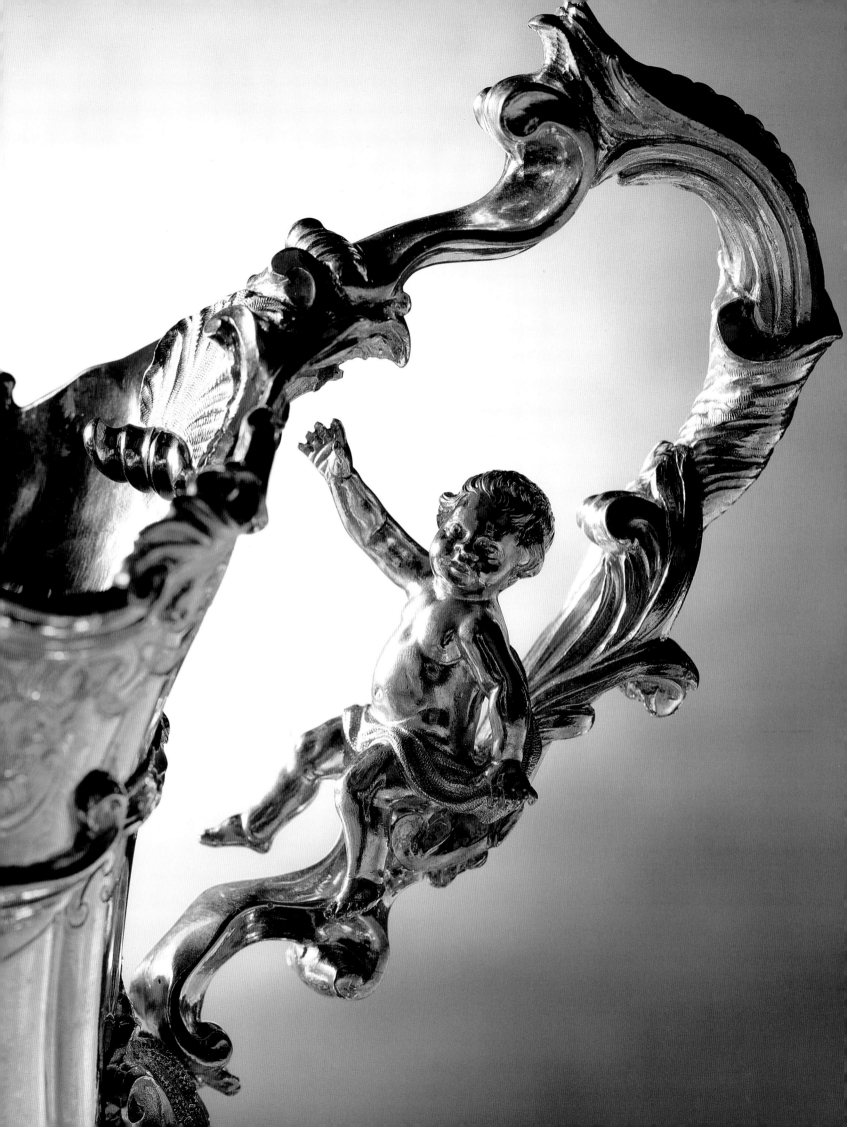

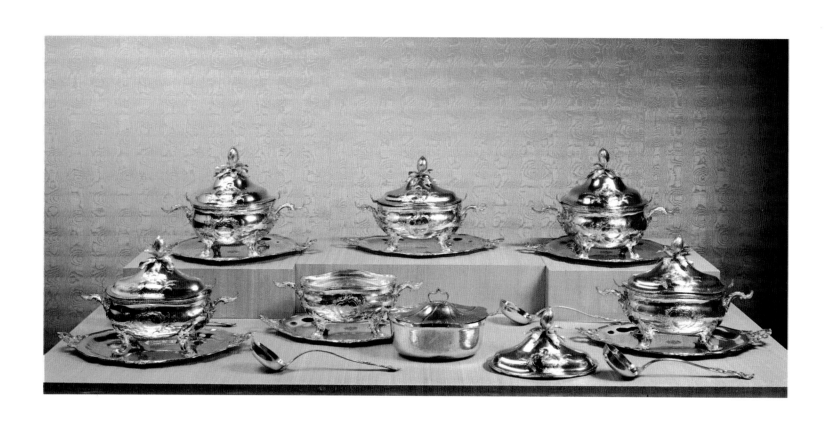

56 Tureens from a dinner service,
Johann Wilhelm Dammann and Emanuel Gottlieb Oernster, *c.* 1759 - 61

57 Detail of a tureen, Johann Wilhelm Dammann, *c.* 1759 - 61

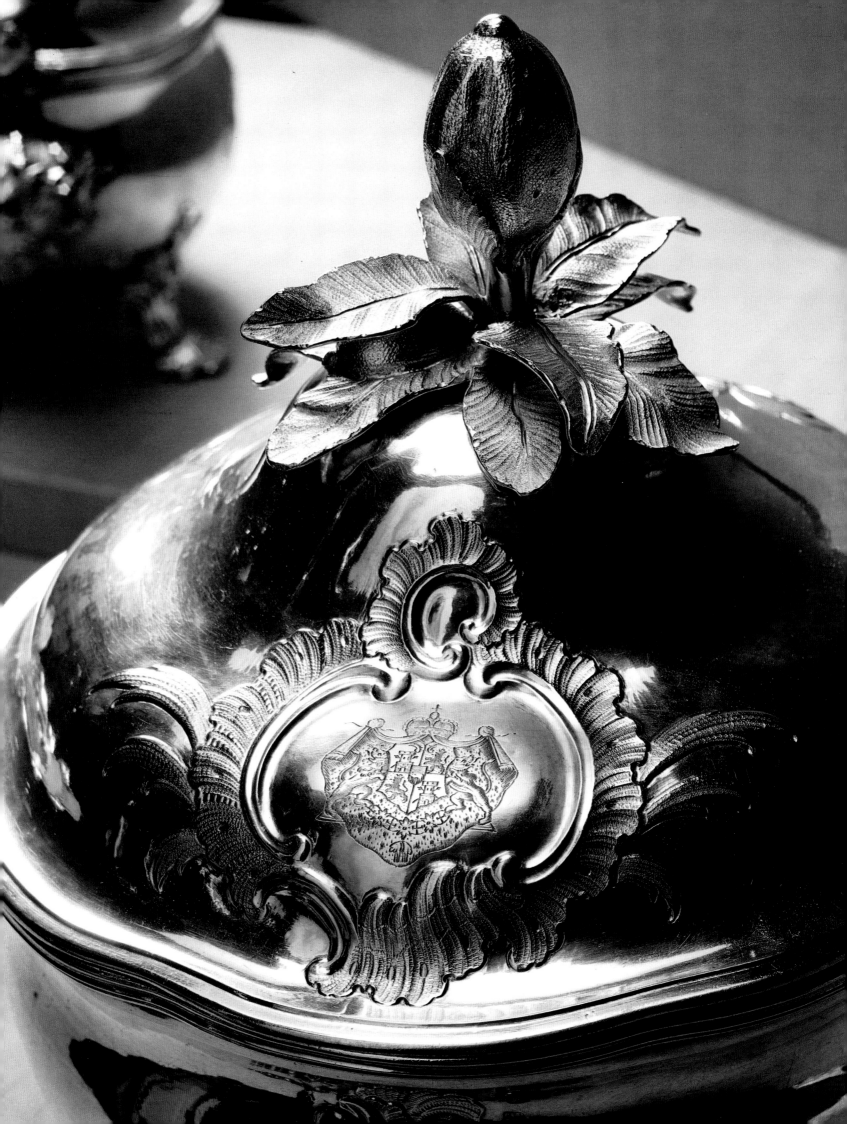

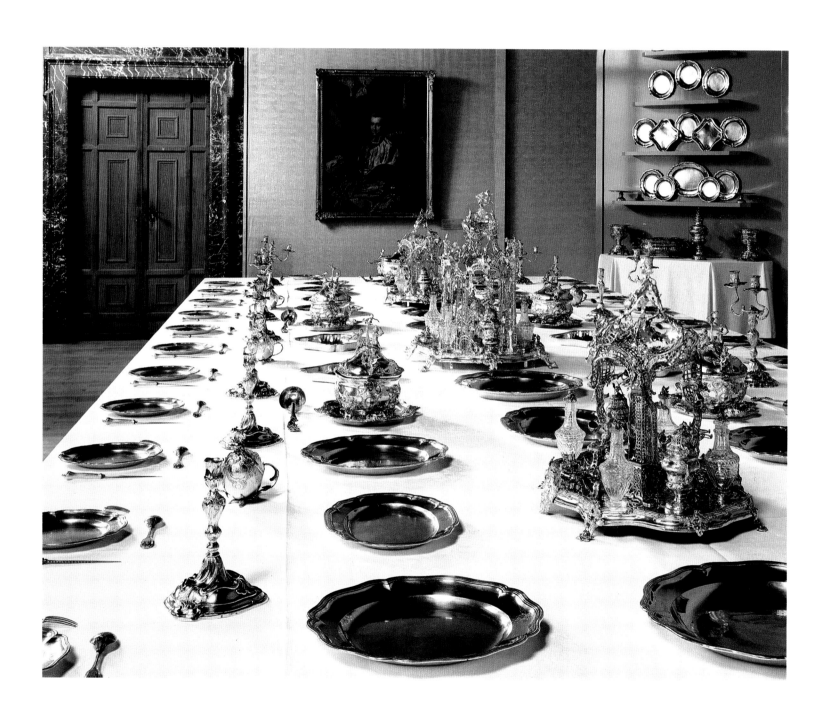

58 Dinner service made for Friedrich Wilhelm von Westphalen,
Prince Bishop of Hildesheim, *c.* 1759 - 65

59 Large centrepiece from the Hildesheim dinner service,
Bernhard Heinrich Weyhe, *c.* 1761 - 3

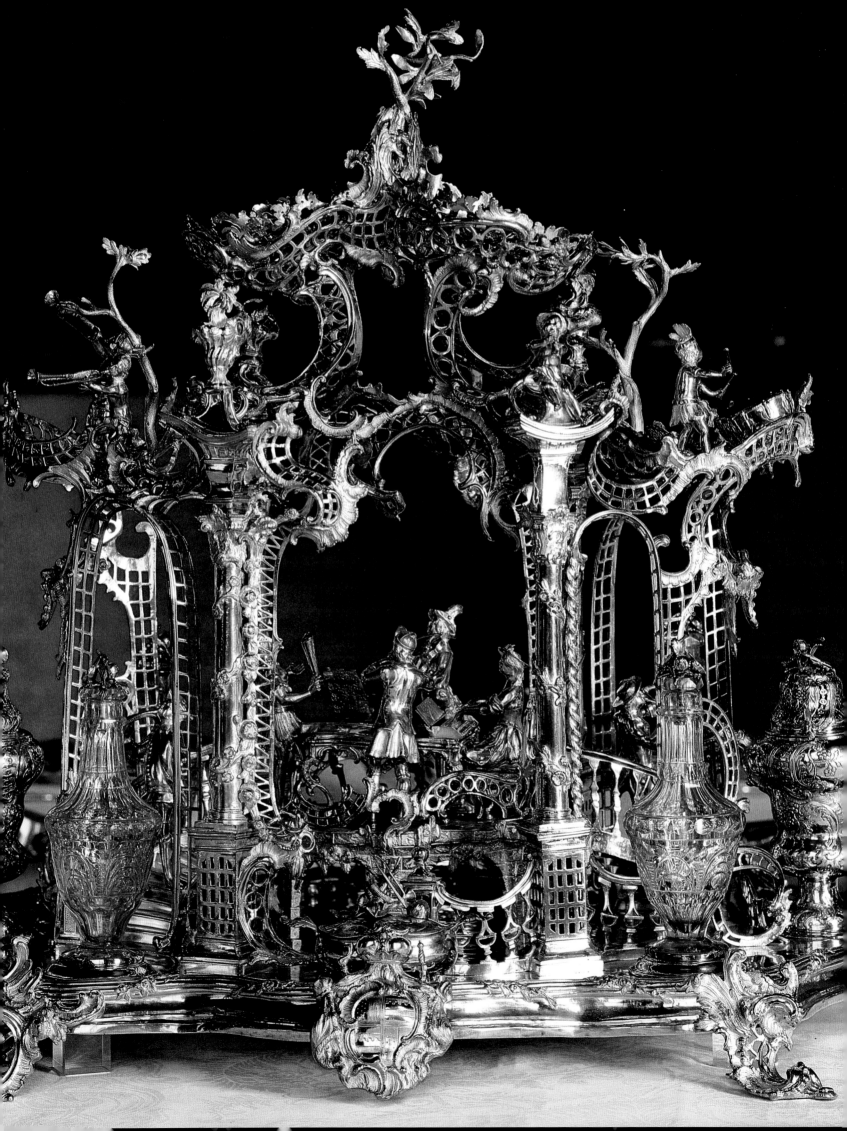

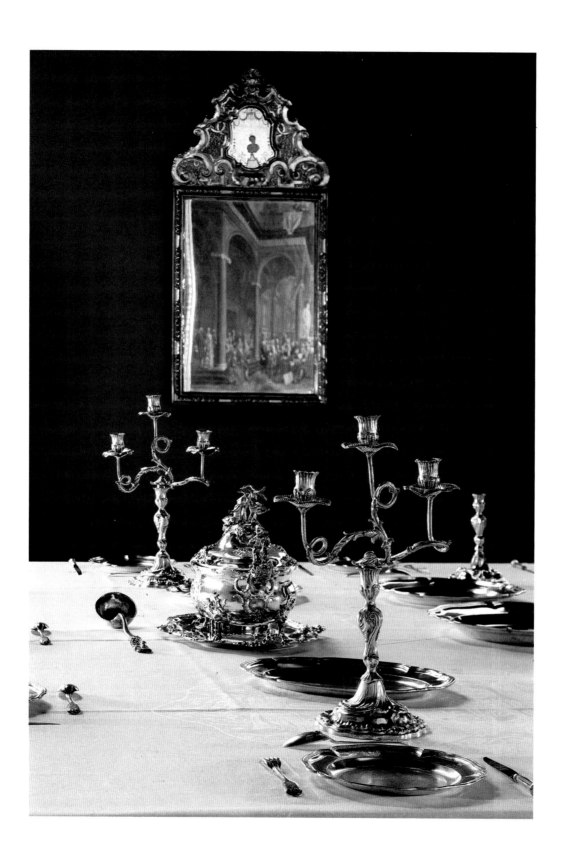

60 Detail from the Hildesheim dinner service

61 Small tureens from the Hildesheim dinner service, Bernhard Heinrich Weyhe and Johann Joseph Meckel, *c.* 1759 - 63

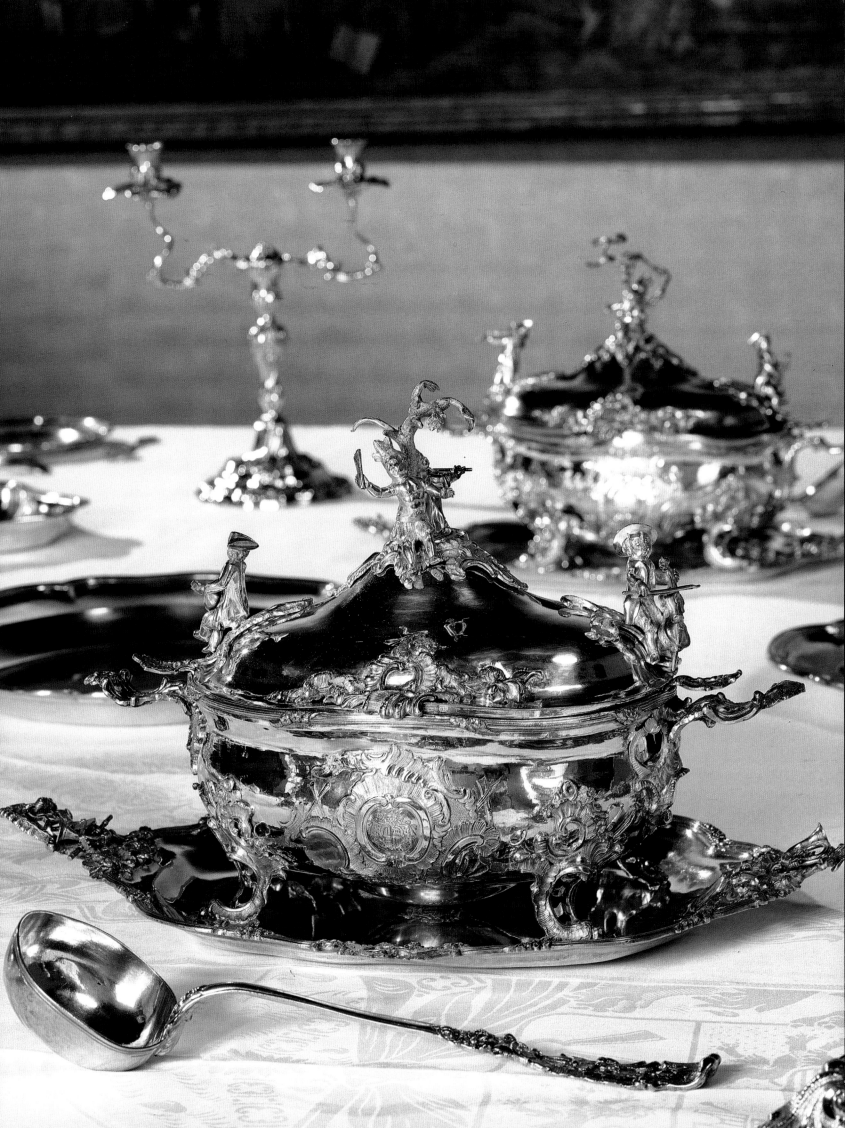

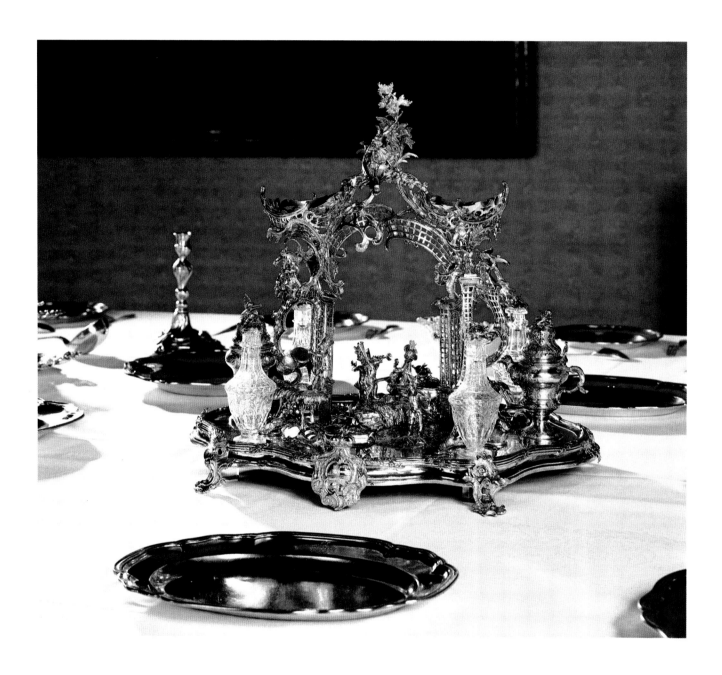

62 Small centrepiece from the Hildesheim dinner service,
Bernhard Heinrich Weyhe, c. 1759 - 63

63 Detail of the large centrepiece from the Hildesheim dinner service,
detail of plate 59

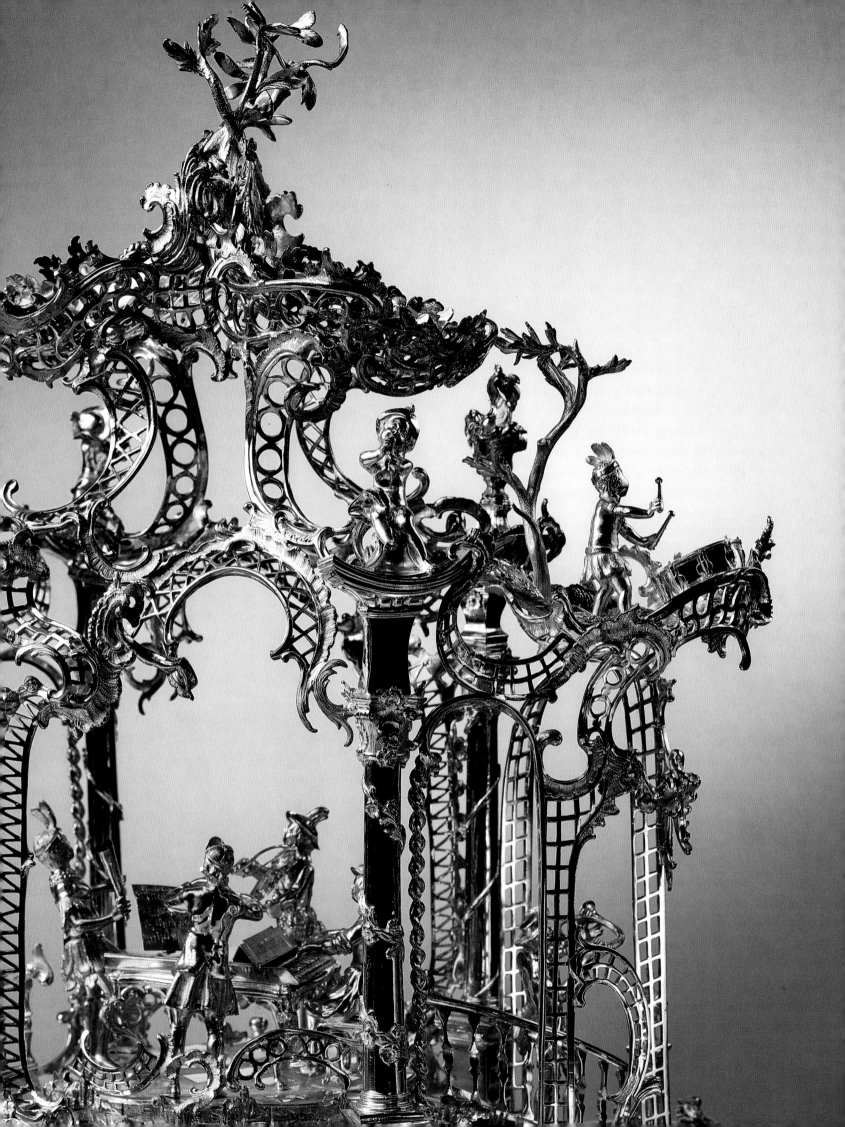

APPENDIX

64 Gaming table
with four candlesticks,
Johann Philipp Heckenauer,
c. 1763-5

List of Plates

In the case of several identical objects, the inventory numbers and measurements of all those belonging to the same series are given, even when only *one* object of the group is illustrated.

Frontispiece
Pie dish with cover
(from the Berlin buffet)

Johann Ludwig II Biller, Augsburg, c. 1731-3

Silver gilt; dish: height 56 cm, width 75 cm;
stand: width 95 cm, depth 67 cm
Berlin, Staatliche Museen zu Berlin, Preussischer Kulturbesitz, Kunstgewerbemuseum (Schloss Köpenick), inv. nos. s 514-517
See also plates 34, 38
Bibliog.: exhibition catalogue *Silber und Gold: Augsburger Goldschmiedekunst für die Höfe Europas* (Bayerisches Nationalmuseum, Munich, 1994), p. 329-44, cat. nos. 78-80, fig. on p. 342 (Christiane Keisch)

1 ## Drinking vessel in the form
of a strutting stag

Albrecht von Horn, Augsburg, c. 1616-7

Silver gilt; height 32.5 cm, length 25.1 cm;
base: length 21.3 cm, width 10.4 cm
Munich, Bayerisches Nationalmuseum, inv. no. 93/45
Bibliog.: exhibition catalogue *Silber und Gold*, 1994 (as in frontispiece), pp. 144-6, cat. no. 3 (Lorenz Seelig)

2 At extreme left:
Drinking vessel in the form
of a rearing he-goat

Melchior I Gelb, Augsburg, 1641

Silver gilt; height 36.4 cm, length 20.1 cm;
base: length 17.6 cm, width 14.3 cm
Munich, Bayerisches Nationalmuseum, inv. no. 90/301 (Collection of Fritz Thyssen, bequest of Anita Gräfin Zichy-Thyssen)
Bibliog.: exhibition catalogue *Silber und Gold*, 1994 (as in frontispiece), pp. 150-2, cat. no. 7 (Lorenz Seelig)

Second from the left:
Drinking vessel in the form
of a rearing horse

Elias Zorer, Augsburg, early 17th century

Silver gilt; height 21.2 cm, length 17.2 cm;
base: length 15.9 cm, width 9.9 cm
Munich, Bayerisches Nationalmuseum, inv. no. 90/296 (Collection of Fritz Thyssen, bequest of Anita Gräfin Zichy-Thyssen)
Bibliog.: exhibition catalogue *Silber und Gold*, 1994 (as in frontispiece), pp. 146-8, cat. no. 5 (Lorenz Seelig)

Third from the left:
Drinking vessel in the form
of a rearing boar

Elias Zorer, Augsburg, first quarter of 17th century

Silver gilt; height 19.3 cm, length 14.5 cm;
base: length 11.5 cm, width 8.3 cm
Munich, Bayerisches Nationalmuseum, inv. no. 90/297 (Collection of Fritz Thyssen, bequest of Anita Gräfin Zichy-Thyssen)
Bibliog.: exhibition catalogue *Silber und Gold*, 1994 (as in frontispiece), pp. 142-4, cat. no. 2 (Lorenz Seelig)

Fourth from the left:
Drinking vessel in the form
of a strutting stag

See plate 1

At extreme right:
Drinking vessel in the form
of a rearing ox

Elias Zorer, Augsburg, c. 1590

Silver gilt; height 28 cm; base: length 11.8 cm
Kassel, Staatliche Museen, Sammlung Kunsthandwerk und Plastik, Hessisches Landesmuseum, inv. no. B 11.30
Bibliog.: exhibition catalogue *Silber und Gold*, 1994 (as in frontispiece), pp. 148-50, cat. no. 6 (Eckehard Schmidberger)

3 Left:
Automaton with figures:
The Triumph of Bacchus

Goldsmith work: *Sylvester II Eberlin*; organ mechanism: *Hans Schlotheim the Elder (?), Augsburg, c. 1604-10*

Silver gilt, partially painted; brass, iron;
height 40 cm, length 52 cm, width 17 cm
Vienna, Kunsthistorisches Museum, Kunstkammer, inv. no. 959
Bibliog.: exhibition catalogue *Silber und Gold*, 1994 (as in frontispiece), pp. 160-3, cat. no. 12 (Lorenz Seelig)

Right:
Automaton with figures:
Diana mounted on a centaur

Melchior Mair, Augsburg, c. 1610

Silver, partially gilt; *basse-taille* enamel; rubies, emeralds; ebony; height 51 cm, width 33.3 cm, depth 21.3 cm
Dresden, Staatliche Kunstsammlungen, Grünes Gewölbe, inv. no. IV 150
Bibliog.: exhibition catalogue *Silber und Gold*, 1994 (as in frontispiece), pp. 152-4, cat. no. 9 (Ulli Arnold)

4 ## Automaton:
Saint George as Dragon Killer

Jakob I Miller, Augsburg, c. 1618

Silver, partially gilt and painted; precious stones;
height 39 cm, length 26.7 cm, width 13.5 cm
Munich, Bayerisches Nationalmuseum, inv. no. 86/227 (acquired with funds from the Ernst von Siemens-Kunstfonds)
Bibliog.: exhibition catalogue *Silber und Gold*, 1994 (as in frontispiece), pp. 159-60, cat. no. 11 (Lorenz Seelig)

5 ## Automaton: Diana mounted on a stag

Joachim Fries, Augsburg, c. 1615-20

Silver, partially gilt and painted; height 35 cm
Darmstadt, Hessisches Landesmuseum, inv. no. KG 52:55
Bibliog.: exhibition catalogue *Silber und Gold*, 1994 (as in frontispiece), pp. 154-9, cat. no. 10 (Lorenz Seelig)

6 Four sweetmeat salvers

Probably Hans Jakob I Baur, Augsburg, c. 1653

Silver, partially gilt; height 30 - 1 cm
Moscow, State Armoury of the Kremlin, from
the original collection, inv. nos. MZ-542, MZ-546,
MZ-2009, MZ-2010
Bibliog.: exhibition catalogue *Silber und Gold*, 1994 (as
in frontispiece), pp. 206 - 10, cat. no. 38 (Zoja Kodri-
kova/Ralf Schürer)

7 Left and right:

Two automata in the form, respectively,
of Hercules supporting a terrestrial
sphere and Saint Christopher supporting
a celestial sphere

Elias Lenker, Augsburg, c. 1626 - 9

Silver, partially gilt; iron; height 63.2 cm and
64.4 cm
Dresden, Staatliche Kunstsammlungen, Grünes
Gewölbe, inv. nos. IV 294, IV 290
Bibliog.: exhibition catalogue *Silber und Gold*, 1994
(as in frontispiece), pp. 163 - 4, cat. nos. 13 - 14 (Ulli
Arnold)

Centre:

Table decoration in the form of a man
carrying a spherical bale of merchandise
or a bomb

Heinrich Mannlich, Augsburg, c. 1695 - 8

Silver, partially gilt; height 44.5 cm
Berlin, Staatliche Museen zu Berlin, Preussischer
Kulturbesitz, Kunstgewerbemuseum (Schloss
Köpenick), inv. no. S 552
Bibliog.: exhibition catalogue *Silber und Gold*, 1994
(as in frontispiece), pp. 164 - 8, cat. no. 15 (Stefan
Bursche)

8 Upper row, left:

Covered standing-cup

Jeremias Nathan, Augsburg, c. 1597

Silver gilt; height 47 cm, diameter 13.1 cm (at rim)
Munich, Bayerisches Nationalmuseum,
inv. no. 84/151
Bibliog.: exhibition catalogue *Silber und Gold*, 1994
(as in frontispiece), pp. 184 - 6, cat. no. 24 (Ralf
Schürer)

Upper row, centre:

Drinking vessel in the form
of a leaping stag

Balthasar I Lerff, Augsburg, c. 1610 - 15

Silver gilt; coral; height 30.1 cm, length 21.1 cm;
base: length 12.8 cm, width 8.9 cm
Munich, Bayerisches Nationalmuseum,
inv. no. 90/298 (Collection of Fritz Thyssen, bequest
of Anita Gräfin Zichy-Thyssen)
Bibliog.: exhibition catalogue *Silber und Gold*, 1994
(as in frontispiece), p. 146, cat. no. 4 (Lorenz Seelig)

Upper row, right:

Covered standing-cup with coat of arms
of the Dukes of Bavaria

Jobst Zwickel, Augsburg, c. 1597 - 1600

Silver gilt; height 48.8 cm, diameter 14.4 cm
(at rim)
Munich, Bayerische Verwaltung der staatlichen
Schlösser, Gärten und Seen, Residenz München,
Silberkammer, inv. no. Res.Mü. SK 3
Bibliog.: exhibition catalogue *Silber und Gold*, 1994
(as in frontispiece), pp. 186 - 7, cat. no. 25 (Sabine
Heym)

Middle row, left:

Covered standing-cup
(originally one half of a double standing-cup)

Cup: *Hans Schebel, Augsburg, c. 1565 - 70*;
cover: *South Germany, late 16th century*

Silver gilt; *basse-taille* enamel; height 65.8 cm
(including cover), 42.2 cm (without cover),
maximum diameter 23.5 cm
Dresden, Staatliche Kunstsammlungen, Grünes
Gewölbe, inv. no. IV 252
Bibliog.: exhibition catalogue *Silber und Gold*, 1994
(as in frontispiece), pp. 182 - 4, cat. no. 23.2 (Ulli
Arnold)

Middle row, centre:

Windmill beaker

Georg Christoph I Erhart, Augsburg, c. 1595 - 1600

Silver gilt; height 19.8 cm, diameter 10.6 cm (at rim)
Kassel, Staatliche Museen, Sammlung Kunst-
handwerk und Plastik, Hessisches Landesmuseum,
inv. no. B II.22
Bibliog.: exhibition catalogue *Silber und Gold*, 1994
(as in frontispiece), p. 172, cat. no. 19 (Eckehard
Schmidberger)

Middle row, right:

Covered standing-cup
(originally one half of a double standing-cup)

Cup: *Hans Schebel, Augsburg, c. 1565 - 70*;
cover: *Kaspar Bauch the Elder, Nuremberg,
probably 3rd quarter of 16th century*

Silver gilt; *basse-taille* enamel; height 55.4 cm
(with cover) respectively 42.5 cm (without cover),
maximum diameter 23.5 cm
Dresden, Staatliche Kunstsammlungen, Grünes
Gewölbe, inv. no. IV 254
Bibliog.: exhibition catalogue *Silber und Gold*, 1994
(as in frontispiece), pp. 182 - 4, cat. no. 23.1 (Ulli
Arnold)

Lower row, extreme left:

Covered standing-cup in the form
of a gourd

Heinrich Winterstein, Augsburg, c. 1600 - 5

Silver, partially gilt; height 47 cm, diameter 10.3 cm
Moscow, State Armoury of the Kremlin, from the
original collection, inv. nos. MZ-325/1-2
Bibliog.: exhibition catalogue *Silber und Gold*, 1994
(as in frontispiece), p. 187, cat. no. 26 (Zoja Kodri-
kova)

Lower row, second from the left:

Double standing-cup

Christoph I Epfenhauser, Augsburg, c. 1550 - 60

Silver gilt; height 53.5 cm
Moscow, State Armoury of the Kremlin, from the
original collection, inv. nos. MZ-319/1-2
Bibliog.: exhibition catalogue *Silber und Gold*, 1994
(as in frontispiece), p. 180, cat. no. 20 (Zoja Kodri-
kova/Ralf Schürer)

Lower row, centre:

Tazza

Christoph Lencker, Augsburg, c. 1595 - 1600

Silver gilt; height 14.8 cm, diameter 21 cm (bowl)
Munich, Bayerisches Nationalmuseum,
inv. no. 55/149
Bibliog.: exhibition catalogue *Silber und Gold*, 1994
(as in frontispiece), pp. 188 - 90, cat. no. 27 (Ralf
Schürer)

Lower row, second from the right:

Double standing-cup

Sylvester I Eberlin, Augsburg, c. 1564 - 72

Silver gilt; height 47 cm
Moscow, State Armoury of the Kremlin, from the
original collection, inv. nos. MZ-2003, MZ-2004
Bibliog.: exhibition catalogue *Silber und Gold*, 1994
(as in frontispiece), pp. 180 - 2, cat. no. 21 (Zoja
Kodrikova / Ralf Schürer)

Lower row, extreme right:

Double standing-cup

Theophil Glaubich, Augsburg, c. 1565 - 70

Silver gilt; height 46.5 cm
Moscow, State Armoury of the Kremlin, from the
original collection, inv. no. MZ-320/1-2
Bibliog.: exhibition catalogue *Silber und Gold*, 1994
(as in frontispiece), p. 182, cat. no. 22 (Zoja Kodri-
kova / Ralf Schürer)

9 Top:

Covered standing-cup
(originally one half of a double standing-cup)

See plate 8, middle row, left

Left:

Covered standing-cup in the form
of a gourd

See plate 8, lower row, extreme left

Centre:

Double standing-cup

See plate 8, lower row, second from the left

26 Silver furniture made for
the House of Guelph

Collection of S. K. H. Ernst August, Prinz von
Hannover, Herzog zu Braunschweig und Lüneburg
Bibliog.: exhibition catalogue *Silber und Gold*, 1994
(as in frontispiece), pp. 354 - 73, cat. nos. 83 - 87
(Lorenz Seelig)

Mirror (one of a pair)
*Unknown goldsmith (Philipp Heggenauer?),
Augsburg, c. 1725 - 6*

Silver; wooden core; mirror glass (replaced);
height 327 cm and 328 cm, width 169 cm

Table (one of a pair)
Johann Ludwig II Biller, Augsburg, c. 1725 - 6

Silver, partially gilt; wooden core;
height 82.1 cm and 83.1 cm, width 119.1 cm and
119.3 cm

Two *guéridons* (of a set of four)
Johannes Biller, Augsburg, c. 1725 - 6

Silver; wooden core; height 88 - 88.6 cm

Two chairs (of a set of four)
Philipp Jakob VI Drentwett, Augsburg, c. 1729 - 30

Silver; wooden core; red velvet (replaced);
height 147.3 - 148.4 cm, width 59.5 - 60.5 cm,
depth 58.3 - 59.8 cm

27 Armchair from the ensemble of silver
furniture made for the House of Guelph
Philipp Jakob VI Drentwett, Augsburg, c. 1729 - 30

Silver; wooden core; red velvet (replaced);
height 157.3 cm, width 80.6 cm, depth 78.2 cm

28 Mirror
See plate 26

29 Detail of crowning motif of mirror:
horse
See plate 26

30 Detail of the table:
horse
See plate 26

31 Detail of mirror frame:
lion
See plate 26

32 - 33 Two candelabra
Johann Ludwig II Biller, Augsburg, c. 1725

Silver; height 49.6 cm and 50.1 cm, width 30.3 cm
and 29.5 cm, diameter 20 cm and 19.9 cm (at base)
Munich, Bayerisches Nationalmuseum,
inv. nos. 93/55.1-2
Bibliog.: exhibition catalogue *Silber und Gold*, 1994
(as in frontispiece), p. 373 - 6, cat. no. 88 (Lorenz
Seelig)

34 Buffet from the *Rittersaal* of the
Berlin Schloss

*Albrecht Biller, Johann Ludwig I Biller and
Lorenz II Biller, with an unknown goldsmith
probably of the Biller family, Augsburg, c. 1695 - 8;
Christian Winter, Augsburg, c. 1698; and
Johann Ludwig II Biller, Augsburg, c. 1731 - 3*

Silver gilt
Berlin, Staatliche Museen zu Berlin, Preussischer
Kulturbesitz, Kunstgewerbemuseum (Schloss
Köpenick), inv. nos. s 500 - 521, s 524 - 535
Bibliog.: exhibition catalogue *Silber und Gold*, 1994
(as in frontispiece), pp. 329 - 44, cat. nos. 78 - 80
(Christiane Keisch; although the whole buffet was
shown in the Munich exhibition of 1994, the cata-
logue devotes separate entries to only three items)

In descending order of position, from top to bottom:

Three ewer and basin sets from
the upper section
Johann Ludwig I Biller, Augsburg, c. 1695 - 8

Ewers: height 49 cm; basins: diameter 82 cm
inv. nos. s 524 - 526, s 530, s 531, s 534

Four ewer and basins sets from
the central section
*Johann Ludwig I Biller and an unknown Augsburg
goldsmith, Augsburg, c. 1695 - 8*

Ewers: height 51 cm; basins: diameter 92 - 95 cm
inv. nos. s 509, s 518, s 520, s 521, s 527, s 532, s 533, s 535

Six pilgrim bottles from the upper, central
and lower sections
Christian Winter, Augsburg, c. 1698

Height 57 cm
inv. nos. s 504 - 507, s 528, s 529

Two ewer and basin sets from
the lower section
Albrecht and Lorenz II Biller, Augsburg, c. 1695 - 8

Ewers: height 56 cm; basins: diameter 103 cm
inv. nos. s 501, s 503, s 510, s 519

Two pilgrim bottles from
the lower section
Albrecht Biller, Augsburg, c. 1695 - 8

Height 75,5 cm, width 42 cm
inv. nos. s 502, s 508

Fountain and cistern standing on the counter
*Johann Ludwig I and Albrecht Biller, Augsburg,
c. 1695 - 8*

Fountain: height 100 cm; cistern: height 53 cm,
width 118 cm
inv. nos. s 512, s 513

Two covered pie dishes standing on either
side of the cistern
Johann Ludwig II Biller, Augsburg, c. 1731 - 3

Pie dishes: height 56 cm, width 75 cm;
stands: width 95 cm, depth 67 cm
inv. nos. s 514 - 517
See also frontispiece

Two cisterns in the shape of glass-coolers
standing on the counter
Lorenz II and Albrecht Biller, Augsburg, c. 1695 - 8

Height 32,5 cm, width 59 cm, diameter 46 cm
(wreath)
inv. nos. s 500, s 511

35 Top of the fountain and ewer and
basin set from the central section
between two pilgrim bottles
See plate 34

36 Ewer and basin set from the lower section
See plate 34

37 Lower part of the Berlin buffet in
oblique view from the right
See plate 34

38 Pie dish (detail)
See frontispiece and plate 34

39 Top of the fountain
See plate 34

40 Central axis of the wall modelled
on the Dresden buffet room
Silver gilt

In descending order of position, from top to bottom:

Two pilgrim bottles of ruby glass with
silver mounts
Mounts: *Samuel Baur, Augsburg, c. 1700 - 5*

Height 36.7 cm, width 15.5 cm, depth 10.2 cm
Dresden, Staatliche Kunstsammlungen, Grünes
Gewölbe, inv. nos. IV 219, IV 220
Bibliog.: exhibition catalogue *Silber und Gold*, 1994
(as in frontispiece), p. 475, cat. no. 127 (Ulli Arnold)

Two covered beakers
Carl Schuch, Augsburg, c. 1689

Height 32.1 cm and 32.2 cm, width 16.5 cm
Dresden, Staatliche Kunstsammlungen, Grünes
Gewölbe, inv. nos. IV 184, IV 188
Bibliog.: exhibition catalogue *Silber und Gold*, 1994
(as in frontispiece), pp. 474 - 5, cat. no. 126 (Ulli
Arnold)

Ewer and basin set
Daniel I Schäffler, Augsburg, c. 1712 - 15

Ewer: height 30 cm; basin: diameter 56.3 cm
Dresden, Staatliche Kunstsammlungen, Grünes
Gewölbe, inv. nos. IV 155, IV 182
Bibliog.: exhibition catalogue *Silber und Gold*, 1994
(as in frontispiece), p. 480, cat. no. 131 (Ulli Arnold)

Two pilgrim bottles
Georg Friebel, Augsburg, c. 1712 - 15

Height 41.7 cm and 42.5 cm
Dresden, Staatliche Kunstsammlungen, Grünes
Gewölbe, inv. nos. IV 258, IV 263

Bibliog.: exhibition catalogue *Silber und Gold*, 1994
(as in frontispiece), pp. 475-6, cat. no. 128 (Ulli
Arnold)

Ewer and basin set on the left

Johann Erhard II Heuglin, Augsburg, c. 1717-18

Ewer: height 30.8 cm; basin: diameter 53.7-54.1 cm
Dresden, Staatliche Kunstsammlungen, Grünes
Gewölbe, inv. nos. IV 299, IV 282
Bibliog.: exhibition catalogue *Silber und Gold*, 1994
(as in frontispiece), pp. 481-2, cat. no. 134 (Ulli
Arnold)

Ewer and basin set on the right

Daniel I Schäffler, Augsburg, c. 1717-18

Ewer: height 28 cm; basin: diameter 53.7 cm
Dresden, Staatliche Kunstsammlungen, Grünes
Gewölbe, inv. nos. IV 19, IV 15
Bibliog.: exhibition catalogue *Silber und Gold*, 1994
(as in frontispiece), pp. 480-1, cat. no. 132 (Ulli
Arnold)

Two display vases

Abraham II Drentwett, Augsburg, c. 1708-10

Height 64.4 cm and 63.9 cm, width 40.8 cm
and 39 cm
Dresden, Staatliche Kunstsammlungen, Grünes
Gewölbe, inv. nos. IV 122, IV 152
Bibliog.: exhibition catalogue *Silber und Gold*, 1994
(as in frontispiece), pp. 478-9, cat. no. 130 (Ulli
Arnold)

Two wine-coolers

Johann Christoph I Treffler, Augsburg, c. 1712-15

Height 21.4 cm and 21.2 cm, width 23.3 cm and 24 cm
Dresden, Staatliche Kunstsammlungen, Grünes
Gewölbe, inv. nos. IV 190, IV 191
Bibliog.: exhibition catalogue *Silber und Gold*, 1994
(as in frontispiece), pp. 476-8, cat. no. 129 (Ulli
Arnold)

41 Lateral axis of the wall modelled on
the Dresden buffet room

Silver gilt

Fountain and cistern (one of two sets)

Hans Jakob III Baur, Augsburg, c. 1690-4

Fountain: height 78 cm, width 46.5 cm, depth
47 cm; cistern: height 45 cm (without handles),
width 127 cm and 128 cm, depth 81 cm and 77.5 cm
Dresden, Staatliche Kunstsammlungen, Grünes
Gewölbe, inv. nos. IV 62, IV 63, IV 213, IV 214
Bibliog.: exhibition catalogue *Silber und Gold*, 1994
(as in frontispiece), pp. 482-3, cat. no. 135 (Ulli
Arnold)

Two *guéridons* (of a set of four)

Johann Ludwig I Biller, Augsburg, c. 1708-10

Height 125 cm, diameter 38.5 cm (at base),
29 cm (at top)
Dresden, Staatliche Kunstsammlungen, Kunstge-
werbemuseum, inv. nos. 37 464 a-d
Bibliog.: exhibition catalogue *Silber und Gold*, 1994
(as in frontispiece), pp. 486-7, cat. no. 137 (Gisela
Haase)

42 Dressing-table set

*Johann Erhard II Heuglin, Christian Baur and
Johann Christoph II Treffler, Augsburg, c. 1725*

Silver gilt; *émail de Saxe*; glass etc.; case: wood
with gold-stamped leather covering and
wrought-iron mounts; red velvet, gold braid;
case: height 37 cm, width 84.5 cm, depth 58.7 cm
Hamburg, Museum für Kunst und Gewerbe,
inv. nos. 1949.71 a-ee
Bibliog.: exhibition catalogue *Silber und Gold*, 1994
(as in frontispiece), pp. 446-9, cat. no. 120 (Bernhard
Heitmann)

43 Items from the dressing-table set

See plate 42

Johann Erhard II Heuglin

Large box with hinged cover

Width 26 cm, depth 16,3 cm

Candle-snuffer with tray

Length 15.3-20.5 cm

Ewer and basin

Ewer: height 21.7 cm; basin: height 5.6 cm,
width 44.5 cm, depth 29.8 cm

Johann Christoph II Treffler

Candlestick

Height 19 cm

44 Eight items from the gold dressing-table
set made for the Tsarina Anna Ivanovna

*Johann Ludwig II Biller and Johann Jakob Wald,
Augsburg, c. 1736-40*

Gold
St Petersburg, State Hermitage, inv. nos. E 5228,
E 5229, E 5233, E 5237, E 5249, E 5250, E 5258, E 5259,
E 5267
Bibliog.: exhibition catalogue *Silber und Gold*, 1994
(as in frontispiece), p. 450-7, cat. no. 121 (Marina
Lopato)

From left to right:

Covered beaker

Probably Johann Ludwig II Biller

Height 19.2 cm

Candlestick

Probably Johann Ludwig II Biller

Height 19.6 cm and 19.8 cm

Covered bowl (*écuelle*)

Johann Jakob Wald

Height 8.9 cm, width 18.5 cm (with handles),
diameter 14 cm

Box

Probably Johann Ludwig II Biller

Height 12.6 cm, width 17.3 cm, depth 12.4 cm

Ewer and basin set

Probably Johann Ludwig II Biller

Ewer: height 25.3 cm; basin: height 5 cm,
width 49 cm, depth 35 cm

Covered beaker

Probably Johann Jakob Wald

Height 17.7 cm

Candlestick

Probably Johann Ludwig II Biller

Height 19.6 cm and 19.8 cm

Box

Probably Johann Jakob Wald

Height 12.5 cm, width 20.5 cm

45 Items from the gold dressing-table set
made for the Tsarina Anna Ivanovna

See plate 44

46 Box from the gold dressing-table set
made for the Tsarina Anna Ivanovna

See plate 44

47 Ewer and basin from the gold
dressing-table set made for the
Tsarina Anna Ivanovna

See plate 44

48 Dressing-table set from the
Thurn und Taxis Collection

*Franz Christoph Saler (?), Christian Friedrich
Lauch and Johann Ludwig Laminit, Augsburg,
c. 1741-3*

Silver gilt; wood; glass etc.; case: wood with leather
covering and wrought-iron mounts; green felt
(replaced), gold braid
Munich, Bayerisches Nationalmuseum,
inv. nos. 93/59-86
Bibliog.: exhibition catalogue *Silber und Gold*, 1994
(as in frontispiece), pp. 457-61, cat. no. 122 (Lorenz
Seelig)

49 Items from the dressing-table set from
the Thurn und Taxis Collection

See plate 48

Franz Christoph Saler (?)

Mirror

Height 67.3 cm, width 51 cm

Large box with spring catch

Height 11 cm, width 18.6 cm, depth 14.4 cm

Medium-sized box

Height 8.7 cm, width 13.7 cm, depth 10.6 cm

Small box

Height 7.3 cm, width 12 cm, depth 9.1 cm

Candlestick (one of a pair)

Height 18.1 cm, diameter 11.7 and 11.9 cm

Brush

Length 8.5 cm (handle)

Tray (one of a pair)

Width 18.5 cm and 18.7 cm, depth 12.9 and 12.8 cm

Bell

Height 6.3 cm, diameter 5.2 cm

Unknown Augsburg goldsmith

Two glass bottles

Height 11.6 cm and 11.7 cm, width 5.7 cm,
depth 3.7 cm and 3.8 cm

50 Dressing-table set

*Gottlieb Satzger, Johann Georg Klosse, Johann IV
or Johann V Beckert et al., Augsburg, c. 1755-7*

Silver gilt; wood; glass etc.; case: wood with
gold-stamped leather covering and wrought-iron
mounts; interior: walnut veneer and gilt, carved
soft wood, gilt brass mounts, red velvet, gold braid;
case: height 36 cm, width 86.5 cm, depth 63 cm
Stuttgart, Württembergisches Landesmuseum,
inv. nos. 1938/137-174
Bibliog.: exhibition catalogue *Silber und Gold*, 1994
(as in frontispiece), pp. 462-7, cat. no. 123 (Lorenz
Seelig)

51 Items from the dressing-table set

See plate 50

Gottlieb Satzger

Small box

Height 10.1 cm, width 12.5 cm, depth 9.9 cm

Ewer and basin

Ewer: height 25.1 cm, depth 19.7 cm;
basin: height 3.8 cm, width 38 cm, depth 28.3 cm

Johann Georg Klosse

Chocolate pot

Height 25.5 cm, width 19.5 cm

Coffee-pot

Height 21 cm, width 17 cm

Teapot

Height 15.2 cm, width 19.5 cm

Unknown Augsburg goldsmith

Mirror

Height 68.5 cm, width 53.5 cm

Two glass bottles

Height 13.1 cm and 13.5 cm, width 7.3 cm,
depth 4.6 cm

52 Four circular tureens and
two rectangular covered dishes
with six ladles from the
Thurn und Taxis Collection

Tureens and covered dishes:
Johann Ludwig II Biller, Augsburg, c. 1725;
ladles:
Samuel Bardet, Augsburg, c. 1781-3;

Silver; larger circular tureens: height 29.8 cm
and 30.3 cm, width 32.7 cm and 32.3 cm (including
handles), stands: diameter 41.7 cm; smaller circular
tureens: height 24.8 cm and 26.8 cm, width 26 cm
and 27.8 cm (including handles), stands: diameter
35.7 cm; rectangular covered dishes: height 17 cm
and 16.8 cm, width 35.2 cm and 35.6 cm, depth 22.3 cm
and 22 cm, stands: width 41.5 cm, depth 34 cm and
34.2 cm; ladles: length 36.8-37.4 cm, width 6.5-7.8 cm
Munich, Bayerisches Nationalmuseum,
inv. nos. 93/46-52
Bibliog.: exhibition catalogue *Silber und Gold*, 1994
(as in frontispiece), pp. 516-23, cat. no. 147 (Lorenz
Seelig)

53 Detail of one of the rectangular
covered dishes

See plate 52

54 Ewer and basin set from the
Thurn und Taxis Collection

Johann Christoph Stenglin, Augsburg, c. 1739-41

Silver gilt
Ewer: height 30.8 cm, length 28.2 cm, width 11.3 cm;
basin: height 5.2 cm, diameter 53.9 cm
Munich, Bayerisches Nationalmuseum,
inv. no. 93/56
Bibliog.: exhibition catalogue *Silber und Gold*, 1994
(as in frontispiece), pp. 512-16, cat. no. 146 (Lorenz
Seelig)

55 Detail of ewer and basin set from the
Thurn und Taxis Collection

See plate 54

56 Two circular and four oval tureens
with four ladles from the
Thurn und Taxis Collection

Circular tureens:
Johann Wilhelm Dammann;
oval tureens and ladles:
Emanuel Gottlieb Oernster, Augsburg, c. 1759-61

Silver (liners of the tureens, also bowls of the ladles
silver gilt); circular tureens: height 33.6 cm and
33.5 cm, width 46.9 cm and 46.7 cm, depth 28 cm
and 27.8 cm, stands: width 55.5 cm and 55 cm,
depth 44.5 cm and 44.1 cm; oval tureens:
height 30-30.5 cm, width 43.9-44.5 cm, depth
21-21.3 cm, stands: width 54.7-55.4 cm, depth
34.2-34.5 cm; ladles: length 39.2-40 cm
Munich, Bayerisches Nationalmuseum,
inv. nos. 93/88-93
Bibliog.: exhibition catalogue *Silber und Gold*, 1994
(as in frontispiece), pp. 523-9, cat. no. 148 (Lorenz
Seelig)

57 Detail of a circular tureen

See plate 56

58 Dinner service made for
Friedrich Wilhelm von Westphalen,
Prince-Bishop of Hildesheim

c. 1759-65

Silver (liners silver gilt)
Hildesheim, Roemer-Museum, inv. nos. H 3187-3206,
H 4201; Munich, Bayerisches Nationalmuseum, inv.
nos. 81/216-349; private collection
Bibliog.: exhibition catalogue *Silber und Gold*, 1994
(as in frontispiece), pp. 532-94 and 596-7, cat. nos.
150-176 and 178 (Lorenz Seelig); of the Hildesheim
dinner service as a whole, only those groups of
plates, bowls and salvers shown at the Munich
exhibition of 1994 are listed below:

Various plates (of a set of thirty)
*Emanuel Gottlieb Oernster, Gottfried Bartermann
and Johann Wilhelm Dammann, Augsburg,
c. 1761-5*

Height 2.4 cm, diameter 25.3 cm
Munich, Bayerisches Nationalmuseum,
inv. nos. 81/270-288, 81/290-299, 81/307
Bibliog.: exhibition catalogue *Silber und Gold*, 1994
(as in frontispiece), pp. 573-5, cat. no. 164 (Lorenz
Seelig)

Various sets of cutlery (of a total of thirty)
*Principally Abraham IV Warnberger, Augsburg,
c. 1759-63*

Spoon: length 20 cm, fork: length 19.4 cm,
knife: length 9.2 cm (handle)
Munich, Bayerisches Nationalmuseum,
inv. nos. 93/104-106 (acquired from the House of
Thurn und Taxis)
Bibliog.: exhibition catalogue *Silber und Gold*, 1994
(as in frontispiece), pp. 593-4, cat. no. 176 (Lorenz
Seelig)

In left foreground:
Candlestick (one of a set of four)
Salomon Dreyer, Augsburg, c. 1753-5

Height 23.5 cm, diameter 17.5 cm (at base)
Munich, Bayerisches Nationalmuseum,
inv. nos. 81/258-261
Bibliog.: exhibition catalogue *Silber und Gold*, 1994
(as in frontispiece), pp. 581-2, cat. no. 168 (Lorenz
Seelig)

Standing behind the candlestick:
Sauce-boat (one of a set of six)
*Emanuel Abraham Drentwett, Augsburg,
c. 1761-3*

Height 12.2-12.8 cm, width 18.5-19 cm,
depth 15.5-16.7 cm
Munich, Bayerisches Nationalmuseum,
inv. nos. 81/231-234 and private collection
Bibliog.: exhibition catalogue *Silber und Gold*, 1994
(as in frontispiece), pp. 564-5, cat. no. 155 (Lorenz
Seelig)

At centre of foreground:
Middle-sized circular dish
(one of a set of eight)
*Gottfried Bartermann and Abraham IV Drentwett,
Augsburg, c. 1759-63*

Height 3.6 cm, diameter 37.4-37.7 cm
Munich, Bayerisches Nationalmuseum,
inv. nos. 81/338-345

Bibliog.: exhibition catalogue *Silber und Gold*, 1994 (as in frontispiece), pp. 571 - 3, cat. no. 162 (Lorenz Seelig)

Standing behind the circular dish:
Middle-sized oval dish (one of a set of eight)
Gottfried Bartermann and Abraham IV Drentwett, Augsburg, c. 1759 - 61 and 1763 - 5

Height 2.7 cm, width 38.5 cm, depth 27.6 cm
Hildesheim, Roemer-Museum, inv. nos. H 3197.1-4
and Munich, Bayerisches Nationalmuseum,
inv. nos. 81/322 - 325
Bibliog.: exhibition catalogue *Silber und Gold*, 1994 (as in frontispiece), pp. 569 - 70, cat. no. 159 (Lorenz Seelig)

In right foreground:
Large circular dish (one of a set of four)
Abraham IV Drentwett, Augsburg, c. 1761 - 3

Height 4.5 cm, diameter 43.6 cm
Hildesheim, Roemer-Museum, inv. nos. H 3196.1-4
Bibliog.: exhibition catalogue *Silber und Gold*, 1994 (as in frontispiece), pp. 571 - 3, cat. no. 161 (Lorenz Seelig)

In the background:
Portrait of Friedrich Wilhelm von Westphalen, Prince-Bishop of Hildesheim
Johann Georg Ziesenis, probably Hildesheim, c. 1763

Oil on canvas, height 153 cm, width 125 cm
Hildesheim, Roemer-Museum, inv. no. G 10
Bibliog.: exhibition catalogue *Silber und Gold*, 1994 (as in frontispiece), pp. 611 - 12, cat. no. G 14 (Lorenz Seelig)

59 Part of the dinner service made for Friedrich Wilhelm von Westphalen, Prince-Bishop of Hildesheim
See plate 58

Large centrepiece
Bernhard Heinrich Weyhe, Augsburg, c. 1761 - 3

Height 68.5 cm, width 73.5 cm, depth 58 cm
Munich, Bayerisches Nationalmuseum,
inv. nos. 81/216, 235 - 238, 248, 251 and
Hildesheim, Roemer-Museum, inv. nos. H 3191.1-2
(two spice boxes)
Bibliog.: exhibition catalogue *Silber und Gold*, 1994 (as in frontispiece), pp. 547 - 54, cat. no. 150 (Lorenz Seelig)

60 Part of the dinner service made for Friedrich Wilhelm von Westphalen, Prince-Bishop of Hildesheim
See plate 58
In the foreground and background:
Two three-branched candelabra
Johann Philipp Heckenauer, Augsburg, c. 1761 - 3

Height 48.5 cm, width 30.5 cm and 31 cm,
diameter 18 cm (at base)
Munich, Bayerisches Nationalmuseum,
inv. nos. 81/266 - 267
Bibliog.: exhibition catalogue *Silber und Gold*, 1994 (as in frontispiece), p. 576, cat. no. 165 (Lorenz Seelig)

In right background:
Candlestick (one of a set of four)
Salomon Dreyer, Augsburg, c. 1753 - 5

Height 23.5 cm, diameter 17.5 cm (at base)
Munich, Bayerisches Nationalmuseum,
inv. nos. 81/258 - 261
Bibliog.: exhibition catalogue *Silber und Gold*, 1994 (as in frontispiece), pp. 581 - 2, cat. no. 168 (Lorenz Seelig)

In the middle distance:
Large tureen (one of a pair)
Bernhard Heinrich Weyhe, Augsburg, c. 1759 - 61

Tureens: height 30 cm and 31 cm, width 49.3 cm
and 49 cm, depth 23 cm; stands: width 58.8 cm and
59.4 cm, depth 36.6 cm and 36.8 cm; ladles:
length 38.3 cm and 39.1 cm
Munich, Bayerisches Nationalmuseum,
inv. nos. 81/220, 222
Bibliog.: exhibition catalogue *Silber und Gold*, 1994 (as in frontispiece), pp. 559 - 61, cat. no. 153 (Lorenz Seelig)

In the background:
Wall mirror (one of a pair)
Johann Valentin Gevers, Augsburg, c. 1729 - 30

Height 156.2 cm and 155.7 cm, width 77.6 cm
and 76.8 cm
Munich, Bayerisches Nationalmuseum,
inv. nos. 93/54.1-2 (acquired from the House of
Thurn und Taxis)
Bibliog.: exhibition catalogue *Silber und Gold*, 1994 (as in frontispiece), pp. 376 - 8, cat. no. 89 (Lorenz Seelig)

Painting reflected in the mirror:
Part of *Court Concert at Schloss Ismaning*
Peter Jakob Horemans, Munich, 1733

Oil on canvas, height 186 cm, width 240.5 cm
Munich, Bayerisches Nationalmuseum,
inv. no. R 7159
Bibliog.: exhibition catalogue *Silber und Gold*, 1994 (as in frontispiece), pp. 612 - 13, cat. no. G 15 (Lorenz Seelig)

61 Part of the dinner service made for Friedrich Wilhelm von Westphalen, Prince-Bishop of Hildesheim
See plate 58

Two small tureens (of a set of four)
Bernhard Heinrich Weyhe and Johann Joseph Meckel, Augsburg, c. 1759 - 63

Tureens: height 30.2 - 31 cm, width 43.9 - 44.2 cm,
depth 20.1 - 20.5 cm; stands: width 52.9 - 53.6 cm,
depth 31.9 - 32.5 cm; ladles: length 32.5 - 36.3 cm
Munich, Bayerisches Nationalmuseum,
inv. nos. 81/219, 81/221, 81/223 - 226, 81/229, 81/230
Bibliog.: exhibition catalogue *Silber und Gold*, 1994 (as in frontispiece), pp. 562 - 4, cat. no. 154 (Lorenz Seelig)

In the background:
Two-branched candelabrum (of a set of four)
Johann Philipp Heckenauer, Augsburg, c. 1761 - 3

Height 38.5 - 39 cm, width 32.5 cm, diameter 15.3 cm
(at base)
Munich, Bayerisches Nationalmuseum,
inv. nos. 81/262 - 265
Bibliog.: exhibition catalogue *Silber und Gold*, 1994 (as in frontispiece), pp. 576 - 7, cat. no. 166 (Lorenz Seelig)

62 Part of the dinner service made for Friedrich Wilhelm von Westphalen, Prince-Bishop of Hildesheim
See plate 58

Small centrepiece (one of a pair)
Bernhard Heinrich Weyhe, Augsburg, c. 1759 - 63

Height 54 cm and 55 cm, width 60.5 cm and 61.9 cm,
depth 47 cm and 46.8 cm
Munich, Bayerisches Nationalmuseum, inv. nos.
81/217, 81/218, 81/239 - 246, 81/249, 81/250, 81/252 - 257
Bibliog.: exhibition catalogue *Silber und Gold*, 1994 (as in frontispiece), pp. 554 - 9, cat. nos. 151 - 2 (Lorenz Seelig)

In the foreground:
Middle-sized oval dish (one of a set of eight)
Gottfried Bartermann and Abraham IV Drentwett, Augsburg, c. 1759 - 61 and 1763 - 5

Height 2.7 cm, width 38.5 cm, depth 27.6 cm
Hildesheim, Roemer-Museum, inv. nos. H 3197.1-4
and Munich, Bayerisches Nationalmuseum,
inv. nos. 81/322 - 325
Bibliog.: exhibition catalogue *Silber und Gold*, 1994 (as in frontispiece), pp. 569 - 70, cat. no. 159 (Lorenz Seelig)

Left background:
Candlestick (one of a set of four)
Salomon Dreyer, Augsburg, c. 1753 - 5

Height 23.5 cm, diameter 17.5 cm (at base)
Munich, Bayerisches Nationalmuseum,
inv. nos. 81/258 - 261
Bibliog.: exhibition catalogue *Silber und Gold*, 1994 (as in frontispiece), pp. 581-2, cat. no. 168 (Lorenz Seelig)

63 Part of the dinner service made for Friedrich Wilhelm von Westphalen, Prince-Bishop of Hildesheim
Large centrepiece (detail)
See plate 59

64 Gaming table with four candlesticks
Candlesticks:
Johann Philipp Heckenauer, Augsburg, c. 1763 - 5

Silver; height 16.8 cm, diameter 14.2 cm (at base)
Munich, Bayerisches Nationalmuseum,
inv. no. 93/1046
Bibliog.: exhibition catalogue *Silber und Gold*, 1994 (as in frontispiece), pp. 596 - 7, cat. no. 178 (Lorenz Seelig)

Gaming table:
South Germany, mid-18th century

Walnut; height 72 cm, width 86 cm
Munich, Bayerisches Nationalmuseum,
inv. no. R 5142

On the Techniques Used in the Goldsmith's Art

The objects made by the Augsburg goldsmiths' workshops were produced using the most varied techniques. Here we must distinguish between those techniques that altered the shape of the metal being worked (raising, embossing, spinning) and those that removed a small amount of metal from the surface (engraving, drilling, turning, filing). The techniques of saw-piercing and casting were also used.

The techniques most specific to the goldsmith's art are raising and embossing. The blank silver is first beaten to a thin sheet by means of a hammer and then raised to the desired shape by hammering it on steel stakes. In embossing, the goldsmith works the silver sheet into the desired form by placing it on a resilient surface and striking it repeatedly with an embossing hammer. From time to time the piece is annealed by heating to a dull red colour before quenching in water to recover its malleability. The final smoothing of the surface would then be achieved using a planishing hammer. The making of a beaker on a stake is represented in the foreground of fig. 5.

Chasing and matting were used to carry out more detailed work on the surface. In the former process the goldsmith would work on the piece (which would be resting on a sandbag or set in pitch) with a punch, usually of his own making, which would be moved across the surface with the blows of a hammer. The silversmith sitting by the window in fig. 5 is chasing a large basin on a sandbag with such a punch. Thus, depending on whether he worked from the front or the rear of the piece, either hollow or raised areas would be produced. In the art of sculptural chasing the goldsmiths of Augsburg achieved an astonishing brilliance.

In the matting process individual punch marks were generally placed very close to each other, thus producing matt effects on the surface of the metal; by employing variously shaped punches, and applying them more or less densely, a great diversity of surface effects could be achieved.

While the processes of both chasing and matting only altered the material to hand, engraving involved a greater degree of intervention in as far as it removed small quantities of the material. 'Engraved' drawings were executed using the engraving tool. This too was a particular specialization of the Augsburg workshops. Engravings were often used for the representation of coats of arms on silver (plates 53, 57).

Cast pieces were produced using a wax, lead or wooden model, usually supplied by a sculptor (only exceptionally did goldsmiths themselves prepare these). Smaller elements were produced by solid casting (most frequently by sand-casting), but larger parts were made as hollow casts using the lost-wax process. Over a core of clay, a layer of wax would be applied, its strength determined by the proposed thickness of the piece to be cast. The layer of wax would in turn be encased in a layer of clay so that the core, supported by metal rods, would remain firmly fixed in relation to the outer layer. The layer of wax between the two would melt when the whole construct was heated: molten silver would then be poured so as to flow through the hollow space produced by these means. Finally, the surface of the cast piece would be cleaned, and also worked in greater detail by means of chasing and engraving.

A refined element could be achieved by gilding, which also prevented the tarnishing of the silver surface. In the earlier period the usual method was fire-gilding (or mercury gilding). An amalgam of gold and mercury was smeared by the goldsmith as a paste over the surface of the cleaned silver. When heated, the mercury would vaporize and the remaining gold would be fused with the silver surface. Additional polishing increased the lustre of the gold. Subtle differentiation was achieved by means of partial gilding (also known as parcel gilding) in which white and gilt areas of silver are contrasted.

The individual elements of a complex piece of goldsmith's work were assembled by means of soldering or the use of rivets, pegs or screws. For larger objects in particular, attachment by means of screws was preferred, so that such items could easily be taken apart for cleaning. By this means it was also possible to avoid the comparatively risky process of soldering. During the ultimate 'finishing', the seams and knobs produced by the processes of casting and soldering were filed and smoothed away. Cleaning took place by whitening or 'pickling' the silver in a bath of sulphuric acid or tartar. For polishing, numerous materials were used: these included various types of steel and haematite. The contrast between highly polished and unpolished areas of the silver surface could yield distinctive effects, although these have often been lost through subsequent cleaning, repairs and regilding.

Supplementary Remarks on the Introduction

The introductory chapter and the picture captions are based on the text of the catalogue of the exhibition held at the Bayerisches Nationalmuseum in Munich entitled *Silber und Gold: Augsburger Goldschmiedekunst für die Höfe Europas*, edited by Reinhold Baumstark and Helmut Seling (Munich 1994), and awarded the 'Minda de Gunzburg Prize 1994'. In addition to reports in the press, the exhibition and its catalogue were reviewed by the following: Philippa Glanville in *Burlington Magazine* CXXXVI/1094 (May 1994), pp. 331-2; Clare Lloyd-Jacob in *Apollo* CXI/390 (August 1994), p. 72; Gloria Ehret in *Weltkunst* 64 (1994), pp. 820-1; Ulla Stöver in *Goldschmiede- und Uhrmacher-Zeitung* 92/5 (May 1994), pp. 24-32. Commentary on the exhibition and catalogue also appeared in *Connaissance des Arts* 506 (May 1994), pp. 40-53; and in *Gazette des Beaux-Arts* CXXIV/1506-7 (July-August 1994), 'Chronique des Arts', p. 12. Especially noteworthy in the catalogue itself, in addition to the individual entries, are the essays by Helmut Seling ('Einleitung', pp. 17-31; 'Die Beschauordnung des Augsburger Goldschmiedehandwerks', pp. 66-7) and Ralf Schürer ('"ein erbar handwerckh von goldschmiden"', pp. 57-65). The following supplementary remarks draw particular attention to publications of the period 1993-5 that appeared too late to be taken into account in the preparation of the catalogue. The additional information pertains only to objects dealt with in the present volume, not to the other ninety-three entries in the exhibition catalogue – most of them for groups of objects – which are neither discussed nor illustrated here.

p. 14 For a survey of the important collections of silver deriving from those established at princely courts, see Dirk Syndram, 'Reste einstigen Reichtums: Zu den historischen Silbersammlungen Europas', in: Peter Heinrich, ed., *Metall-Restaurierung. Beiträge zur Analyse, Konzeption und Technologie* (Munich 1994), pp. 8-19.

p. 15 On the animal figures discussed here, see Vincent Laloux and Philippe Cruysmans, *L'œil du hibou: Le bestiaire des orfèvres* (Lausanne 1994), figs. 34, 48, 70, 192; also the doctoral thesis being completed at the University of Freiburg by Claudia Siegel-Weiss on the subject of animal figures in the art of the goldsmith.

p. 15 On the motif of Diana mounted on a stag, see also Andrea Weinläder, 'Ein "Hirsch, welches ein schön Stück und Uhrwerk dorin gewesen": Studien zu einem Augsburger Trinkspiel zu Beginn des 17. Jahrhunderts'. MA thesis, University of Tübingen, typescript, in particular p. 54, where the author cites a previously unconsidered source describing one of the prizes awarded at a tournament in 1612 as a stag with a clockwork mechanism; see also Laloux / Cruysmans 1994 (as above), pp. 212-19.

pp. 15-16 On Saint George, see Laloux / Cruysmans 1994, fig. on p. 230.

p. 16 For the interpretation of the bound sphere as a bomb, see Winfried Baer: 'La cour de Prusse au XVIIIe siècle'. Paper given at the conference 'Tables royales et festins de cour en Europe 1661-1789', Versailles, 26 February 1994 (to be included in the forthcoming volume of conference papers).

p. 18 On the work of Augsburg goldsmiths in the Grünes Gewölbe in Dresden, see Dirk Syndram, ed., *Das Grüne Gewölbe zu Dresden. Führer durch seine Geschichte und seine Sammlungen.* (Munich and Berlin 1994), p. 44, nos. 32-33, fig. on p. 45; p. 48, no. 49a, fig. on p. 47; p. 53, no. 80, fig. on p. 53; p. 54, no. 84, fig. on p. 54; p. 80, plate 8; p. 202, no. 3, fig. on p. 202; p. 203, no. 6; pp. 204-5, fig. on p. 205; p. 210, no. 3, fig. on p. 209; p. 210, no. 2, fig. on p. 210; also idem, *Prunkstücke des Grünen Gewölbes zu Dresden* (Munich and Berlin 1994), p. 45, fig. on p. 44; pp. 72-3, fig. on p. 73; p. 92, with fig.; p. 146, with fig.; pp. 148-9, with fig.

p. 19 On the drawing by Hanns Ulrich Franck, with clarification of its subject, see Tilman Falk, 'Eine Gruppe von Zeichnungen des Hanns Ulrich Franck', in: Bärbel Hamacher and Christl Karnehm, eds., *pinxit / sculpsit / fecit. Kunsthistorische Studien. Festschrift für Bruno Bushart* (Munich 1994), pp. III-21, in particular p. 112, fig. 1.

p. 22 On Philipp Hainhofer's Augsburg cabinets, see Hans-Olof Boström, 'Philipp Hainhofer: Seine Kunstkammer und seine Kunstschränke', in: Andreas Grote, ed., *Macrocosmos in Microcosmo. Die Welt in der Stube. Zur Geschichte des Sammelns 1450 bis 1800* (Opladen 1994), pp. 555-80.

p. 31 On the Berlin silver buffet, see Christiane Keisch, *Das grosse Silberbuffet im Rittersaal des ehemaligen Schlosses zu Berlin* (Berlin 1995, forthcoming).

p. 36 For information concerning the reliefs on the vases made by Abraham II Drentwett, I am grateful to Werner Schwarz, whose doctoral thesis on the goldsmith at the University of Erlangen is nearing completion. See also Werner Schwarz, 'Meister dreier Medien. Anmerkungen zu einem Kupferstich und verwandten Wachs- und Silberarbeiten von Abraham II Drentwett [1647-1729]', in: *Zeitschrift des Historischen Vereins für Schwaben* 86 (1993), pp. 211-18.

p. 38 I am most grateful to Helmut Seling for his comments on the dating of the *guéridons* of 1708-10. On the candelabra stands and the other items of silver furniture made in Augsburg for Augustus the Strong, see also Lorenz Seelig, 'Silbermöbel für Dresden, Berlin und Wien: Stilvarianten und Programme höfischer Raumausstattungen', paper given at the XXIII Deutscher Kunsthistorikertag in Dresden, 27 September 1994 (to be published in *Zeitschrift für Kunstgeschichte*).

p. 43 On the silver gilt dinner service made for Augustus the Strong, see: Ulli Arnold, *Staatliche Kunstsammlungen Dresden: Grünes Gewölbe. Dresdner Hofsilber des 18. Jahrhunderts* (Berlin and Dresden 1994; KulturStiftung der Länder – Patrimonia 74), in particular pp. 27-30, 52-75; also Lorenz Seelig, 'Das Dresdner Vermeil-Service: Zu einem spätbarocken Ensemble Augsburger Herkunft', in: *Weltkunst* 65 (1995), pp. 373-5.

p. 46 On the presentation of the Hildesheim dinner service at the Munich exhibition, see Lorenz Seelig, 'Das Hildesheimer Tafelsilber: Rekonstruktion einer höfischen Tafel im 18. Jahrhundert', in: *Weltkunst* 64 (1994), pp. 1180-1. On the Hildesheim dinner service, see also the comments of Michel Ceuterick in the exhibition catalogue *Augsburgs Zilver in België*, Provinciaal Museum Sterckshof, Antwerp, 1994 (Antwerp 1994), pp. 125-6, cat. no. 81.

p. 47 On the centrepieces of the Hildesheim dinner service, see also Charles Truman, ed., *Sotheby's Concise Encyclopedia of Silver* (London 1993), p. 97, fig. on p. 97; and Henry Hawley, 'Rococo Silver in Europe', in: *Antiques* 147/1 (January 1995), p. 153, fig. on p. 154 and cover.

p. 48 On the gaming-table candlesticks, see Lorenz Seelig, 'Berichte der Staatlichen Kunstsammlungen. Neuerwerbungen. Bayerisches Nationalmuseum', in: *Münchner Jahrbuch der bildenden Kunst* 3/45 (1994), in print.

I am especially grateful to Dr. Annette Schommers for her generous support during the preparation of this volume. I am also much indebted to Dr. Helmut Seling for his critical discussion of attributions and his interpretation of makers' and assayers' marks: I relied on both aspects of this crucial contribution above all in drawing up the list of illustrated works.

Bibliography

Alfter, Dieter, *Die Geschichte des Augsburger Kabinettschranks* (Augsburg 1986; Schwäbische Geschichtsquellen und Forschungen, vol. 15)

Augsburger Stadtlexikon. Geschichte, Gesellschaft, Kultur, Recht, Wirtschaft, eds. Wolfram Baer, Josef Bellot, Tilman Falk et al. (Augsburg 1985)

Augusta 955-1955: Forschungen und Studien zur Kultur und Wirtschaftsgeschichte Augsburgs, ed. Hermann Rinn (Augsburg 1955)

Blair, Claude, ed., *The History of Silver* (New York 1987)

Brunner, Herbert, *Altes Tafelsilber: Ein Brevier für Sammler und Liebhaber* (München 1964); English edition *Old table Silver: A Handbook for Collectors and Amateurs*, trans. Janet Seligman (London 1967)

Bursche, Stefan, *Tafelzier des Barock* (Munich 1974)

Drach, Alhard von, *Ältere Silberarbeiten in den Königlichen Sammlungen zu Cassel* (Marburg 1888)

Frankenburger, Max, *Die Silberkammer der Münchner Residenz* (Munich 1923)

Gottlieb, Gunther, et al., eds., *Geschichte der Stadt Augsburg: 2000 Jahre von der Römerzeit bis zur Gegenwart* (2nd edn., Stuttgart 1985)

Gruber, Alain, *Gebrauchssilber des 16. bis 19. Jahrhunderts* (Würzburg 1982); French edition *L'argenterie de maison du XVIe au XIXe siècle* (Fribourg 1982)

Hayward, John F., 'Silver Furniture' (parts I-IV), in *Apollo* LXVII (January-June 1958), no. 397 (March), pp. 71-4; no. 398 (April), pp. 124-7; no. 399 (May), pp. 153-7; and no. 400 (June), pp. 220-3

Hayward, John F., *Virtuoso Goldsmiths and the Triumph of Mannerism, 1540-1620* (London 1976)

Heitmann, Bernhard, *Die deutschen sogenannten Reise-Service und die Toiletten-Garnituren von 1680 bis zum Ende des Rokoko und ihre kulturgeschichtliche Bedeutung*, PhD thesis Munich 1977 (Hamburg 1979)

Heitmann, Bernhard, 'Magnificence, significance and daily usage: the German toilet set of the late baroque and rococo period', in: *The International Fine Art and Antique Dealers' Show, New York 1992* (New York 1992), pp. 33-8

Hernmarck, Carl, *The Art of the European Goldsmith and Silversmith from 1450 to 1830*, trans. from Swedish by Paul Britten (London 1978); German edition *Die Kunst der europäischen Gold- und Silberschmiede von 1450 bis 1830*, trans. from Swedish by Karin Goedecke (Munich 1978)

Hoos, Hildegard, *Augsburger Silbermöbel*, PhD thesis Frankfurt am Main 1981, 2 vols. (Frankfurt am Main 1985)

Irmscher, Günter, *Kleine Kunstgeschichte des europäischen Ornaments seit der frühen Neuzeit (1400-1900)* (Darmstadt 1984)

Keisch, Christiane, 'Zur Geschichte des Berliner Silberbuffets', in: exhibition catalogue *Metall im Kunsthandwerk*, Kunstgewerbemuseum, Schloss Köpenick, East Berlin (East Berlin 1967), pp. 239-51

Kuhn, Hans Wolfgang, 'Gerhard Greiff (1642-1699) und der Augsburger Silberwarenhandel im späteren 17. Jahrhundert', in: *Zeitschrift des Historischen Vereins für Schwaben* 78 (1984), pp. 117-58

Lehne, Barbara, *Süddeutsche Tafelaufsätze vom Ende des 15. bis Anfang des 17. Jahrhunderts* (Munich 1985)

Lessing, Julius, 'Der Silberschatz des königlichen Schlosses zu Berlin', in: *Gesammelte Studien zur Kunstgeschichte: Eine Festgabe zum 4. Mai 1885 für Anton Springer* (Leipzig 1885), pp. 121-42

Lessing, Julius, and Brüning, Adolf, eds., *Der Pommersche Kunstschrank* (Berlin 1905; Königliches Kunstgewerbemuseum)

Löwe, Regina, *Die Augsburger Goldschmiedewerkstatt des Matthias Walbaum* (Munich and Berlin 1975; Bayerisches Nationalmuseum: Forschungshefte, vol. 1)

Markova, Galina, *Nemetskoe khudozhestvennoe serebro 16-18 vekov s sobraniy qosudarstvennoy oruzheinoy palat' / Deutsche Silberkunst des XVI.-XVIII. Jahrhunderts in der Sammlung der Rüstkammer des Moskauer Kreml* (bilingual edn. Moscow 1975)

Menzhausen, Joachim, *Das Grüne Gewölbe* (Leipzig 1968)

Menzhausen, Joachim, *Dresdener Kunstkammer und Grünes Gewölbe* (Leipzig and Vienna 1977); English edition *The Green Vault: An Introduction* (Dresden 1977)

Müller, Hannelore, 'Zur Augsburger Goldschmiedekunst vom 16. bis zum frühen 19. Jahrhundert', in: *Ori e Tesori d'Europa. Atti del Convegno di Studio Castello di Udine 3-4-5 dicembre 1991* (Udine 1992), pp. 187-200

O'Byrn, Friedrich August Freiherr von, *Die Hof-Silberkammer und die Hof-Kellerei zu Dresden* (Dresden 1880)

Praël-Himmer, Heidi, *Der Augsburger Goldschmied Johann Andreas Thelot* (Munich 1978; Bayerisches Nationalmuseum: Forschungshefte, vol. 4)

Rathke-Köhl, Sylvia, *Geschichte des Augsburger Goldschmiedegewerbes vom Ende des 17. bis zum Ende des 18. Jahrhunderts* (Augsburg 1964; Schwäbische Geschichtsquellen und Forschungen, vol. 6)

Richter, Ernst-Ludwig, *Altes Silber: imitiert – kopiert – gefälscht* (Munich 1983)

Rosenberg, Marc, *Der Goldschmiede Merkzeichen* (3rd enlarged, illustrated edn., Frankfurt am Main and Berlin 1922 - 8), 4 vols.

Scheicher, Elisabeth, *Die Kunst- und Wunderkammern der Habsburger* (Vienna, Munich and Zurich 1979)

Schiedlausky, Günther, *Tee, Kaffee, Schokolade: Ihr Eintritt in die europäische Gesellschaft* (Munich 1961)

Schröder, Alfred, 'Augsburger Goldschmiede, Markendeutungen und Würdigungen', in: *Archiv für die Geschichte des Hochstifts Augsburg* VI (1929), pp. 541 - 607

Schürer, Ralf, 'Augsburg und Nürnberg', in: exhibition catalogue *Schätze Deutscher Goldschmiedekunst von 1500 bis 1920 aus dem Germanischen Nationalmuseum*, Stadtmuseum, Ingolstadt, 1992 (Nuremberg and Berlin 1992), pp. 83 - 90

Seelig, Lorenz, *Der heilige Georg im Kampf mit dem Drachen: Ein Augsburger Trinkspiel der Spätrenaissance* (Munich 1987; Bayerisches Nationalmuseum: Bildführer, no. 12)

Seelig, Lorenz, 'Die Gruppe der Diana auf dem Hirsch in der Walters Art Gallery', in: *The Journal of the Walters Art Gallery* 49 - 50 (1991 - 2), pp. 107 - 18

Seidel, Paul, *Der Silber- und Goldschatz der Hohenzollern im königlichen Schlosse zu Berlin* (Berlin n. d.; 1895/6)

Seling, Helmut, 'Hans Schebel: ein unbekannter Augsburger Goldschmied des 16. Jahrhunderts', in: *Kunstgeschichtliche Studien für Kurt Bauch zum 70. Geburtstag* (Munich and Berlin 1967), pp. 145 - 50

Seling, Helmut, *Die Kunst der Augsburger Goldschmiede 1529 - 1868: Meister, Marken, Werke*, 3 vols. (Munich 1980), supplement to vol. 3 (Munich 1994)

Seling, Helmut, 'Silberhandel und Goldschmiedekunst in Augsburg im 16. Jahrhundert', in: exhibition catalogue *Welt im Umbruch: Augsburg zwischen Renaissance und Barock*, Rathaus and Zeughaus, Augsburg, 1980 (Augsburg 1981), vol. 3, pp. 162 - 70

Steingräber, Erich, *Der Goldschmied: Vom alten Handwerk der Gold- und Silberarbeiter* (Munich 1966)

Weiss, August, *Das Handwerk der Goldschmiede in Augsburg bis zum Jahre 1681* (Leipzig 1897; Beiträge zur Kunstgeschichte, new series, vol. XXXIV)

Werner, Anton, *Augsburger Goldschmiede: Verzeichnis der Augsburger Goldschmiede, Silberarbeiter, Juweliere und Steinschneider von 1346 - 1803* (Augsburg 1913)

Exhibition catalogues
(in chronological order)

Augsburger Barock, Rathaus and Holbeinhaus, Augsburg, 1968 (Augsburg 1968)

Welt im Umbruch: Augsburg zwischen Renaissance und Barock, Rathaus and Zeughaus, Augsburg, 1980 - 1, 2 vols. (Augsburg 1980)

Das Hildesheimer Tafelservice: Meisterwerke der Augsburger Goldschmiedekunst, ed. Hannelore Müller, Maximilianmuseum, Augsburg, 1985 (Augsburg 1985)

Ori e argenti dall'Ermitage, Villa Favorita, Lugano, 1986 (Milan 1986)

Deutsche Goldschmiedekunst vom 15. bis zum 20. Jahrhundert aus dem Germanischen Nationalmuseum, ed. Klaus Pechstein; Deutsches Goldschmiedehaus, Hanau; Stadtmuseum, Ingolstadt; Germanisches Nationalmuseum, Nuremberg, 1987 - 8 (Nuremberg and West Berlin 1987)

Christian IV's Royal Plate and his Relations with Russia, Rosenborg Castle, Copenhagen, 1988 (Copenhagen 1988)

Königliches Dresden. Höfische Kunst im 18. Jahrhundert, Hypo-Kunsthalle, Munich, 1990 - 1 (Munich 1990)

Schätze Deutscher Goldschmiedekunst von 1500 bis 1920 aus dem Germanischen Nationalmuseum, Stadtmuseum, Ingolstadt; Deutsches Goldschmiedehaus, Hanau; Ostpreussisches Landesmuseum, Lüneburg, 1992 (Nuremberg and Berlin 1992)

Die Anständige Lust: Von Esskultur und Tafelsitten, Münchner Stadtmuseum, Munich, 1993 (Munich 1993)

Versailles et les tables royales en Europe XVIIème - XIXème siècles, Château, Versailles, 1993 - 4 (Paris 1993)

Silber und Gold: Augsburger Goldschmiedekunst für die Höfe Europas, ed. Reinhold Baumstark and Helmut Seling, Bayerisches Nationalmuseum, Munich, 1994 (Munich 1994)

Photographic Acknowledgements

Augsburg, Städtische Kunstsammlungen: figs. 24, 26

Berlin, Staatliche Museen zu Berlin, Preussischer Kulturbesitz, Kunstgewerbemuseum: figs. 11, 16

Dachau, Wolf-Christian von der Mülbe: frontispiece; fig. 22; plates 1 - 25, 32 - 64

Dresden, Sächsische Landesbibliothek, Abt. Deutsche Fotothek: fig. 23

Dresden, Staatliche Kunstsammlungen: figs. 17, 18

Frankfurt am Main, Historisches Museum: figs. 7, 8

Hanover, Niedersächsisches Hauptstaatsarchiv: fig. 3

Hanover, Niedersächsisches Landesmuseum, Landesgalerie: fig. 21

Munich, Bayerische Verwaltung der staatlichen Schlösser, Gärten und Seen, Museumsabteilung: fig. 10

Munich, Bayerisches Nationalmuseum, Walter Haberland: plates 26 - 31; figs. 1, 13, 14; Marianne Stöckmann: fig. 20; Archiv zur Augsburger Goldschmiedekunst: figs. 2, 9, 12, 15, 19

Stockholm, Nationalmuseum: fig. 6

Stuttgart, Staatsgalerie, Graphische Sammlung: figs. 4, 5

Vienna, Kunsthistorisches Museum: fig. 25